THE TURNER BOOK

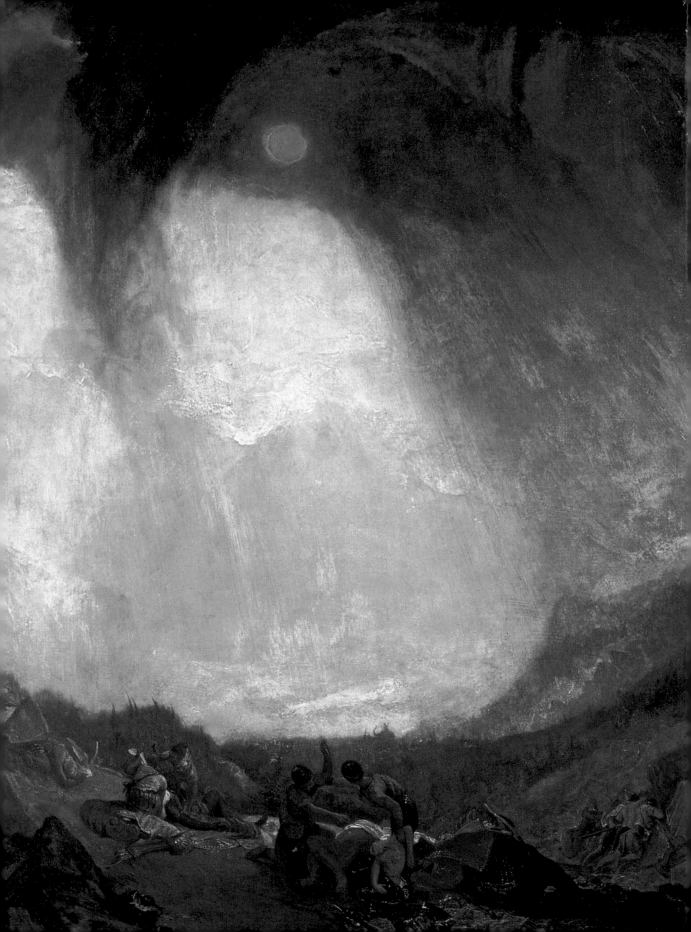

SAM SMILES

THE TURNER BOOK

TATE PUBLISHING

First published 2006 by order of the Tate Trustees
by Tate Publishing, a division of Tate Enterprises Ltd,
Millbank, London SW1P 4RG

www.tate.org.uk/publishing

British Library Cataloguing in Publication Data
A catalogue record for this book is available from
the British Library

ISBN 10: 1 85437 572 5
ISBN 13: 9781 854 375728

Distributed in the United States and Canada by Harry N.
Abrams, Inc., New York

Library of Congress Cataloging in Publication Data
Library of Congress Control Number 2006931283

Designed by
Esterson Associates

Front cover: *The Burning of the House of Lords and
Commons, 16th of October, 1834* 1835 (fig.62 detail)
Oil on canvas 92 × 123 Philadelphia Museum of Art, John H.
McFadden Collection
Frontispiece: *Snow Storm: Hannibal and his Army crossing
the Alps* 1812 (fig.40 detail), Oil on canvas, 146 × 237.5, Tate

For Catherine and Fergus
My thanks to Alice Chasey and John Jervis at Tate Publishing,
as well as Richard Dawes and Julia Beaumont-Jones, for all
their hard work in preparing this book for publication. The
thematic approach adopted here raises particular difficulties
and I am especially grateful to the readers of the original
manuscript for their valuable suggestions. I owe a particular
debt of thanks to Lucy Howarth, whose help enabled me to
complete the project on time.

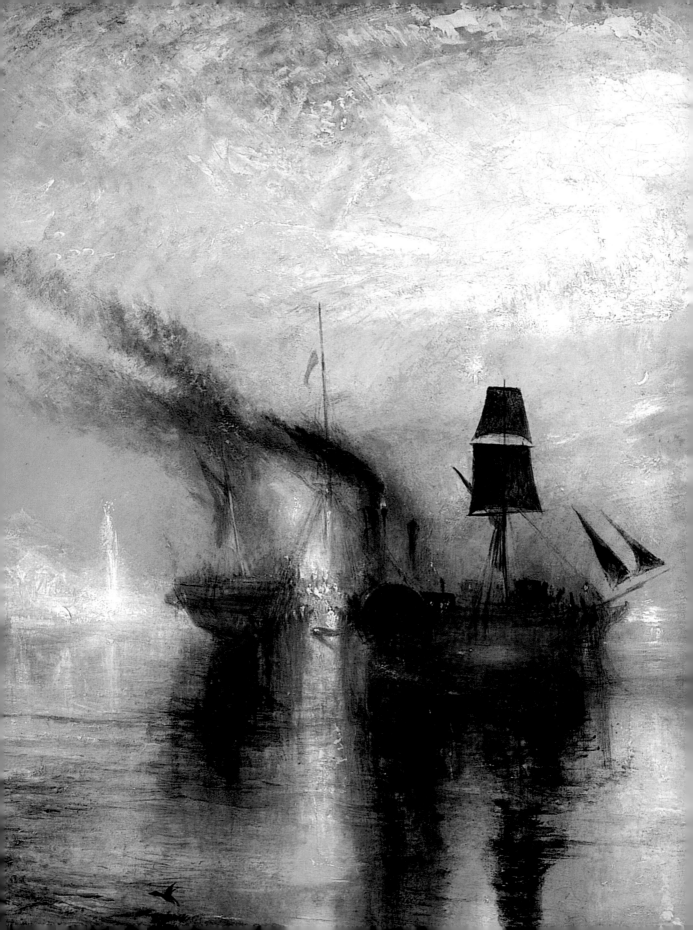

J.M.W. Turner is arguably Britain's greatest painter. His technical skills were unmatched, in oil and in watercolour, and over a long career he transformed landscape painting into an art form of quite extraordinary range and significance. His paintings record the multifarious aspects of the material world and encompass an extensive variety of effects, most especially the liberation of light and colour. Beyond this, however, his art demonstrates a concern to make painting a major vehicle for the contemporary interests of his age. His relish for myth and history was balanced by an avid curiosity about social behaviour, technological development, scientific discovery and political events. Landscape, in Turner's hands, was always much more than a simple transcript of nature.

This book is intended to offer the interested general reader an overview of Turner's achievement. Britain's most celebrated artist has had any number of books devoted to his career and he is extremely well served by popular guides and academic studies alike. It is the gap between these two sorts of publication that *The Turner Book* is intended to fill; it makes use of recent advances in Turner scholarship but is written for an audience who may be coming to Turner for the first time. Those of us who have been involved with the artist for many years are prone to forget how daunting approaching Turner may be. The sheer volume of work he produced and the equally large volume of critical studies on that work present challenges that can be rather off-putting. For that reason, perhaps, a thumbnail

treatment of Turner does service for many people instead, concentrating on his exploration of light and colour and his seeming anticipation of Impressionism or even abstract art. While this has the virtue of clarity, it is over-reductive and simply does no justice to the artist.

One aim of the present book is to show that Turner is a great deal more interesting than the thumbnail approach suggests. New research has revealed, with more and more exactness, what Turner's art accomplished, technically, intellectually and institutionally. But that picture has had to be built up by a succession of small contributions, filling in the details of a patron's commission here, a reminiscence from one of Turner's engravers there; in short, refining what we knew, or thought we knew, by an accretion of evidence. That process can sometimes blur the established outlines, and this book's purpose is to redraw them, adjusted to take account of recent developments.

The Turner Book ranges over the whole of Turner's art and his professional life; it includes examples from all phases of his activity and discusses work in a variety of media. Many of the paintings in oil or watercolour will be familiar, as they should be in a book attempting to sum up an artist's career, but less well-known images have also been included to indicate the range of Turner's endeavours. All of the examples have been chosen because they help to illuminate aspects of Turner's procedures and many of them are explored in some detail, because it is by attention to detail that the resonance of his

Introduction

images is most easily understood. For this reason this book has been designed to function rather like a handbook, gathering together in one place information on particular topics. It is important to keep this intention in mind, for although the book opens with a look at the art world Turner inherited and closes with his posthumous reputation, it is not arranged as a chronological survey. Instead, each chapter takes a theme and ranges over examples selected from the whole of Turner's career. The benefit of doing this is that it allows Turner's preoccupations to reveal themselves, as we watch the emergence and development of particular concerns that mattered to the artist and sometimes stayed with him for many years.

Again, following the handbook rubric, within each chapter will be found subheadings, dividing its theme into separate components. It is obvious, however, that many of Turner's pictures could just as happily be included in one division as another and their separation by category must be understood as a necessary convenience. Turner himself attempted a codification of landscape painting by categories, in the engravings published in his *Liber Studiorum*, but his own practice tended towards a complex and many-sided vision. In fact, if there is one thing the reader should come away with after reading this book it is that Turner tended to operate on many levels simultaneously. A picture that at first sight is merely an exploration of light and landscape might indeed be exhibiting technical daring in its use of colour, perspective or handling, but it may also be playing a knowing game of art-historical reference to the old masters and simultaneously competing with one of Turner's contemporaries, especially in the context of the annual Royal Academy exhibitions. Time and again individual paintings can be shown to respond to a variety of different concerns and it is a measure of Turner's distinction as an artist that this is so.

Within each section the arrangement of examples is usually chronological, allowing the reader to trace the course of Turner's artistic development as manifested in his pursuit of different quarries. This approach has the important additional benefit of putting works from different periods of Turner's career into conversation, whereas a strictly chronological approach, from one chapter to the next, tends rather to let the later work supersede or even eclipse the work of his youth and early maturity. As Chapter 6 reveals, our contemporary taste for the work of Turner's final years, which is to say the period *c.*1835–50, and including canvases left unfinished on his death, has dominated modern appreciation of the artist, encouraging the public to skip impatiently through his earlier productions in search of the paintings that seem to anticipate modern art. But this seemingly 'prophetic' Turner of the 1830s and 1840s did not emerge, butterfly-like, from a 'traditional' chrysalis. His work of the 1790s and the three following decades is not merely a prelude to his maturity, nor is it explained as some sort of slow apprenticeship from which he finally

cast free. Turner's technical mastery was acknowledged from very early on in his career and his intellectual sophistication is also markedly in evidence then.

Similarly, his artistic development cannot be characterised satisfactorily as simply a straightforward decade-by-decade transition from tight, descriptive handling to loose, quasi-abstract chromatic fantasies. While the beginning and end of his career do represent different approaches to the business of painting landscapes, the years in between witness a variety of pictorial experiments, technical discoveries and stylistic departures which are best understood in their own terms rather than as mileposts on the way to abstraction.

The other preoccupation, characteristic of some of the interest in Turner today but largely missing from this book, concerns his biography, or rather those parts of it which have a tinge of the sensational about them: his mother's madness, his illegitimate children, his sometimes eccentric behaviour, his last years in Chelsea living with Mrs Booth under an assumed name. In fact, as we look over Turner's entire career, the nature of much of the surviving evidence suggests that his private life was dominated by his professional concerns, with little of the spectacular to relate. Unfortunately, significant evidence from three of Turner's most intimate acquaintances, who had known him in his youth and early maturity, was destroyed by their executors.[1] Consequently, when Turner's first biographer, Walter Thornbury, collected information about the artist immediately after his death the secretive and oracular figure Turner had become in his last years was fresh in many people's memory and their testimony produced a partial and distorted picture of the artist's character. For all these reasons Turner's personal life, while undoubtedly interesting, is better undertaken in a biography and two good recent studies are readily available (see Bibliography).

The chapters that follow have comparatively little to say about Turner's private affairs and the resulting picture may imply that he lived only to paint. Whether or not this is true, perhaps it is as it should be; Turner placed his art in a public arena, to succeed or fail through its own qualities. His art was not confessional and when it did exhibit autobiographical elements his references were almost always to his professional identity, not his personal one. Art was the cause to which he devoted his life and it was by his art that he wanted to be judged.

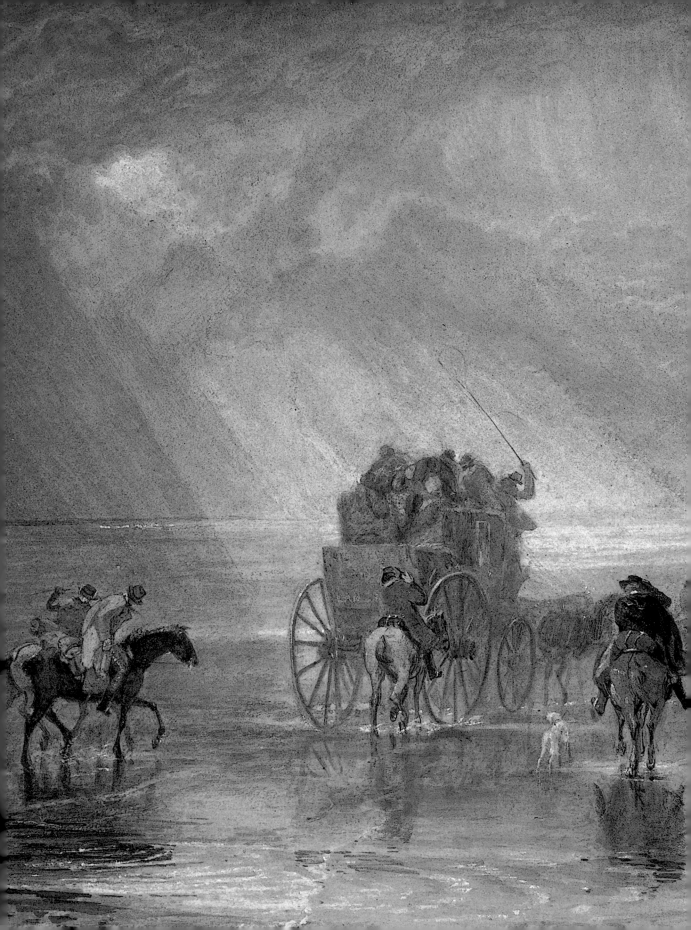

If there was one public arena for the artist in the late eighteenth and early nineteenth centuries it was the Royal Academy in London, and Turner's career is intimately connected with it. As he wrote in the 1810s, in the draft of a lecture to its students, the Academy was 'an institution to which I owe everything'. He reminisced fondly about the time when he had been in their place: 'I cannot look back but with pride and pleasure to that time, the Halcyon perhaps of my days, when I received instruction within these walls and listen'd, I hope I did, with a just sense and respect towards the institution and the then President Sir Joshua Reynolds whose discourses must be yet warm in many a recollection.'[1]

The Royal Academy had been founded in 1768, with Sir Joshua Reynolds as its first president, and from the 1780s was located in Somerset House, in the Strand. The young artist who was admitted as a Probationer there in December 1789 had already travelled more than the few hundred yards separating the Academy from his family home in Maiden Lane, Covent Garden. Turner's father, William, was a barber and wig maker, originally from Devon; his mother, Mary Marshall, came from a family of Middlesex tradespeople, some of whom had made a little money. Turner's origins were therefore modest and he had few advantages of education and background, as was also true for other artists of his generation, such as Thomas Girtin (1775–1802), the son of a brush maker from Southwark. Yet, thanks to his talent and the professional cachet of the

Academy, Turner would soon be a welcome guest in the homes of the gentry and aristocracy, the companion of artists, writers and scientists, and the possessor on his death of a considerable fortune. He did, indeed, owe the Royal Academy everything.

Outside the Royal Academy, the possibility of art training was hit-and-miss. Most instruction was akin to an apprenticeship and relatively unstructured, and Turner's early experiences in learning his craft were not unusual. In 1789, for example, just before entering the Academy, he worked in the drawing office of the architect Thomas Hardwick (1752–1829) and then trained in the studio of the architectural draughtsman Thomas Malton Junior (1748–1804), learning perspective and the other skills necessary for architectural drawing. His earliest exhibited watercolour, as one might expect, is indebted to these formative influences, but was successful enough to be exhibited at the Academy in 1790 (fig.1).[2] As the apprentice work of a fifteen-year-old youth this watercolour is reasonably accomplished, the rather mannered figures are animated and the detailed presentation of the architectural features shows a nice understanding of texture. Yet, looking at it, one feels that Turner's fledgling talent needed the stimulus of a more creative environment.

At this time the Royal Academy provided the only centre of systematic art training in England, including practical instruction and lectures on anatomy, architecture, painting, geometry and perspective. As such it was recognised as an almost essential passport

1 Turner's Inheritance: The British Art World and the Landscape Tradition

to professional success and by 1800 some 800 students were enrolled there. The instruction provided by the Academy was predicated on the idea that art training would acquaint students with the highest reaches of art practice: the tradition of figurative sculpture and painting descending from classical antiquity and the Renaissance. For painters the official goal of this preparation was history painting, then considered to represent the apogee of the art, below which were ranked portraiture, 'genre' painting, landscape and still life.[3]

For his first three years as a Royal Academy student Turner copied the plaster models of classical sculpture in the Academy's Plaister Academy and from 1792 to 1799 he studied the nude in the Life Academy (fig.2). His surviving Life Class drawings reveal that he applied himself diligently to the task and was perfectly capable, at least in his early years, of taking pains with the figures he included in his compositions. The dancing girls in the foreground of *The Festival upon the Opening of the Vintage of Macon* (1803, fig.3) are not only anatomically correct but, in their variety of postures and rhythmic organisation, perfectly convey the idea of gaiety and exuberance associated with the festival. Two years later, in *The Deluge* (1805, fig.12), Turner again demonstrated his understanding of figure drawing with a range of poses and body types.

These two pictures owe a considerable debt to two seventeenth-century French artists: respectively, Claude Lorrain (see fig.50) and Nicolas Poussin (see fig.11). English collectors were avid purchasers of their paintings and

Turner is known to have expressed equal admiration. Visiting the collection of William Beckford in his London house in 1799, he had admired the two Claudes recently purchased from the Altieri collection. Turner spoke to the landscape artist Joseph Farington about one of them, *The Sacrifice to Apollo*: 'he was both pleased and unhappy when he viewed it, it seemed to be beyond the power of imitation.'[4] Although Turner did eventually take Claude's measure, the artist remained something of a touchstone for his art throughout his career. Poussin was equally important to connoisseurs; by 1800 almost half of his surviving pictures were in British collections. Revered for his ability to structure historical compositions with lucid geometry, and for his achievement in communicating important ethical and philosophical statements, Poussin stood as the great example for a morally serious landscape art.

While still a student at the Royal Academy Turner also joined the informal 'Academy' organised by Dr Thomas Monro (1759–1833), a physician and amateur artist, at his home in Adelphi Terrace. Monro had a collection of drawings, watercolours and prints by the old masters and contemporary British artists, especially the watercolour artist John Robert Cozens, and he made these available to students. Young artists attended every Friday to copy drawings in the collection and Turner was employed in this line of work from at least 1794 until 1797, working in collaboration with Thomas Girtin, his exact contemporary, whose innovations in landscape rivalled Turner's at the turn of the century. Although

1
The Archbishop's Palace, Lambeth 1790
Pencil and watercolour
26.3 × 37.8
Indianapolis Museum of Art

2
Academy Study of a Standing Male Nude, with Right Arm Raised, Seen from Behind ?1797
Black and white chalk and red body-colour on blue paper
51.4 × 34.9
Tate

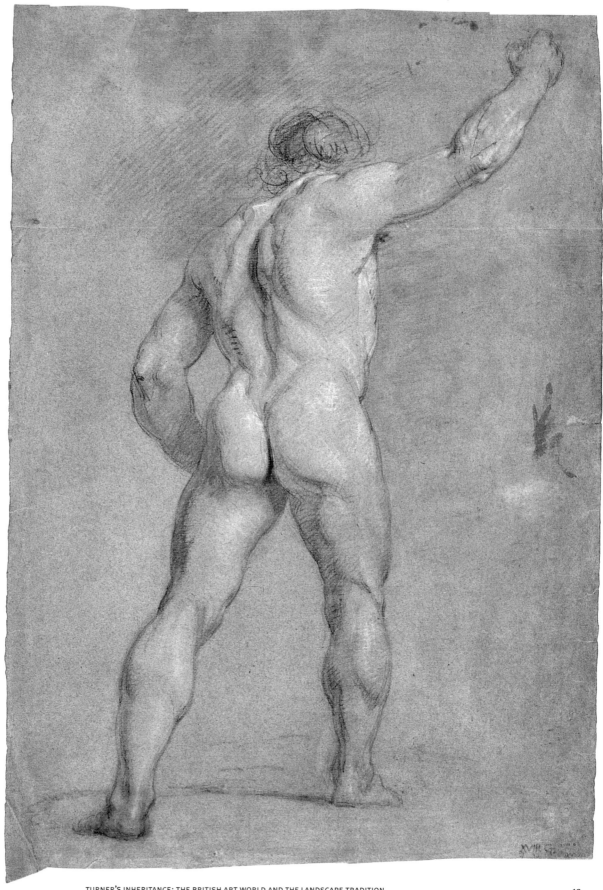

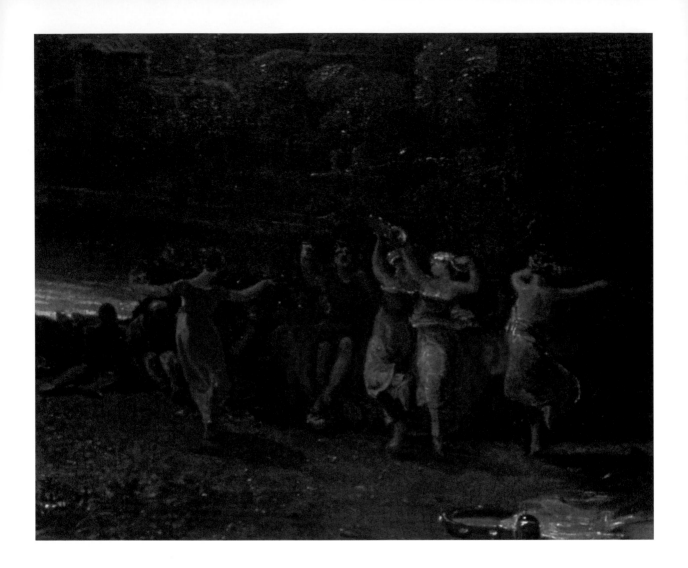

THE TURNER BOOK

the work of copying was repetitive and creatively limited, Monro's collection provided both artists with a comprehensive introduction to the rise of watercolour painting, its technical possibilities and the stylistic vocabulary of its most important practitioners.

Early success

As his training proceeded Turner's growing competence was recognised by others. In 1793 the Society of Arts awarded him its Great Silver Pallet for a landscape drawing. He began to make sketching tours: to Malmesbury and Bath in 1791, to South Wales in 1792, the River Wye, Sussex and Kent in 1793, the Midlands and North Wales in 1794. Turner explored the topographical possibilities of English landscape, concentrating especially on architectural detail, for which his training had well prepared him. In 1794 he also began offering tuition to private pupils, perhaps encouraged by the favourable notices his watercolours at the Royal Academy exhibitions had just received.[5] In 1796 he was commissioned by the topographer and antiquarian Sir Richard Colt Hoare, the owner of Stourhead in Wiltshire, who ordered large watercolour drawings of Salisbury Cathedral and its surroundings.[6] These drawings present a useful overview of Turner's capabilities as a designer. His accuracy in recording the details of the architecture and its ornaments is of a very high order, as is his control of the space, using a viewpoint that encourages a wide field of view. His watercolour showing the *Choir of Salisbury Cathedral* (1797, fig.4) includes a representation of the stained-glass window designed by Sir Joshua Reynolds depicting Christ's resurrection. In a nice conceit the sun streaming through the window seems to bring the resurrection to life. It is likely that Turner intended this as an homage to Reynolds, whose professional achievements and stature as the President of the Royal Academy had struck him so deeply in 1790.

The Salisbury series also reveals the extent to which Turner believed he had arrived: no longer the Maiden Lane apprentice but a professional artist with a growing reputation and the commissions that came with it. He includes his name on a tombstone on the floor of the aisle, at bottom right: 'Turner/Sarum'. He had done the same in another watercolour of this period, *St Erasmus in Bishop Islip's Chapel* (1796, fig.5), where 'William Turner Natus 1775' is inscribed on a tombstone on the floor of Westminster Abbey. Turner was twenty-one in 1796 and here declares that he has come of age. In inscribing his name on the floors of such venerable buildings, Turner includes himself in the national story, binding himself to the structures in which reside the historical memory of the nation. This intention is echoed in the mystery surrounding his birthday. No record of the day on which he was born has survived, but Turner let it be known later in life that his birthday fell on 23 April, St George's Day, which was also Shakespeare's birthday.[7] Until such time as concrete evidence is found to confirm or deny his assertion, we should at least note the extraordinary coincidence of England's greatest painter and greatest writer sharing their birthday with the national saint.

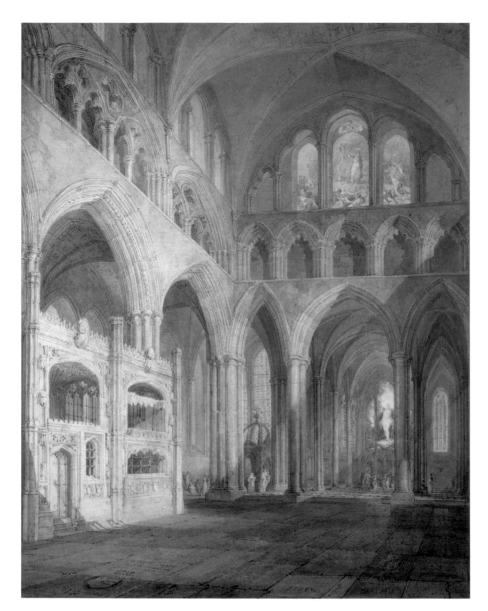

5
*St Erasmus in Bishop
Islip's Chapel, Westminster
Abbey* 1796
Pencil and watercolour
54.6 × 39.8
British Museum

4
*Choir of Salisbury
Cathedral (with Lady
Chapel)* 1797
Pencil and watercolour
64.8 × 50.8
Salisbury and South
Wiltshire Museum

6
Fishermen at Sea 1796
Oil on canvas
91.5 × 122.4
Tate

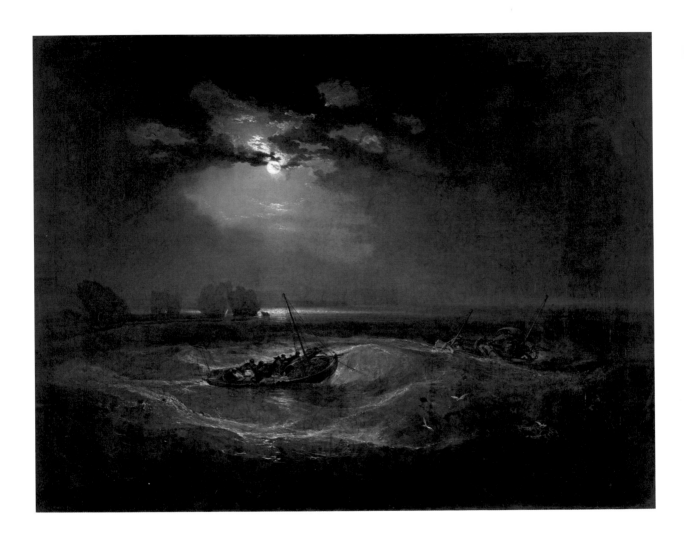

As well as his twenty-first birthday, 1796 also marked Turner's first exhibition of an oil painting at the Royal Academy: *Fishermen at Sea* (fig.6). In this picture, showing a fishing scene off the westernmost point of the Isle of Wight, Turner made use of sketches he had taken in 1795, but aggrandised the actual scene by his control of light. Many of Turner's earliest pictures used a relatively dark tonality and seem at first to differ absolutely from his experimentation with light and colour as a mature artist. Yet, even though the tonal impact here is achieved within a very restricted range of colours, his sophisticated understanding of light is already apparent. The central portion of the image is effectively an envelope of luminosity, contrasted with the darkness beyond, within which Turner opposes two light sources, one cold, the other warm: the silvery moonlight and its reflection contrasted with the reddish glow from the lantern. In contrasting two different light sources, Turner was following a well-worn trail, but with hindsight we can perhaps view this first oil as already announcing the possibility of light and colour as dynamic presences in nature.

Turner's gallery

Turner was elected an Associate of the Royal Academy in 1799 and became a full Academician in 1802. His growing success as an artist, his professional reputation, his sales and his recognition by the Academy must all have contributed to his decision to leave Maiden Lane for the more upmarket neighbourhood of Marylebone. In 1799

he rented rooms in a house at 64 Harley Street, at the junction with Queen Anne Street West, and this location would remain his official residence for the rest of his career. In 1804 he opened his own picture gallery at this address, an extension built over the garden providing a room some 70ft long and 20ft wide.[8] Having moved around the corner, he redesigned this gallery in 1811 to provide, among other improvements, a new entrance, but this can only have been an awkward and temporary expedient. Between 1820 and 1822, therefore, he built a new house and gallery on a plot of land next to his current residence, providing for himself a purpose-built studio and exhibition space at 47 Queen Anne Street West.[9] The new gallery, lined with Indian red cloth, was about 55 ft long by 19 ft wide, top-lit and orientated north–south (fig.7). Between twenty and thirty paintings were usually on view, hung frame to frame, with more recent work displayed on easels. The ceiling was relatively low, as we can see in George Jones's painting of the gallery in its prime, with *Dido Building Carthage* (1815, fig.51) at the far end. The Revd William Kingsley remembered it as 'the best lighted gallery I have ever seen, and the effect got by the simplest means; a herring net was spread from end to end just above the walls, and sheets of tissue paper spread on the net, the roof itself being like that of a greenhouse. By this the light was diffused close to the pictures.'[10]

Loyalty to the Royal Academy

Turner used the gallery initially for an annual demonstration of his new work, especially in

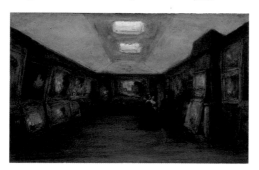

7
George Jones
Turner's Gallery: The Artist Showing his Work c.1852
Oil on panel
14.2 × 22.5
Ashmolean Museum, Oxford

the 1800s and 1810s, but increasingly its function seems to have been more to display his (unsold) artistic achievements than to act as a shop window for his latest work. The place for this new work was almost invariably the Royal Academy, for it was here that Turner evidently felt his commitment to serious art could best be understood. Of course, exhibiting at the Academy would expose his art to the widest possible appreciation, but there is also a sense of collegial responsibility in his activities there.

The Royal Academy, although ostensibly benefiting from the patronage of the Crown, presided over its own affairs and sought the promotion of the visual arts in Britain through its training and exhibition policies. It offered, in short, a social space in which the individual artist could make common cause with fellow professionals to advance a view of the arts that insisted on their public relevance and their importance to society. As Turner declared in a speech to Royal Academy students in 1847: 'never mind what anybody else calls you. When you become members of this institution you must fight in a phalanx – no splits – no quarrelling – one mind – one object – the good of the Arts and the Royal Academy.'[11] Thus, against the stereotype of the Romantic artist as an isolated genius whose art is fundamentally an expression of individual thoughts and feelings, we can posit the idea of the artist as effectively engaged in communion with his contemporaries in the public space of the exhibition and the professional arts organisation of the Academy.

As so often with Turner, this emphasis on art's utility as a public discourse, as opposed to a private expression, is an eighteenth-century inheritance. For all his embrace of the new material and political culture of the nineteenth century, his intellectual habits seem closer to Reynolds than to many of his contemporaries. Turner maintained a respect for history painting throughout his career, produced numerous historical and mythological subjects and even in works seemingly orientated to topography would include details which, when attended to, suggested social, political or historical readings of the image. Characteristically, then, much of his art is turned outwards and invites its spectators to respond to its seriousness: its ability to comment on contemporary events, to meditate on history, to anatomise the social and technological world of the nineteenth century. If this sounds like an educator's programme we should remember that Turner actively contributed to teaching in the Royal Academy. He acted as Visitor in the Life Academy eight times between 1812 and 1838 and was considered to be highly effective in that role. He was also elected Professor of Perspective in 1807 and began delivering his lectures on that subject from 1811.[12] Although a failure as a public speaker, Turner nevertheless took inordinate pains to improve his presentation, especially in the production of visual exemplifications of his topic (fig.8). To these didactic activities we should add the production of his *Liber Studiorum*, a part-work produced between 1807 and 1819 which offered its subscribers a visual demonstration

8
Perspective lecture diagram: 'Reflections in a Single Polished Metal Globe and a Pair of Polished Metal Globes'
*c.*1810
Oil and pencil on paper
64 × 96.8
Tate

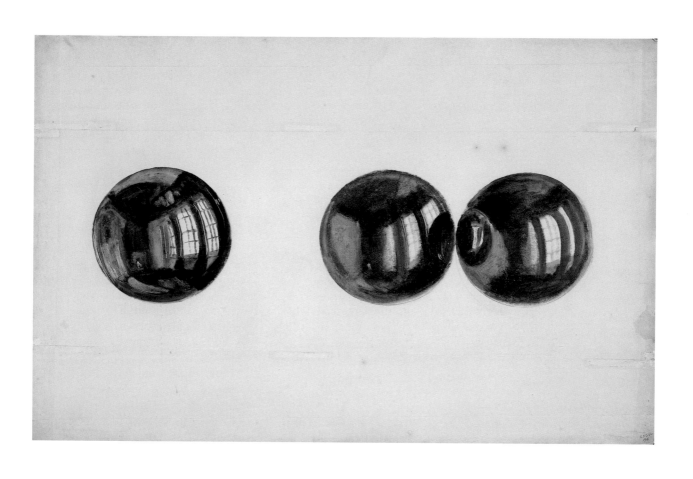

of the modes of landscape painting employed in his art (fig.9). Turner's willingness to use his art as an educational device is telling, for it might be seen as recapitulating the educational role of the Academy, especially in its lecture series, inaugurated so successfully with Reynolds's *Discourses*. Turner's paintings can be understood as contributions to a dialogue with his fellow artists, with the great masters of the past, with history and with society.

The influence of the old masters

The high seriousness of the artistic calling, as Reynolds and others had outlined it, made little sense without exposure to great art. War with France, which broke out in 1793 and continued, with the exception of the short-lived Peace of Amiens (1802–3), until 1815, made foreign travel hazardous and access to the old masters problematic. There were no public art galleries in Britain at the beginning of the nineteenth century; for many artists and members of the public, seeing old master paintings was most reliably secured by visiting auctioneers when great collections went under the hammer. From the 1770s to the 1830s the London art market was at its zenith and handled a large number of significant sales, chiefly of European collections. The decline of privilege in Europe, accelerated by the impact of the French revolution, led a number of aristocratic and royal families to dispose of their collections. Works of art shaken loose from Europe because of the Napoleonic wars also appeared on the London art market. The most spectacular sale amid all this activity was that of the collection belonging to the Duc

d'Orléans, sold between 1792 and 1800, comprising hundreds of old master paintings of the highest quality. In 1798 three British collectors, Francis Egerton, Duke of Bridgewater, his nephew George Granville Leveson-Gower, Marquess of Stafford, and Frederick Howard, Earl of Carlisle, purchased the Duc d'Orléans' Italian masterpieces, the cream of the collection, for the colossal sum of £43,000.

Especially after 1800, some patrons and collectors allowed access to their London houses. Charles Townley's residence in Park Street, Westminster, contained an unrivalled collection of classical antiquities, which the public were allowed to visit; the entire collection was purchased by the British Museum in 1805 and redisplayed in a purpose-built gallery in 1808. The Marquess of Stafford, who inherited Bridgewater House and its collection in 1803, was one of the first connoisseurs to open his picture gallery to the public, who could apply for a ticket on viewing days.[13] Shortly afterwards, in 1805, Earl Grosvenor redecorated his picture gallery at Grosvenor House for the display of his old master collection and opened it to the public in May and June each year. Likewise, from 1800 Sir John Fleming Leicester actively promoted the cause of contemporary British art, which he displayed at his country seat in Cheshire, Tabley House, and at his London home, 24 Hill Street, which he acquired in 1805. The latter collection was arranged in a special picture gallery designed by Thomas Harrison and was opened to the general public in 1818, providing a showcase for new

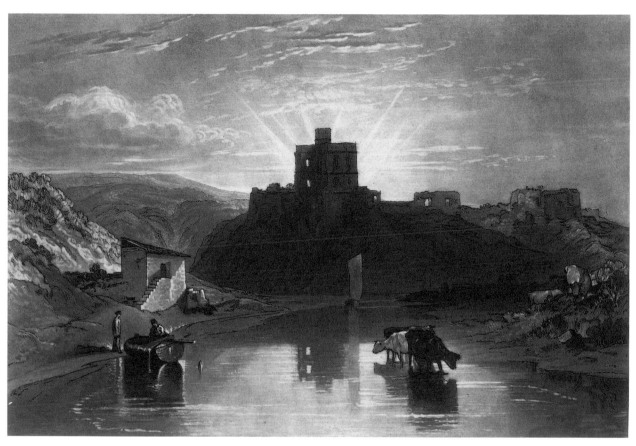

9
Norham Castle on the Tweed
Etching and mezzotint
17.8 × 26.2
from *Liber Studiorum* 1816
etched by J.M.W. Turner,
engraved by Charles
Turner
Tate

developments in British art. Leicester's patronage of living British artists was not unique: the Earl of Essex and the Duke of Bedford both actively supported Turner's contemporaries, and, in Essex's case, Turner himself.[14]

These developments in the public exposure of collections accelerated in the 1810s and afterwards. Dulwich Picture Gallery opened to the public in 1817, in a purpose-built museum designed by Turner's colleague John Soane. The collection of pictures at Dulwich had been assembled by the Royal Academician Sir Francis Bourgeois, building on a stock of pictures he had originally assembled with the art dealer Noel Desenfans, as the nucleus of a collection for Stanislaus, King of Poland, whose abdication in 1795 had brought the original project to an end. The collection included Dutch, French and Italian old masters as well as more recent work by British artists from Hogarth to Reynolds.

Seven years later, in 1824, the National Gallery was established. Its founding collection was first displayed in the Pall Mall town house that had belonged to the collector and connoisseur John Julius Angerstein, thirty-eight of whose old master paintings had been bought by Parliament. In 1838 the National Gallery moved to its present premises in Trafalgar Square, in a building designed for the purpose by William Wilkins, where it was joined by the Royal Academy, relocated from its old premises in Somerset House. Turner can only have approved these developments, for they allowed British artists to measure themselves against the old masters. As well as bequeathing two of his pictures to hang alongside landscapes by Claude in the National Gallery collection (see fig. 51), Turner also paid homage to Titian's *Bacchus and Ariadne*, acquired by the National Gallery in 1826, with a painting of the same title, whose figures are clearly based on the Venetian painter.[15]

If Turner's respect for the old masters seems at first unlikely for an artist whose reputation today is wedded to some notion of his premonition of modern art, we need to remember that his attitude to tradition was formed from eighteenth-century precepts. In 1784 Sir Joshua Reynolds had declared that 'the daily food and nourishment of the mind of an Artist is found in the great works of his predecessors. There is no other way for him to become great himself.'[16] Turner was clearly inspired by much of Reynolds's teaching and would have been well aware of his scepticism about inspiration as some sort of innate quality that could supply an artist's creative needs from his own resources. Moreover, Reynolds warned against the idea of genius, when separated from the lessons usefully provided by tradition, as leading only to mannerism and creative exhaustion. Instead, careful study of the old masters would equip the artist's mind with valuable lessons about the ways in which excellence can be achieved. In the peroration to his sixth Discourse, delivered the year before Turner was born, Reynolds had advised his listeners:

Study therefore the great works of the great masters, for ever. Study as nearly as you can, in the

order, in the manner, and on the principles, on which they studied. Study nature attentively, but always with those masters in your company; consider them as models which you are to imitate, and at the same time as rivals with whom you are to contend.[17]

First tour abroad

Despite the abilities of British connoisseurs to establish good collections, to study the European masters Turner would have to travel abroad. His first major exposure to the legacy of the old masters came in 1802 when the Peace of Amiens allowed him to make a short tour of Switzerland, including a visit to Paris on his way home. The sketchbook recording his studies in the Louvre (see 'Turner's Writings') is testament to his response, with written notes and graphic studies of works by Titian (fig.10), Raphael, Domenichino, Rembrandt and Poussin, among others. Much of what Turner saw on this occasion would inform the remarks he made on the history of art in the lectures he gave from 1811 as the Royal Academy's Professor of Perspective. His analyses demonstrate that he used his visit to the Louvre as an opportunity to study the old masters very closely and, crucially, that they did not overawe him. Turner's critique of Poussin's *Winter, or The Deluge* (fig.11) shows that he now had the confidence to note faults as well as virtues in the work of his illustrious predecessors. He particularly draws attention to the artificiality of this picture, which fails to convey 'the conception of a swamp'd world and the fountains of the deep being broken

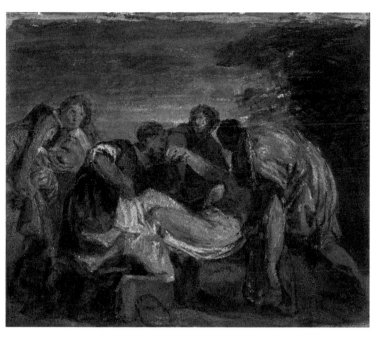

10
Copy after Titian's
Entombment
Watercolour on paper
primed with brown wash
11.2 × 12.9
from 'Studies in the
Louvre' sketchbook 1802
Tate

up'. For Turner, the water has no dynamism and the waterfall is tame and artificial, 'not tearing and desolating, but falling placidly in another pool'.[18] He also attacks the placid expressions on the faces of the flood's victims.

Turner's own *Deluge* (fig.12), painted in 1805, three years after his visit to the Louvre, offers an entirely different conception of the scene, with an intensely aggressive thrust of energies, as opposed to Poussin's classical balance. In place of Poussin's melancholic yet strangely undemonstrative scene, Turner's vision unleashes pulverising forces of destruction: lightning, hurricane-force winds, tidal waves and raging torrents. And where Poussin organised his composition in regular intervals, with different episodes parallel to the picture plane, Turner accelerates the movement of the eye into depth, establishing a strong diagonal from the figures in the bottom right to the lightning flickering on the horizon.

What ultimately separates Turner's vision from Poussin's is a more dynamic conception of space. But that dynamism is itself reliant on ideas about the sublimity of nature that many of Turner's generation would have shared. Edmund Burke's *A Philosophical Enquiry into the Origins of our Ideas of the Sublime and Beautiful* dates from the middle of the eighteenth century and in it Burke had proposed that the sublime represents our mental reaction to the grandeur of nature.[19] When we are able to contemplate power, vastness, danger and obscurity from a position of safety, we may experience the sublime emotion. Nature's overwhelming forces, which would be terrifying when acting on us, are admirable when viewed disinterestedly. The Sublime therefore represents a psychological state only possible when the forces of nature are distanced or seen at one remove, as in a picture. As a critical term in circulation at the turn of the century and beyond, the Sublime had lost much of Burke's original precision. It was routinely deployed to identify the qualities of mountainous scenery and wild weather and was particularly associated with the works of the seventeenth-century landscape painter Salvator Rosa.

Although Turner had already seen Welsh mountains, it was his trip to Switzerland in 1802 that equipped him with a profound sense of the majesty of nature and the need to recapture that emotion in pictorial structures. Nothing in Britain can have prepared him for the scale of what he encountered there; the watercolours he produced after his return, such as *The Great Fall of the Reichenbach, in the Valley of Hasle, Switzerland* (1804, fig.13), are, like *The Deluge*, the first expressions of the Turnerian sublime. The vertical format encourages our feeling of being dwarfed by the enormous height of the waterfall, whose rushing torrent sweeps forward towards us, while the lowering clouds at the top and smashed trees below are ciphers for the forces of nature when fully unleashed. The success of Turner's rendition brought him to the attention of Walter Fawkes (1769–1825), a Yorkshire landowner of radical political opinions, who bought many of Turner's Swiss landscapes, becoming his firm friend and patron for the next twenty years.[20]

Turner's trip abroad had been sponsored

11
Nicolas Poussin
Winter, or The Deluge
1660–4
Oil on canvas
11.8 × 16
Musée du Louvre, Paris

12
The Deluge 1805
Oil on canvas
14.3 × 23.5
Tate

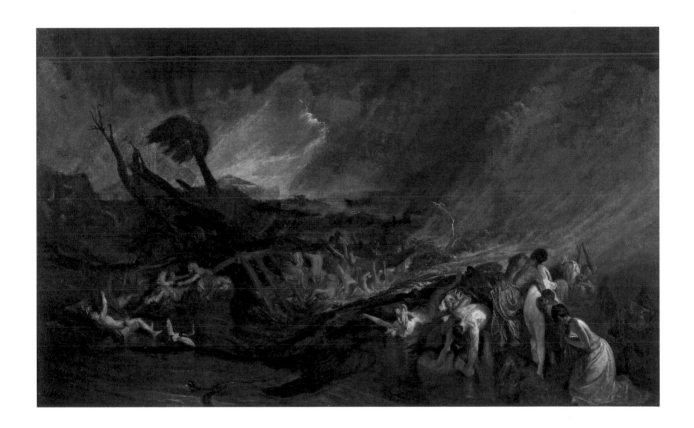

by Lord Yarborough and two unnamed noblemen. Turner had worked for Yarborough in 1798 at his country seat, Brocklesbury Hall, Lincolnshire, and would sell him *The Festival upon the Opening of the Vintage of Macon* (fig.14) in 1804. Yarborough's collection of old masters included works by Claude, Poussin, Salvator Rosa and Cuyp; as such it represented the widespread enthusiasm in England for the two great European landscape traditions: Italian and Dutch. His sponsorship of Turner's travels may have been as much to acquaint the artist with the work of the old masters as to allow him to experience new landscapes. If so, his support implied that the native landscape tradition would not rise to greatness without further stimulus. To understand this, we need to briefly consider the progress of landscape painting in England.

Landscape painting in England

The landscape tradition in England had developed since the seventeenth century, but it had only really come to the fore after the middle of the eighteenth century. View painters had provided British connoisseurs with prospects of Italian landscape and delineations of classical architecture and a growing market for this kind of product embraced not just Italian scenery but also landed estates back home. Richard Wilson (1713/14–82), in particular, had elevated pictures of country houses from plodding topography into art, making of British landscape an idealised, Arcadian delight. In a further bid to raise the status of landscape painting he had also produced pictures incorporating narratives that were usually considered the preserve of history painting (fig.15). Of the many who had contributed to the development of landscape painting in England, we can single out Thomas Gainsborough (1727–88), Alexander Cozens (c.1717–86), his son John Robert Cozens (1752–97), Joseph Wright of Derby (1734–97) and George Stubbs (1724–1806). Many of these painters and their colleagues were versed in the European traditions or had travelled to Italy and were concerned to elevate British landscape to the same eminence seen in the Dutch and Italian traditions.

Occupying a less exalted position were the many topographical painters who explored the face of the British countryside and documented its antiquities. Samuel (1696–1779) and Nathaniel Buck (fl. 1727–53) had published *Antiquities or Venerable Remains of above Four Hundred Castles, Monasteries, Palaces etc. in England and Wales* (1726–52), and similar explorations included Francis Grose's *Antiquities of England and Wales* (1784) and William Byrne and Thomas Hearne's *Antiquities of Great Britain* (1786–98). As a schoolboy in 1785, Turner himself had his earliest experiences as an artist, colouring engravings from a pirated edition of Grose for his uncle at Brentford.

While idealised landscape and the portrayal of country seats tended towards the production of oil paintings, topographical and antiquarian studies were predominantly the preserve of watercolour artists, among them Edward Dayes (1763–1804), Michael

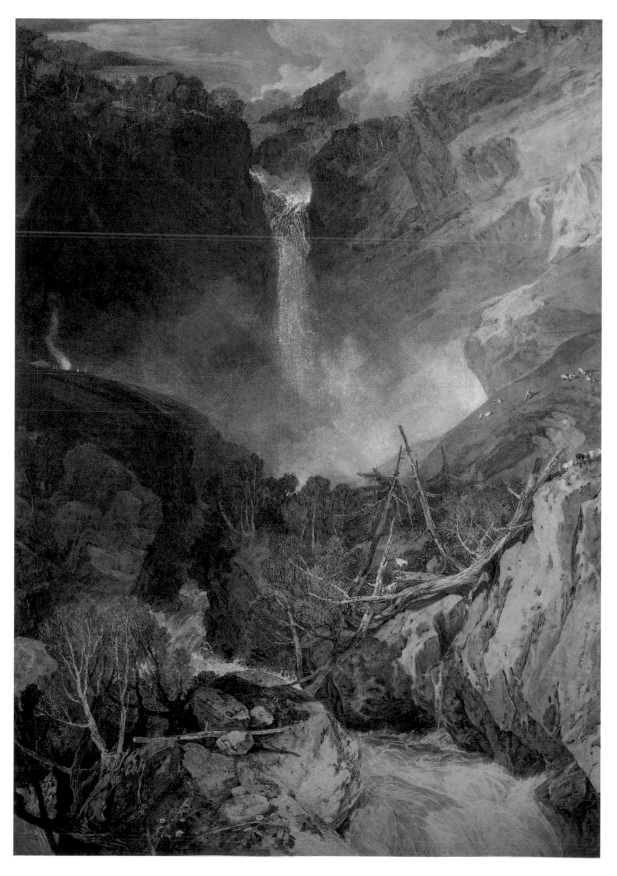

14
The Festival upon the
Opening of the Vintage of
Macon 1803
Oil on canvas
146 × 237.5
Sheffield City Art Galleries

'Angelo' Rooker (1743–1801) and Paul Sandby (1730–1809). Watercolours had been exhibited alongside oils since the 1760s, first at the Society of Artists and the Free Society and then at the Royal Academy, allowing artists to make and exhibit work independently of the more routine commissions they received to provide illustrations for topographical publications. But these works' status as tinted drawings had two drawbacks: first, they tended to be hung badly at the Academy (by 1791, the only surviving exhibiting venue), away from the more important rooms and mingled with engravings and miniatures; second, expertise in watercolour alone was not sufficient grounds for election to membership of the Royal Academy. By the 1790s, therefore, ambitious watercolour artists had begun a series of technical developments that allowed their work to compete with oil painting in terms of size and boldness of colouring, emphasising painting over drawing and, above all, providing watercolour with an aesthetic that incorporated imagination as well as topographical accuracy.

The idea of watercolour as an inventive medium was advanced with the establishment of Girtin's Sketching Society in 1799, where artists met regularly to paint landscapes inspired by literature. This impetus was renewed in 1808 with the formation of the Society for the Study of Epic and Pastoral Design. In addition, the Society of Painters in Water-Colours was founded in November 1804 and mounted its first exhibition the following April with great success. Membership was restricted, however, to twenty-four watercolour painters, and a rival organisation, the New Society of Painters in Miniature and Water-Colours (also known as the Associated Artists), emerged in 1807. Although over-supply diminished the public appetite for watercolours and led to an unsettled period of institutional developments in the 1810s and 1820s, by the 1830s the place of watercolour in the British art world was secure.[21]

Turner did not exhibit with these societies, but his example was of great importance to them, especially his demonstration of the inherent power that watercolour possessed. Moreover, it can only have been beneficial to his own practice to have watercolour advance as a publicly admired medium, and for artists' colour-men to have developed new pigments and also new papers strong enough to withstand experimental techniques. Turner's working methods were thus facilitated by more general developments in the field and he would no doubt have agreed with the sentiments expressed at the relaunch of the Society of Painters in Water-Colours in 1821:

Painting in Water Colours may justly be regarded as a new art, and, in its purest application, the invention of British artists... Within a few years the materials employed in this species of painting, and the manner of using them, have been equally improved, by new chemical discoveries and successful innovations, on the old methods of practice. The feeble tinted drawings formerly

15
Richard Wilson
The Destruction of the Children of Niobe
c.1759–60
Oil on canvas
147.3 × 188
Yale Center for British Art, Paul Mellon Collection

supposed to be the utmost efforts of this art, have been succeeded by pictures not inferior in power to oil-paintings, and equal in delicacy of tint and airiness of tone.[22]

Topography and its transformation

In one sense landscape painting in general, and watercolour in particular, flourished because of the particular situation of the British Isles in the 1790s and 1800s. The wars with France restricted foreign travel and tourism was instead turned inwards on to the United Kingdom, which led to exploration of its historic antiquities and picturesque tours through those areas deemed to be of outstanding scenic importance: notably the River Wye, the Lake District and the mountainous regions of Wales and Scotland. The fascination with picturesque scenery is associated especially with William Gilpin (1724–1804), who criss-crossed Britain between 1768 and 1776, publishing his findings in a series of *Observations* on landscape scenery and picturesque beauty. The books sold well and encouraged picturesque tourism in their wake. The popularity of this genre can be instanced by the topographer and antiquarian John Britton, who was asked to review almost 150 antiquarian and topographical books for the *Annual Review* between 1803 and 1810.[23]

This new taste was both an opportunity and a snare for landscape painters, providing them with a ready-made market for views of British scenery but at the same time laying landscape painting open to the charge of becoming a servile art content merely with copying appearances. No matter that its technical accomplishment was plain for all to see, landscape painting in Britain, in oils or watercolours, needed to withstand the assaults of those whose understanding of art was predicated on quite different assumptions. The Royal Academician Henry Fuseli did not mince his words:

To portrait painting … we subjoin, as the last branch of uninteresting subjects, that kind of landscape which is entirely occupied with the tame delineation of a given spot; an enumeration of hill and dale, clumps of trees, shrubs, water, meadows, cottages and houses, what is commonly called Views… The landscape of Titian, of Mola, of Salvator, of the Poussins, Claude, Rubens, Elzheimer, Rembrandt and Wilson, spurns all relation to this kind of mapwork.[24]

Turner clearly felt Fuseli's remarks to be unjust, believing that it was possible to combine topography with a more idealised and creative approach to making landscape.[25] *Dolbadern Castle, North Wales* (1800, fig.16), exhibited at the Royal Academy the same year, is a good example. It draws on sketches Turner had made when touring Wales in 1798 and 1799 (fig.94) but the subject is patently more than a picturesque response to the landscape. The figures in the foreground participate in a scene of potential violence, with the kneeling figure at the mercy of his companions. The whole group, in turn, is made insignificant by the grandeur of nature looming over them, Turner using scale and a dark tonality to suggest the attributes of power associated

THE TURNER BOOK

with the Sublime. The tension represented in this group thus works as some sort of correlative for the ideas presented in the verses Turner attached to the catalogue:

How awful is the silence of the waste,
Where nature lifts her mountains to the sky.
Majestic solitude, behold the tower
Where hopeless OWEN, long imprison'd, pined
And wrung his hands for liberty, in vain.

The Owen of Turner's verse is taken to be Owain Goch, who was imprisoned in this castle by his brother Llewellyn from 1254 to 1277 and released after Edward I had defeated Llewellyn, thereby ending Welsh resistance to English rule. Turner's intentions are obscure, but he may well have wanted to explore the irony in Owen's personal imprisonment ending only when his country lost its freedom.

Turner's exploration of Welsh history in the late 1790s saw him produce another picture that alludes to Edward I's conquest of Wales. Caernarvon Castle was begun in 1283 at the end of the hostilities, following the death of Llewellyn and the execution of his brother, David, in the winter of 1282–3. Turner's watercolour of Caernarvon (1800, fig.17) shows the castle in the background outlined against the River Seiont and the Menai Strait, much as any number of picturesque landscape drawings depicted it. In addition, however, he adds an historical allusion. In the shade of a tree a bard accompanied by his harp recites verse to an attentive audience and this group should be understood as referring to the widely accepted belief that Edward I had brutally suppressed the bards, whose recitations might have focused opposition to English rule. Their destruction had become extremely well known thanks to Thomas Gray's ode *The Bard*, published in 1757 and thereafter frequently illustrated, and the poem Turner wrote to accompany this picture (see 'Turner's Writings') is clearly indebted to Gray's example. He seems to have intended to produce a companion for this watercolour, showing Edward's army winding through the Welsh mountains.[26] By including a bard and his followers here, Turner not only alludes to a well-known historical event but perhaps suggests that Edward's oppression could not completely extinguish Welsh culture. He would not have been alone in thinking this at the turn of the century, when enthusiasm for the so-called Celtic Revival was at its height.[27]

These Welsh works are infused with history and, in that elevation of purpose, overcome any suggestion of being merely views, as Fuseli would have it. But even in seemingly straightforward depictions of contemporary landscape Turner freights topography with more complex understandings. His watercolour of *Lancaster Sands* (c.1818, fig.18) provides a good example of his mature attitude to topography, in which everyday occurrences are also capable of saving landscape from banality. It was one of a set of watercolours commissioned by the author Thomas Dunham Whitaker to be engraved for his *History of Richmondshire*.[28] Whitaker and his publisher, Longman, were

17
Caernarvon Castle, North Wales 1800
Watercolour
70.6 × 105.5
Tate

capitalising on the new enthusiasm for tourism in Britain and, in securing Turner as their artist, would have expected commercial success. Turner's attitude to topography was already distinctive and, in his other major topographical series of the 1810s and 1820s, he pushed topography to its limits.[29] Whereas his contemporaries were content to delineate the most characteristic feature of a locale, moving in close to portray a medieval cathedral or some other noteworthy building or a scenic prospect, Turner could also offer a much more idiosyncratic view. He was as much interested in the daily goings-on of these locations as in their historical importance, peopling his watercolours with a throng of carefully observed and individualised characters. Here, for example, as the stagecoach begins its crossing of the treacherous sands, a whole world is displayed: the coachmen urging on their team, the passengers, the fickle weather and an overall sense of urgency before the tide returns.

It is this ability to animate his landscapes that most distinguishes Turner from other artists of his generation. In doing so he grounds the landscape experience in particularities of action, of place and of time. Rather than a typical or an ideal landscape Turner chooses to concentrate on a specific location at a specific moment. Paradoxically, however, this concentration on the immediate lived reality of a place does not mean that his topography is merely a species of social reportage. What propels topography away from the routine is precisely Turner's ability to think of his subject more comprehensively than most other artists. His knowledge of the dangers of making this crossing is made apparent not only by the fragility of the markers stuck in the sand but also by the way he uses light and colour to obscure the coach's route towards an uncertain horizon. What might otherwise have remained a straightforward scene of a stagecoach on the sand is invested with something of the Sublime.

Turner's ambition to elevate landscape so that it vied with history painting as the most important of the academic genres reached a point in the early 1830s where the essential quality of landscape painting – the depiction of atmosphere, light and colour – could suggest something beyond straightforward narrative. This is not to claim, however, that the motif became simply a pretext for the manipulation of formal elements, as though the resulting painting were merely the disposition of coloured shapes on a flat surface. On the contrary, the human associations of the landscape always remained in play, even if the recognition of detail was less straightforward. Turner's mature art suggests that the act of looking combines intellectual and physiological reactions; we respond to atmospheric conditions as much as we are prompted by social and historical knowledge. The strength of landscape painting over history painting was its ability to take relatively unassuming subjects and confer on them a dignity conventionally associated with classical or biblical narratives. Landscape painting, in Turner's hands, is a creative activity that transmutes its subjects.

18
*Lancaster Sands c.*1818
Watercolour
28 × 36.6
City Museums and Art
Gallery, Birmingham

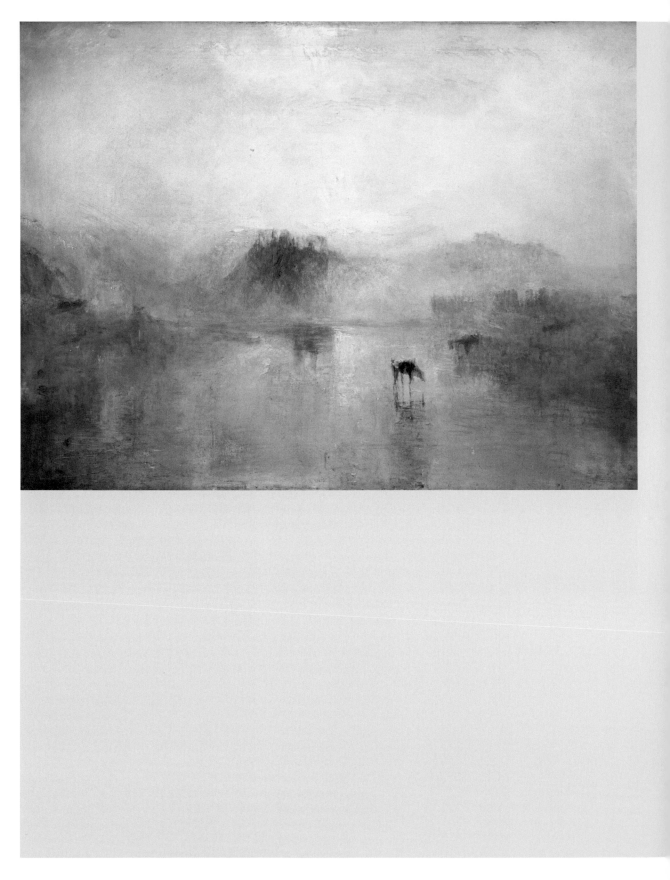

Norham Castle, Sunrise

Situated close to the Scottish border, about eight miles south of Berwick, Norham Castle was built in the twelfth century by Hugh de Puiset, Bishop of Durham, and from the start was caught up in the wars between Scotland and England. Probably its greatest claim to fame was the occasion in June 1291 when the King of England, Edward I, came to the castle as Scottish overlord, to settle the rival claims of thirteen candidates to the throne of Scotland. The selection of John Balliol in November 1292 was followed by thirty-five years of warfare between England and the eventual King of Scotland, Robert the Bruce.

Turner's first approach to the subject dates from 1797, when he sketched the castle during his tour of the north of England. Given his exploration in the late 1790s of Welsh history and the wars with Edward I (figs.16, 17), it is likely that he approached Norham Castle with the same historical curiosity.[30] Two large coloured studies and two finished watercolours (c.1798) were then produced, one of which was exhibited at the Royal Academy that year.

In 1801 Turner returned to the castle, en route to Scotland for the first time, and again in 1831, when he made further drawings. A number of watercolour studies, 'colour beginnings' and finished watercolours also exist, derived from these experiences, and he chose the castle as one of his Pastoral subjects in the *Liber Studiorum*, the engraving being published in 1816 (fig.9).[31] In 1831 the publisher Robert Cadell was with Turner as he made a sketching tour for their collaboration on the engraved edition of Walter Scott's *Poetical Works*. Walter Thornbury takes up the story as they approach the castle:

as they passed Norham, Turner took off his hat and made a low bow to the ruins. Observing this strange act of homage, Cadell exclaimed, 'What the Devil are you about now?' 'Oh,' was the reply, 'I made a drawing or painting of Norham several years since. It took; and from that day to this I have had as much to do as my hands could execute.'[32]

Clearly, Norham Castle was a place of some significance to Turner and so it is fitting that he chose it as one of the subjects from the *Liber Studiorum* that he later developed in oils (fig.19). This picture is probably now at the centre of contemporary understandings of Turner, alongside *The Fighting 'Temeraire'* (1839, fig.81) and *Rain, Steam and Speed – The Great Western Railway* (1844, fig.88) as an exemplar of his achievement. When we examine the differences in approach between Turner's work of the 1790s and that of the 1840s we seem to have stepped

from one world into another, from the past into the modern age. Yet *Norham Castle, Sunrise* for all its qualities, is at best a fickle guide to what Turner had achieved over the course of his lifetime. The canvas is unfinished and is best understood as an interrupted process, with the main colour masses blocked in and only some of the detail supplied. We have no indication why Turner abandoned the picture, or whether it was merely laid aside for completion at another date, either in his studio or during Varnishing Days at the Royal Academy exhibition (see Chapter 3). Like his so-called 'colour beginnings' in watercolour (see 'Turner's Technique'), this picture allowed Turner to work with the major colour oppositions with which he would underpin the composition.[33] Pale yellow and blue are the key notes here, with additions of warm colour (browns and umbers) in the cattle and river banks. What it is not, however, is a realised picture; the title is a modern convenience, as is any decision to exhibit it in a frame.

What we can say about *Norham Castle, Sunrise* is that it clearly reveals the extent to which Turner's mature style relied on light and colour for its effects and how his experience as a painter in watercolours had encouraged his pursuit of luminosity, even in an opaque medium like oil painting. Its unfinished state exaggerates its seeming avoidance of detail, but even when finished the painting may not have contained a superabundance of readily identifiable features. In this respect the picture testifies to Turner's realisation that landscape art was particularly suited to the pursuit of enquiries into the nature of light and vision. This did not mean that his later work eschewed history and the intellectual seriousness associated with the tradition of the old masters; indeed, his last four exhibits at the Royal Academy were all on the theme of Dido and Aeneas. But it did allow Turner to demonstrate that in landscape painting, which he pursued more rigorously than any of his great predecessors, he had a vehicle for discoveries that even the old masters had not truly understood.

19
Norham Castle, Sunrise
c.1845–50
Oil on canvas
91 × 122
Tate

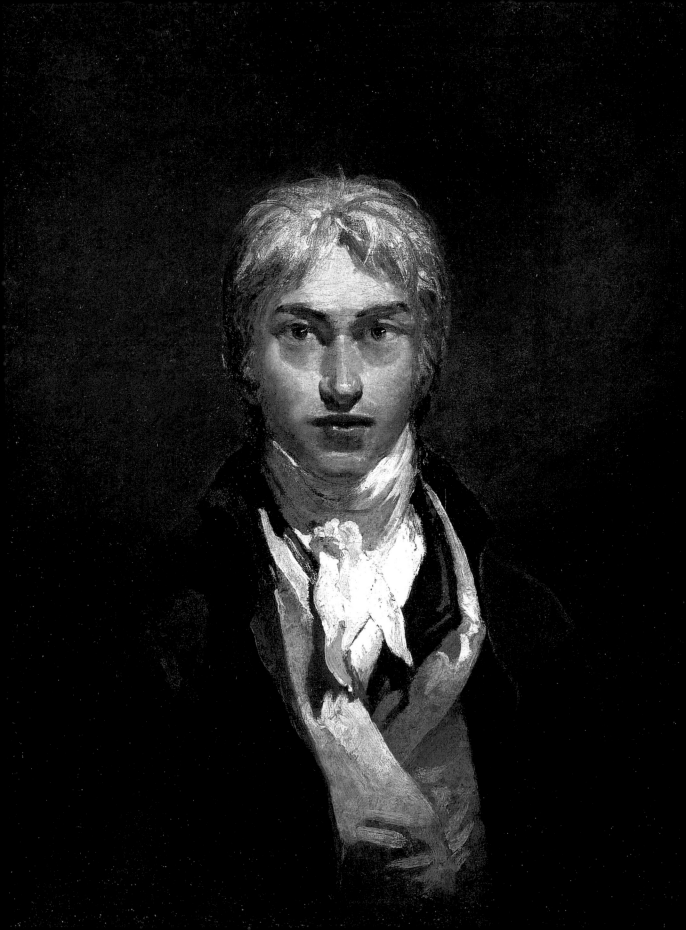

20
*Self-portrait c.*1798–1800
Oil on canvas
74.5 × 58.5
Tate

The art world described in the previous chapter offered opportunities and challenges to the ambitious artist. Although painters were working in an increasingly open market, selling work to a variety of consumers, to secure a reputation it was important to attract eminent patrons and win commissions. Turner was spectacularly successful in doing both in the years around 1800, selling to the Earl of Essex, Lord Harewood, William Beckford, Lord Yarborough, Walter Fawkes and others. In addition to securing the patronage of important collectors he was also achieving institutional success: he was elected an Associate Member of the Royal Academy (ARA) in 1799 at the youngest possible age.

Turner's self-portrait is undated but is presumed to have been painted around this time, *c.*1798–1800 (fig.20). It coincided with the beginnings of his rise to prominence as the landscape painter of his generation, when he was winning favourable reviews at the Royal Academy for his watercolours and, shortly afterwards, for his oil paintings. In the self-possession of this image, Turner seems to be taking stock of himself and his recent achievements, the coming of age of an artist still in his early twenties. The dramatic chiaroscuro concentrates attention above all on the eyes. He is fashionably dressed and his hair is worn long and powdered, a tribute perhaps to his father's hairdressing skill, but, unlike many artists' self-portraits, there are no signs of his calling: no easel, studio bric-à-brac, busts and portfolios, no palette and brushes. His concentration on his isolated figure is due to the fact that this portrait was not intended for exhibition and so did not need to sustain the conventional image of the artist. Perhaps the nearest Turner came to that was in his presentation of some of his predecessors, as we shall see.

Turner consolidated his early success as an oil painter shortly after his election to ARA. *Dutch Boats in a Gale: Fishermen Endeavouring to Put their Fish on Board* (1801, fig.21) was commissioned by Francis Egerton, Duke of Bridgewater, as a pendant to a work in his collection painted in 1671–2 by the Dutch artist Willem van de Velde the younger (1633–1707), *A Rising Gale* (fig.22). When Turner exhibited his painting at the Royal Academy in 1801 it was widely admired, although some critics found fault with what they perceived to be its lack of finish. He used the opportunity to go head to head with van de Velde to assert his own claim to superiority. Turner adds more drama, putting the two foreground ships on a collision course, and he organises the composition more dynamically, not only in the energetic movement of the sea but also in the rhythmic patterning of light and shade.

It seems reasonable to suggest that marine painting offered a particularly strategic ground for Turner, for it allowed him to assert the power of landscape painting independent of topographical considerations. Even when closely studied renditions of boats and their mariners are on offer, the overall environment they inhabit is necessarily unencumbered with detail; the precision required to produce a credible representation of the sea lies more in the artist's ability to capture weather effects

2 Making a Reputation: Patronage, the Art Market and the Independent Artist

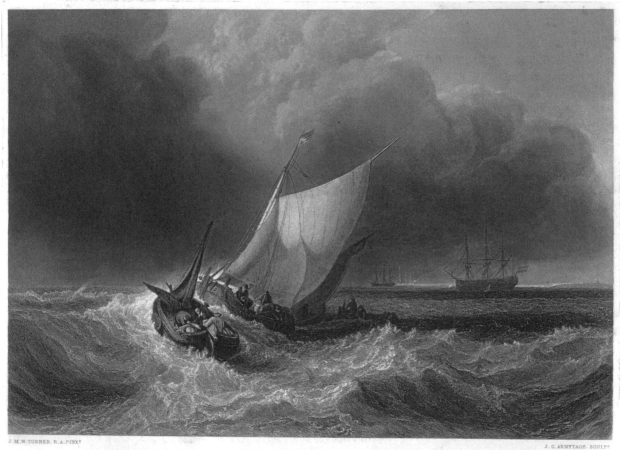

J.M.W.TURNER.R.A..PINXT. J.C.ARMYTAGE.SCULPT

DUTCH BOATS IN A GALE.

21
Dutch Boats in a Gale:
Fishermen Endeavouring
to Put their Fish on Board
(also known as the
Bridgewater Seapiece)
1859–61 engraved by
Armytage
Tate

and the movement of water. These factors produce a situation in which the artist's skill is more evidently on display and the organisation of space is achieved as much by the control of light as by any use of linear perspective. Indeed, we might argue that marine painting is especially geared to a demonstration of artistic prowess. The artist as creator is insistently presented to the spectator, requiring that we respond to his ability to orchestrate effects and to invent a credible situation, as opposed to seeing his picture merely as a more or less truthful representation of a known location. When we consider Turner's early success as an artist it is clear that his abilities as a marine painter helped promote his career. Of the work he exhibited at the Royal Academy between 1796 and 1805, nearly half of his subjects were marines, with three of them entering distinguished collections: the *Bridgewater Seapiece* (*Dutch Boats in a Gale*) (1801, fig.21) in the Duke of Bridgewater's; the *Egremont Seapiece* (1802) in the Earl of Egremont's; and *The Shipwreck* (1805, fig.65) in Sir John Leicester's.

Assertions of independence

Yet, for all Turner's success with commissions, he shared the view of many of his colleagues in the Royal Academy that the professional status of artists gave them the right to arbitrate in matters of taste, without deferring to the opinions of patrons and connoisseurs. This position seemed threatened when the British Institution for promoting the Fine Arts was established in 1805 as a second major venue in London for the encouragement of the visual arts. Unlike the Royal Academy, whose membership was exclusively drawn from the ranks of practising artists, the British Institution was dominated by wealthy connoisseurs and collectors. After taking over the premises in Pall Mall formerly occupied by Boydell's Shakespeare Gallery, it opened its first exhibition in February 1806, showing some 250 works by living artists, including two by Turner.[1] As well as the annual exhibitions of contemporary artists, old master shows were also organised, sometimes including members of the English School such as Reynolds and Wilson, and providing opportunities for students to make copies as part of their artistic training. However, there was a strong sense in the Royal Academy that these old master shows, coupled with the pronouncements on contemporary art associated with Richard Payne Knight and Sir George Beaumont in particular, both of whom were directors of the British Institution, posed a threat to professional artists and the cause of contemporary painting. Matters came to a head in 1815 with the anonymous publication of *A Catalogue Raisonné of the Pictures now Exhibiting at the British Institution*, which attacked the directors and their aesthetic priorities and mounted a strong defence of Turner against their unwarranted criticisms.

Closely associated with this inter-institutional tension is Turner's painting *Apullia in Search of Appullus, Vide Ovid* (1814, fig.23). In Book XIV of Ovid's *Metamorphoses*

22
Willem van de Velde
A Rising Gale 1671–2
Oil on canvas
129.5 × 189
Toledo Museum of Art,
Ohio

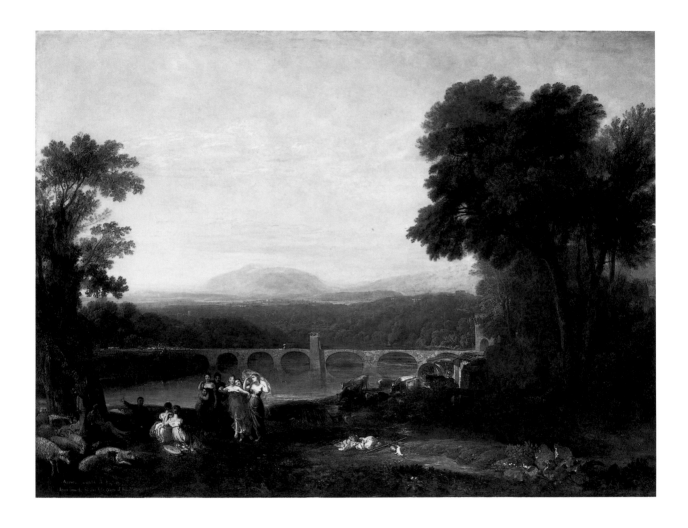

there is a story concerning a shepherd from Apulia, who was punished for mimicking a group of nymphs. In Samuel Garth's translation of 1717 the shepherd was given the masculine name Appullus and Turner has invented for him a feminine partner, Apullia, who is being shown Appullus' name carved on a tree. At first sight this seems to be no more than a clumsy reinterpretation of an already distorted narrative, but there is much more to it than that. The painting was first exhibited at the British Institution in 1814 and scholars now agree that the picture, its title and its exhibition constitute a deliberate intervention in art-world politics. Turner had copied a landscape by Claude in the Earl of Egremont's collection, *Landscape with Jacob, Laban and his Daughters* (1654), and submitted his picture to the British Institution one week after the closing deadline for the annual premium for landscape painting. As the prize was designed for young artists at the outset of their careers, Turner must have known that his candidacy was plainly inappropriate and sent his picture in late to disbar himself from serious contention. What he probably intended was to attack the injurious policies of the British Institution's directors, who supported the old masters as the only standard against which to measure contemporary art and whose competitions specifically awarded premiums only to artists whose works would complement that taste. Turner's pastiche of Claude is the *reductio ad absurdum* of the British Institution's policy and by choosing as a subject the story of someone who is punished for his imitations

23

Apullia in Search of Appullus, Vide Ovid 1814
Oil on canvas
146 × 238.5
Tate

he drove home the message about the creative sterility of the British Institution's position.

One senses from remarks written for his eyes alone in the 1810s that Turner's view of patrons was always conditioned by his need to treat with them without servility. He declared, for example, that 'to have no choice but that of the patron is the very fetter upon genius' and castigated the artist

afraid of choosing for himself [who will] listen to every pretender whose utmost knowledge is a few practical terms or whose greatest pride is to point out the beauties of his collection expecting a humble deference to his opinion – lamenting the dullness and apathy of the rising youth who are incorrigible in not following what he has condescendingly defined 'The direct road to taste.'

And he ended these comments with the defiant declaration that resisting the patron's will was an imperative, even if it reduced an artist to destitution. The independent artist 'should even a beggar stand alone. This Hand is mine and shall remain my own.'[2]

In practice Turner took a number of risks in his early career that seem to bear out this attitude. He exhibited *The Festival upon the Opening of the Vintage of Macon* (fig.14) at the Royal Academy in 1803, where it was much admired by Sir John Leicester. The aborted transaction that followed indicates that Turner was already prepared to treat potential patrons without special favour. According to Joseph Farington, Leicester could have had the picture for 300 guineas in 1803 but was prepared to offer no more than 250. When he

reapplied to Turner the following year, offering the original asking price, the artist insisted that the price had now increased to 400 guineas, which Leicester was not willing to accept. Turner sold the picture shortly afterwards for 300 guineas to Lord Yarborough, one of the three noblemen who had sponsored his trip to France and Switzerland in 1802. His readiness to accept from Lord Yarborough what he had just refused from Leicester may have had something to do with his recognition of Yarborough's generosity to him as his sponsor, but his tactics with Leicester are not an isolated incident. Having completed the *Bridgewater Seapiece* (fig.21), he attempted, unsuccessfully, to extract twenty guineas for the frame, on top of his commission of 250 guineas from the Duke. Although he was within his rights to demand this supplement, his fellow artists were astonished that he would risk antagonising such an influential patron.[3] Similar examples of sharp practice can be found in Turner's dealings with other patrons and with the entrepreneurs who commissioned him to produce pictures for engraving. As a result he became notorious for his reputation as a hard bargainer, attempting to seek the maximum return on his art when negotiating with patrons or when agreeing terms with engravers and publishers.

At a time when most artists were concerned to distinguish their profession as a 'gentlemanly' calling, somehow above the world of commerce, Turner's insistence on making art pay is remarkable. His willingness to overstep the bounds of decorum in his dealings with patrons has struck most commentators as exceptional, but within the context of the early nineteenth century it can be better understood as a local version of a much more widespread debate. At the time he was attempting to secure the best possible return on his painting, arguments about the place of art in society were numerous. Faced with a dearth of state funding and institutional patronage, defenders of the visual arts elaborated the intellectual, economic and social contribution the arts made to society and the concomitant need to sustain their vitality. The seriousness of high art lay in its provision of experiences that stimulated the imagination and exercised the intellect, they argued, and as such it merited proper recognition as an essential guarantor of modern civilisation. But if artists were to achieve proper recognition they should not accept a menial status, and that included their level of remuneration. Modern connoisseurs were prepared to lay out high sums when buying old master pictures but the princely munificence that had supported many of those same painters in the sixteenth and seventeenth centuries was rarely in evidence for Turner and his contemporaries, with a handful of honourable exceptions. We may assume that Turner's understanding of his own worth motivated his financial transactions.

Turner's robust sense of what was appropriate, as seen in his dealings with Sir John Leicester in 1803, did no harm to his prospects. Leicester had already proved to be an important patron; dedicated to the support

24
Tabley, the Seat of Sir J.F. Leicester, Bart.: Windy Day
1809
Oil on canvas
91.5 × 120.6
Victoria University of Manchester on long loan to the Whitworth Art Gallery

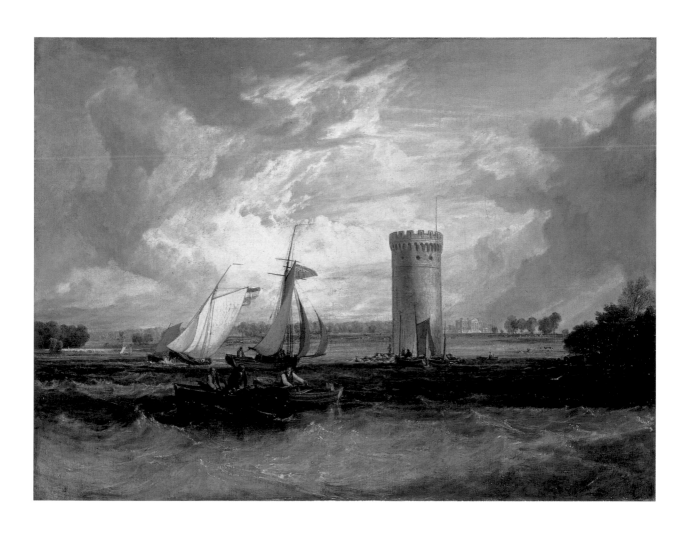

of contemporary British art, he had bought work by Reynolds and Gainsborough and extended his collection with more recent paintings by George Garrard, John Opie, James Ward and Augustus Callcott, among others. Having tried and failed to buy *Macon* in 1803, over the next five years Leicester added seven of Turner's paintings to his collection and commissioned him to paint his country seat, Tabley, in Cheshire. Turner stayed at Tabley in 1808 to fulfil this commission, painting two versions of the view of the house from the lake, one showing a calm morning, the other a windy day (fig.24). By exhibiting both pictures he made abundantly clear his ability to impose significance on otherwise unassuming landscape, as the critic for the *Repository of Arts* spotted: 'the views of Sir John Leicester's seat, which in any other hands would be mere topography, touched by his magic pencil have assumed a highly poetical character. It is on occasions like this that the superiority of this man's mind displays itself.'[4] It has been suggested that Turner's success in the 1809 exhibition resulted in similar commissions the following year, from Lord Lonsdale for two views of Lowther Castle and from the Earl of Egremont for views of his residences, Cockermouth Castle and Petworth (fig.25).

Commerce and the open market

Patrons such as these supported Turner's early career, but the money that sustained the art market derived increasingly not so much from inherited wealth as from successful commerce. As the nineteenth century wore on, Turner diversified his art production to take advantage of it. Not only did he sell on the open market, either directly or in the production of print series, he was also content to secure patronage from the rising class of wealthy entrepreneurs whose commercial activities had helped propel Britain into a position of economic dominance. As with any successful artist, the exhibition of his work at the annual Royal Academy exhibitions could attract potential purchasers as well as keeping his achievement in the public eye. In addition, as we have seen, he moved to a fashionable address in Harley Street in 1799 (the same year he was made an Associate of the Royal Academy) and there in 1804 had a purpose-built gallery constructed for the exhibition of his paintings, where a more select audience could view his most recent productions. This gallery, rebuilt in 1822, remained in operation throughout his career, albeit in a somewhat neglected state towards the end.

From perhaps as early as the late 1820s and certainly in the 1840s, the last decade of his life, Turner was also employing a dealer, Thomas Griffith, to smooth the negotiations between artist and patrons and to secure the sale of works in oil and watercolour on the open market. It is also the case that some pictures were specifically designed to attract sales or further commissions: for example, his so-called 'sample studies' of partially finished watercolours, offered as an inducement to purchasers in the early 1840s (fig.26), or his four whaling pictures of the 1840s calculated to secure more purchases from his patron Elhanan Bicknell, who had made his fortune

25
Petworth, Sussex, the Seat of the Earl of Egremont. Dewy Morning
1810
Oil on canvas
91.4 × 120.6
Petworth House

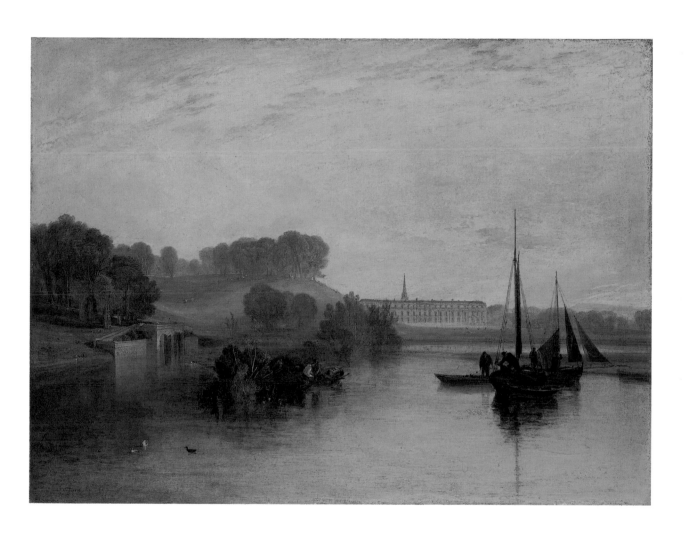

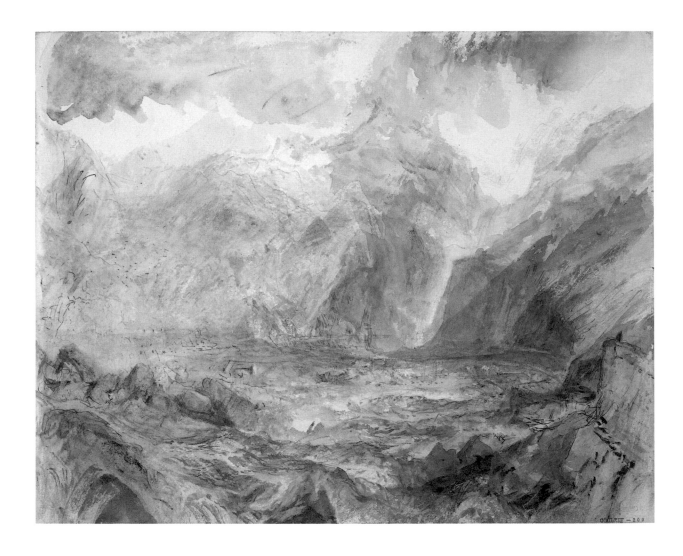

in the Pacific sperm whale fishery. Turner's decision to visit Prince Albert's birthplace, Coburg, in 1840, and the German subject matter of some works of the 1840s, were probably intended to arouse the royal family's interest.[5]

Perhaps the most obvious example of Turner's entrepreneurial spirit lies in his dealings with the publishers of illustrated literary or topographical works. He personally negotiated these commercial deals, driving a hard bargain in the safe knowledge that his contribution to a series was commercially advantageous to the print seller and he could therefore be more exacting in his terms than other artists. He was also active in policing copyright infringements to control other publishers' use of his work and supported the painter John Martin's attempts to restrict copyright to the artist and his estate.

Topographical series

Turner was an avid traveller, taking sketching tours most years of his life, first in Britain and then abroad, once the hostilities had ended. As well as extensive itineraries in the major picturesque areas of England, Scotland and Wales from the 1790s to the 1810s (figs.4, 17, 18, 74, 92), he also made further trips to Scotland in the 1820s and 1830s and explored the Kent coast in the last five years of his life. After 1817, however, he usually set aside the summer months for travel abroad, visiting the Low Countries and Germany in 1817 (fig.27), Italy in 1819, northern France in 1821, the rivers Meuse and Mosel in 1824, Holland in 1825, northern France in 1826 (fig.93), Italy in 1828

(fig.28), Paris and the Seine in 1829 and 1832, Germany, Austria and Venice in 1833, Denmark, Germany and Bohemia in 1835, France, Switzerland and the Val d'Aosta in 1836, Paris and Versailles in 1837, the Meuse and Mosel in 1839, Germany, Austria and Venice in 1840 (fig.29), Switzerland from 1841 to 1844 (fig.26) and the northern French coast in 1845. The mass of work resulting from these journeys ranges from the relatively descriptive style of his maturity to the much more generalised treatments of his old age. Much of it was produced for commissions to be engraved, some of it was purchased by established patrons and some of the later Swiss work was offered to potential patrons on a sample basis, as we have seen. Where his oil paintings were often the butt of derisive comment and sometimes failed to find a purchaser at their first exhibition, his watercolours rarely stayed on his hands for long.

Turner's use of printmaking is of vital importance here. Not only did it secure him an income but it also helped disseminate his art to the widest possible clientele, and close to 900 separate prints based on his designs were published in his lifetime. His earliest work comprised some thirty topographical views produced for the *Copper-Plate Magazine* and allied publications between 1794 and 1798, but engraved indifferently. He had better treatment with a commission to produce the headpieces for the *Oxford Almanack*, published annually, for which he produced ten watercolour drawings from 1798 to 1804, engraved by James Basire, one

26
The Pass of St Gothard,
near Faido (sample study)
1842–3
Pencil, watercolour and
pen
22.9 × 29
Tate

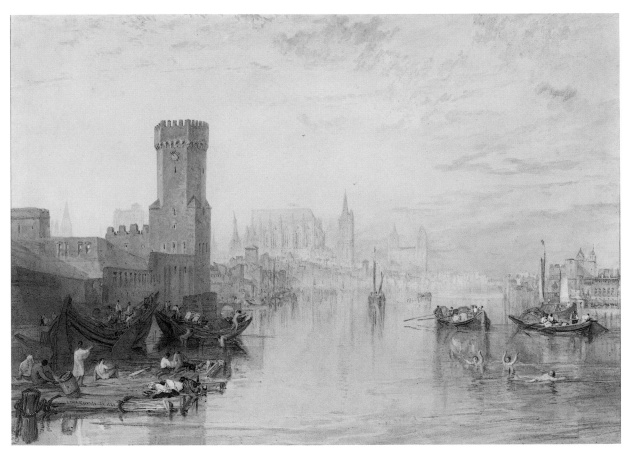

27
Cologne, from the River
1820
Watercolour
30.8 × 46.3
Seattle Art Museum,
Seattle

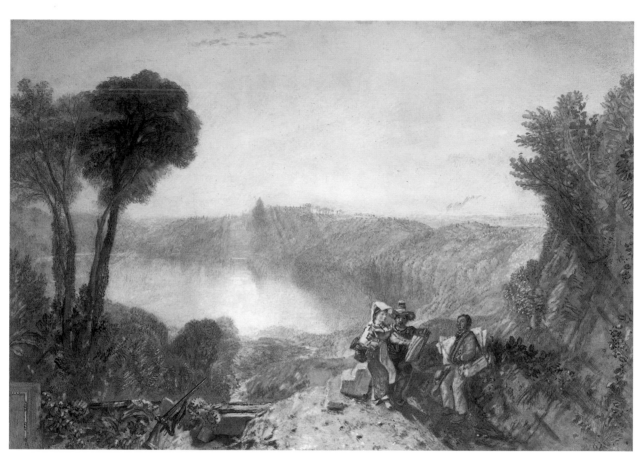

28
Lake Albano c.1828
Watercolour
28.6 × 41.2
Private collection

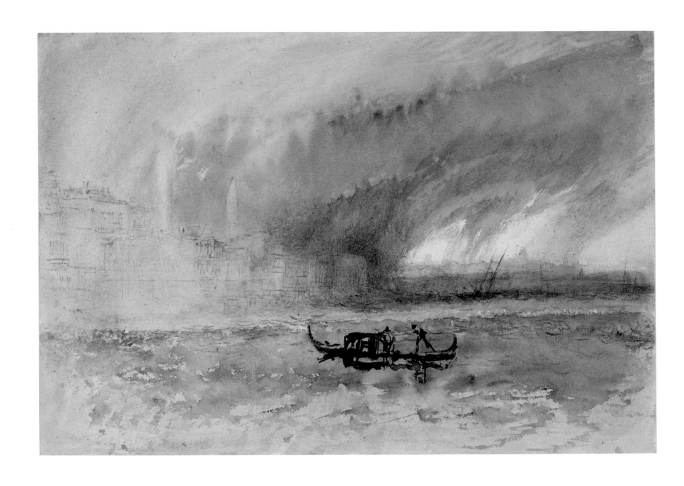

of the ablest practitioners of the day, between 1799 and 1811. Turner also provided ten drawings for illustration in the Revd Thomas Whitaker's *History of Whalley* (1800–1) and between 1807 and 1819 issued seventy-one plates in his own landscape series, the *Liber Studiorum*.

From the 1810s to the 1830s Turner was involved with a number of extensive ventures. The brothers George and William Cooke commissioned him in 1811 to produce forty watercolours for their publication *Picturesque Views on the Southern Coast of England* (published 1814–26, fig.74). He also produced twenty watercolours for Whitaker's *History of Richmondshire* (published 1818–23, fig.18) and 100 watercolours for Charles Heath's *Picturesque Views in England and Wales*, ninety-six of which were published between 1827 and 1838 (figs.32, 60, 61). Heath also commissioned Turner to produce sixty watercolours for the three volumes of engravings entitled *Rivers of France*, published 1832–4.

In addition, Turner supplied landscape illustrations to works of literature, especially the life and works of Lord Byron, Samuel Rogers (fig.75), Walter Scott (fig.76) and Thomas Campbell. This brief account by no means exhausts the record of Turner's involvement with print series and their publishers, nor takes into account the individual plates executed after his oil paintings. Not only did he publish widely, but his exacting demands on the engravers charged with rendering his art into black and white images helped establish new standards in reproductive engraving in this period.[6] The plates produced by the best of them, for example in the *Liber Studiorum* (fig.9), in topographical series such as *Picturesque Views in England and Wales* and *Rivers of France* and in vignette engravings in various works of literature, are of an extraordinarily high quality. Clearly, although Turner was at times an unrelenting taskmaster, the experience of working with him helped his engravers refine their technique to encompass the subtlest of the effects contained in his paintings.

Support for the arts in the early nineteenth century

In all of these activities Turner was acting to secure his reputation in an increasingly commercial market. Yet at the same time he was aware of the difficulties raised by commerce, not just for the arts but also for the common weal. As we shall see, paintings of Carthage and Venice indicate the perils of commercial values infecting a state, a lesson that Turner seems to have intended as a warning to Britain. His awareness of the double edge of commerce is brought out in the draft of a poem he jotted down in his 'Greenwich' sketchbook (*c.*1808) which begins with the line, 'O gold thou parent of Ambition's ardent blush' and goes on to consider the contrast between the world of care, smoke, toil and destruction associated with entrepreneurial activity and the world of virtue, symbolised by the church spires momentarily glimpsed through the murk of London's commercial atmosphere.[7]

The arts offered society an alternative to the utilitarian calculations of a commercial

29
Venice: A Storm 1840
Watercolour
21.9 × 31.8
British Museum

reckoning and Turner would no doubt have endorsed Sir Joshua Reynolds's robust dismissal of Dr Tucker, Dean of Gloucester, who had told the Society for Encouraging Commerce and Manufactures that a pin maker was a more useful and valuable member of society than Raphael. According to Reynolds:

His is an observation of a very narrow mind; a mind that is confined to the mere object of commerce – that sees with a microscopic eye but a part of the great machine of the economy of life, and thinks that small part which he sees to be the whole. Commerce is the means, not the end of happiness or pleasure: the end is a rational enjoyment by means of arts and sciences. It is therefore the highest degree of folly to set the means in a higher rank of esteem than the end. It is as much to say that the brickmaker is superior to the architect.[8]

This defence of the arts was quoted approvingly by the critic Allan Cunningham in his celebration of British artistic achievement, *The Lives of the Most Eminent British Painters, Sculptors and Architects* (1829), a title that self-consciously emulates Giorgio Vasari's biographies of Renaissance artists, first published in 1550. But Cunningham's title points to a poignant contrast between sixteenth-century Italy, when enlightened patronage had supported the flowering of the arts, and contemporary Britain, which seemed largely bereft of any substantial or sustained encouragement of them.

The following year the painter James Northcote, in his *Life of Titian*, reinforced this message when explicitly comparing the fortunes of Italian Renaissance artists with those of his British contemporaries. He mourned the lack of opportunities that might have encouraged a British school of painters as significant as Italy's and deplored the inevitable lowering of standards when the dictates of the market had supplanted ambitious patronage:

For however daring or great may be the mind of an English painter, he will only be employed to furnish pretty pictures for small gay rooms, and not such as are to strike with religious awe in solemn cathedrals – pleasing toys to amuse the idle, adorn the dressing-room or warm the parlour, not magnificent works for the halls of magistrates, chambers of grand councils, or galleries of princes.[9]

Great art, Northcote claims, arrogates to itself the power to represent the noblest and most spiritual themes, whereas in England the most petty calculations underlie what patronage exists. From the government, military memorials; from private patrons, portraits of their family members, their entourage and their estates.[10]

The situation was not necessarily as desperate as these criticisms suggest, for a certain amount of royal and aristocratic patronage is evident in the nineteenth century, but when Northcote and Cunningham attacked commercial considerations they were reacting to a situation in which repeated appeals for

government support of the arts had failed to deliver and the debasement of art to a purely routine activity was still apparent. What makes Cunningham's opinions peculiarly relevant here is that he was an enthusiastic admirer of Turner and was prepared to put his opinions on record.[11] He was of the firm opinion that Turner deployed a poetic art, celebrating invention and creativity, and that this achievement was increasingly misunderstood by a public whose taste had been coarsened by a literal-minded and utilitarian understanding of the arts. Turner is presented as an artist whose exceptional brilliance of representation is of a completely different order to the plodding world of commercial and commonplace understandings in the public at large:

Landscape, in the estimation of the multitude, is simply a well coloured delineation of some real and visible scene, with which fancy has no more to do than the land surveyor has with the natural loveliness of the earth on which he lays his measuring chain. When Turner exhibited his poetic landscape of Italy, in which, as if by enchantment, he assembled all her beauties, the wonder of the spectators was not raised by the natural and brilliant combination of hill and stream, vale and temple, and sunny air and serene sky: No! the inquiry was from what point was it taken – on what hill did the artist stand – and in what time of the day, and season of the year, did he behold all these marvels? It was taken as a literal matter of fact performance, tried in the balance of recollection, found wanting, and dismissed as an idle dream. This is no fanciful account of public

taste in landscape: the studies of Turner will bear us out: in one of his rooms he has more truly brilliant poetic scenes rolled up and laid aside than any collection in the country contains: on some future day, when fac-simile-painters swarm in the land, and the world grows weary of common and every-day things, there will be an unrolling of these splendid pictures, and a general turning up of eyes, and shrugging of shoulders at the lack of taste of this our living generation of connoisseurs and patrons.[12]

The lessons of the past

In this context Turner's images of Renaissance and later artists at work are significant. Between 1820 and 1841 he painted five pictures of his predecessors in the history of art, Raphael, Bellini, van Goyen, Watteau and Canaletto. The first of these homages was exhibited in 1820 to coincide with the three-hundredth anniversary of the death of Raphael: *Rome from the Vatican. Raffaelle, Accompanied by La Fornarina, Preparing his Pictures for the Decoration of the Loggia* (1820, fig.30). Raphael is shown looking back at the loggia, with one of his own fresco designs depicted as an easel painting. He is reviewing his creations in a deliberately anachronistic setting, with Bernini's seventeenth-century colonnade perhaps completing what Raphael's own architectural plans, visible in the foreground, had initiated. La Fornarina, who might otherwise be a genre-like reminder of domestic affairs, is positioned next to Raphael's *Madonna della Sedia*, as though asserting the painter's ability to transform erotic intimacy into a powerful

30
Rome from the Vatican.
Raffaelle, Accompanied by
La Fornarina, Preparing
his Pictures for the
Decoration of the Loggia
1820
Oil on canvas
177 × 335.5
Tate

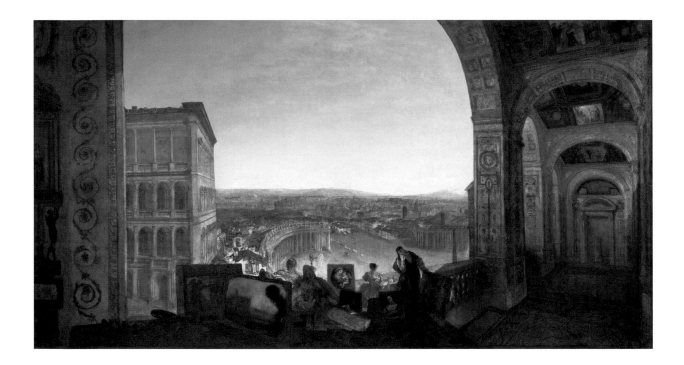

religious icon. By the 1810s Raphael was respected for his ability as a landscape painter and Turner alludes to this with a rather Claudean landscape. Raphael is celebrated, therefore, as a universal artist, but Turner's homage may also be read as autobiographical.

Turner, too, had broadened the artist's remit, in his case landscape painting, to embrace a wide spectrum of endeavours. The Claudean canvas included among Raphael's achievements might as readily refer to Turner's own contributions as to Raphael's. Turner had received early training in architectural drawing and was also active as an architect, producing successive designs for his London house and gallery and his house at Twickenham, Sandycombe or Solus Lodge, built between 1811 and 1813. But, unlike Raphael, he did not live at a time when artists regularly received prestigious commissions from church or state. Modern London could not compete with Renaissance Rome.

Turner's other homage to the Italian Renaissance was exhibited at the Royal Academy in 1841: *Depositing of John Bellini's Three Pictures in La Chiesa Redentore, Venice* (fig.31). The water-borne procession seems to be Turner's invention, with three images of the Madonna from the Redentore's sacristy, believed in Turner's day to be by Giovanni Bellini, in the leading gondola. If Bellini himself is to be detected anywhere in this picture we are looking at another deliberately anachronistic scene, for the artist died in 1516, some seventy years before the Redentore was completed. The procession

accompanying the pictures is a splendid affair, with Venice paying proper homage to one of her greatest artists and to the cause of art itself. Again, the honour afforded Bellini in this picture might be read as a reflection on the contrast between the Italian Renaissance and modern Britain.

In the 1830s the collections of two former Presidents of the Royal Academy, Benjamin West (1738–1820) and Sir Thomas Lawrence (1769–1830), had failed in their purpose: to invigorate the study of art by leaving collections of works for public edification.[13] With no public funds forthcoming to secure these legacies for the nation their collections were dispersed, to the dismay of those, including the Royal Academy, who had argued for state intervention. Unlike Bellini, the modern artist was offered no guarantees that his achievement would be maintained in the public realm. Turner was sixty-six in 1841 and had been drawing up his will in a bid to secure the best possible use of his own estate. His instructions were intended to ensure that 'Turner's Gallery' was established on a proper financial basis to protect it from the perils of inadequate public patronage, to ensure that his work, too, would be properly deposited in a space that kept it on permanent public display.

Yet the art world of 1841 was precisely the environment where market forces, as opposed to public patronage, seemed to hold sway. Turner was acutely aware that some of his newer clients were men who owed their fortunes to the world of commerce. The old landed interest that dominated arts

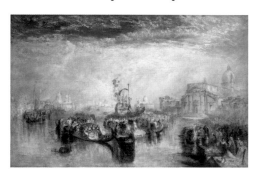

31
Depositing of John Bellini's Three Pictures in La Chiesa Redentore, Venice 1841
Oil on canvas
73.6 × 115.5
Private collection

patronage when he was beginning his artistic career, aristocrats and other wealthy landholders, was giving ground to those who had made their money in manufacturing and trade. Turner sold this picture to Charles Birch, a colliery owner from Birmingham, who built up a collection of the artist's work in the 1840s. New patronage was also represented by the numerous pictures Turner sold, from the 1820s onwards, to Godfrey Windus, a coachmaker from Tottenham who by 1840 had amassed some 200 of his watercolours.

Joseph Gillott was another of Turner's 'new money' customers. He had established a factory for pen nibs in Birmingham and with his fortune built three galleries in his Edgbaston House and another in his home at Stanmore, just outside London. Although reliant on picture dealers after about 1846, Gillott visited Turner's gallery in 1844 and bought £4000 worth of pictures on the spot. His overall expenditure on art was truly lavish and between 1847 and 1871 he spent over £100,000 on paintings. One of his later purchases took place in 1847, when he acquired *Depositing of John Bellini's Three Pictures in the Chiesa Redentore, Venice* from his friend Charles Birch. After keeping the picture for a couple of years he sold it on at a profit.[14]

Turner's vision, showing Venice at the height of her sixteenth-century magnificence, reveals how a vigorous state, not yet corrupted by commerce, honours and advances the arts. As he looks back in the 1840s across three hundred years of history, his realisation of what Venice had become in modern times is underlined by the knowledge that her decline to picturesque ruin has brought her art down with her. Similarly, as we have seen, contemporary commentators fulminated at how the commercial spirit was making arts patronage in Britain inimical to the production of pictures that might vie with those of artists of Bellini's reputation. If we accept the comments of artists and critics complaining that the market had reduced painting in their time to an almost servile occupation, the honouring of art that Turner portrays in Bellini's Venice seems impossible to conceive in mid-nineteenth-century Britain.

Yet there is something of a paradox here. Turner was not a nostalgic commentator. We have plenty of evidence to show how alive he was to the new technologies of the age and how he seems to have observed the growth of industry without regret. Watercolours of Dudley (fig.32) and Leeds, for example, explicitly tackle the new industrialised landscapes of modern England, while pictures involving steam ships (fig.90) and, of course, *Rain, Steam and Speed* (fig.88), indicate his fascination with modern technology. If the paradox is to be resolved its resolution must surely lie in the way that Turner conceived of his art as capable of resisting the pressures placed on it by a market-driven economy. Canny enough to have used that same market to secure economic independence from its worst excesses, Turner was not compelled to follow fashion, and this allowed him to engage with issues and concerns that were as serious and

32
Dudley, Worcestershire
*c.*1832
Watercolour and body-colour
28.8 × 43
Lady Lever Art Collection, Port Sunlight

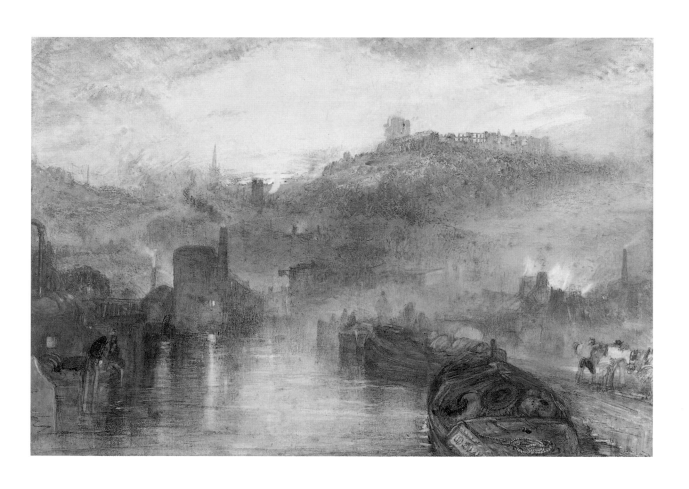

worthwhile as those that had preoccupied his illustrious forebears.[15] But, because he was responsive to his own times, Turner's issues and concerns would both recapitulate and move on from the subject matter of the old masters and manifestly incorporate the advent of a new culture.

'Poetical' painting

From as early as the 1810s Turner became increasingly identified with a tendency in British art towards the production of so-called 'poetical' painting, or pictures whose appeal was primarily to the imagination. In this spirit the *Literary Chronicle* suggested in 1818 that the Royal Academy exhibition be reordered so as to group all the poetical paintings together, adding that 'if there is one man in existence whose works possess the quality of which we are speaking in a higher degree than another, it is Turner'.[16] Four years later, reviewing a collection of drawings and watercolours by old masters, eighteenth-century and contemporary British artists, Robert Hunt said of Turner, 'His *View of Cologne* [1820, fig.27] is, we were going to say, a poetical specimen, though only a View; and why should we not, if it is a just character of Poetry, that it gives an interest to what is common, and elevates what is familiar, which is the case here with objects that have no great importance.'[17]

By the 1830s Turner's supporters would regularly contrast his imaginative approach to painting with the more prosaic responses of some of his contemporaries. The critic of *Arnold's Magazine*, for example, declared in June 1834 that 'the painter who transfers nature to canvas in her literal form is as different from TURNER as the historian from the novelist or poet'.[18] The *Literary Gazette*'s critic agreed:

Much criticism has been bestowed on these extraordinary performances and to some they are no doubt justly liable. Yet by what living artist but Mr. Turner could they have been produced? Whose mind is so replete with rare and gorgeous landscape imagery? What other hand could have produced such streams of rich and lucid colour over the canvass or have filled it with such masses – indistinct and unintelligible when closely inspected, but when viewed at a proper distance, assuming shape and meaning, and delighting the eye with the finest poetical and pictorial beauty?[19]

We might compare this eulogy with the view of the art critic of the *European Magazine* (May 1823), who was

much annoyed by a cold-blooded critic ... who observed that [*The Bay of Baiae, with Apollo and the Sibyl* (1823)] was not natural. Natural! No, not in his limited and purblind view of nature. But perfectly natural to the man who is capable of appreciating the value of practical concentration of all that nature occasionally and partially discloses of the rich, the glowing and the splendid.

The poetical quality of Turner's art helps explain his fondness for the French artist Jean-Antoine Watteau (1684–1721), who was the subject of another of Turner's homages

to the old masters. *Watteau Study by Fresnoy's Rules* (1831, fig.33), exhibited in 1831, shows the artist surrounded by attentive onlookers in an interior containing two of his more famous works, *Les Plaisirs du bal* and *La Lorgneuse*, both of which were in London collections at the time. Turner's picture is designed to demonstrate Fresnoy's analysis of how white pigment, depending on its adjacent colour, can make forms seem to advance or recede, and he added a couplet from the English translation of Fresnoy's *Art of Painting* to the exhibition catalogue to illustrate the point: 'White when it shines with unstained lustre clear, May bear an object back or bring it near.'

As with Raphael and Bellini, Turner's approach to Watteau contains autobiographical elements which bear on his own professional situation. Watteau himself is shown very much as a public figure, painting not in the isolation of a locked studio but in a public or semi-public space. His demonstration to those attending him is very unlike Turner's reluctance to let members of the public watch him at work. Those who accompanied Turner on sketching trips all report that his normal procedure was to work alone, although there were occasions, such as his work around Plymouth in 1813, when he allowed onlookers to observe him. The one major exception to Turner's preference for working alone was his use of Varnishing Days at the Royal Academy, when he seems to have relished his centrality in the proceedings. These days were introduced to allow artists to adjust their paintings in respect of their position in the room and the pictures adjacent to them, acknowledging, in effect, that their works were part of a bigger colloquy. As we shall see in Chapter 3, Turner took the opportunity not only to do that but also, from the 1830s, to offer breathtaking, high-wire demonstrations of how finished pictures could be almost conjured into being in a matter of hours.

Relations with other artists

Alongside these homages to the old masters, Turner was also concerned throughout his career to demonstrate his capabilities vis-à-vis his contemporaries. His motives here are hard to discern. Sometimes the rivalry, as with his friend the history painter George Jones, was good-humoured and mutually accepted; in his maturity he is also recorded as offering technical advice and other forms of assistance to fellow members of the Royal Academy on Varnishing Days. But sometimes his actions seem less generous and the pictures painted to compete with other artists represent his own assertions of dominance, interventions that might check the overenthusiastic acclamation of some newly rising star.

For example, his 1833 painting of Canaletto (fig.43) may have been intended to eclipse Clarkson Stanfield (1793–1867), who had just secured a major commission from Lord Lansdowne to paint Venetian scenes. Turner's picture was reported at the time to have been painted in a couple of days, just before the exhibition opened. The story

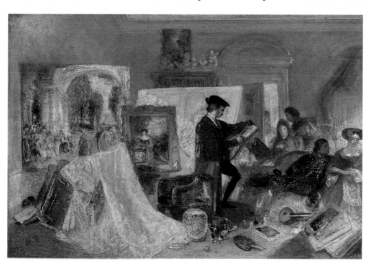

34

Helvoetsluys: The City of
Utrecht, 64, Going to Sea
1832
Oil on canvas
91.4 × 122
Fuji Art Museum, Tokyo

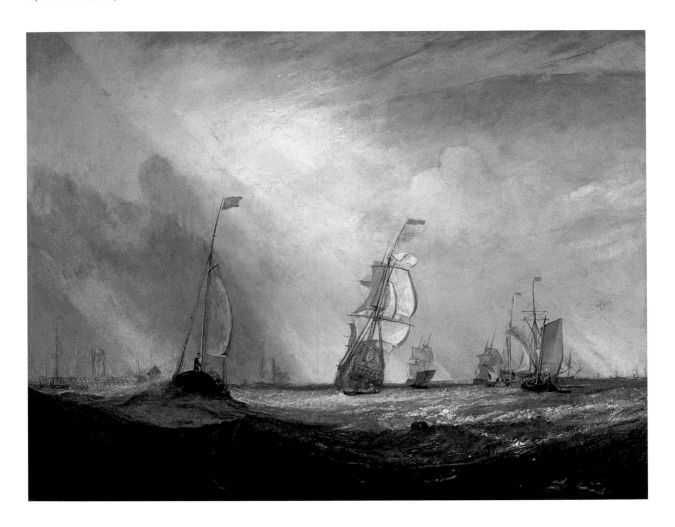

is dubious – no last-minute decision to enter a painting would have allowed the Royal Academy printer time to enter the new title in the exhibition catalogue – yet the fact that Turner's hasty response to Stanfield was mentioned by at least two critics seems to indicate that this tale of artistic rivalry was widely believed.[20] Similarly, Turner's *Snow-Storm, Avalanche and Inundation – A Scene in the Upper Part of the Val d'Aouste, Piedmont* (1837, fig.82) and his 1843 pictures of Noah's flood (figs.47, 48) may well have been painted in response to the work of his successful contemporary John Martin (1789–1854). Other examples of his tendency to see his rivals off concern David Wilkie (1785–1841) (see Picture in Focus, *A Country Blacksmith*) and John Constable (1776–1837).

Constable's eminence as a landscape painter today may not have been foreseen by Turner's contemporaries, but a spirit of rivalry certainly existed between the two artists. Constable called on Turner in 1828 to gain support for his candidacy as a full Royal Academician and, according to his account, was treated with some disdain, although both Turner and George Jones called on Constable to congratulate him on his promotion the following year. In 1831 Constable was on the hanging committee for the Royal Academy and arranged to substitute his painting of *Salisbury Cathedral from the Meadows* for Turner's *Caligula's Palace and Bridge* (1831, fig.55). The artist David Roberts (1796–1864) was shortly afterwards at a dinner attended by both Turner and Constable, and reported:

Constable was, as usual, lavish of the pains he had taken and the sacrifices he had made in arranging the Exhibition. But, most unfortunately, he had, after placing an important work of Turner's, removed it, and replaced it by one of his own. Turner was down upon him like a sledge-hammer; it was no use his endeavour to persuade Turner that the change was for his advantage, and not his own. Turner kept at it all the evening, to the great amusement of the party, and I must add, he [Constable] richly deserved it, by bringing it on himself.[21]

The rivalry flared up again the following year when Turner's *Helvoetsluys: The City of Utrecht, 64, Going to Sea* (1832, fig.34) was positioned alongside Constable's *Opening of Waterloo Bridge* (fig.35), also painted in 1832. According to Constable's biographer C.R. Leslie, the intense coloration of Constable's picture 'seemed as if painted with liquid gold and silver' and contrasted with the grey tonality of Turner's seascape. Having observed Constable at work on Varnishing Days, heightening the vermilion and lake accents in his picture, Turner added a round blob of red lead to the foreground of his own picture, amid the waves in the foreground, which he worked up into a buoy just before the exhibition opened. 'He has been here and fired a gun' was Constable's comment.[22] The contrast between this scarlet detail and the otherwise unassuming coloration of Turner's picture weakened the impact of Constable's work, whose colour range was more limited, for all its intensity.

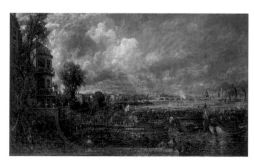

35
John Constable
The Opening of Waterloo Bridge(Whitehall Stairs, June 18th, 1817) 1832
Oil on canvas
130.8 × 218
Tate

A Country Blacksmith Disputing upon the Price of Iron, and the Price Charged to the Butcher for Shoeing his Poney

At first sight this is nothing more than a rustic genre scene, but its title indicates that, in fact, it alludes to the contemporary conflict with Napoleonic France. The war had resulted in substantial government debts to finance it, and in 1806 a proposal was introduced to raise the duty on pig iron as a means of servicing the loan. Opponents of the Pig Iron Duty Bill calculated that every horse employed in husbandry would cost an additional twelve shillings a year as a result of the measure. Turner's lengthy title would therefore have had an immediate contemporary resonance for its spectators.

Yet just as noteworthy is the fact that Turner was exploring a type of subject matter that few would have expected him to essay and the reason for this was the sudden emergence on the London art scene of a painter whose reputation bid fair to rival his own. The young Scottish artist David Wilkie had achieved considerable success at the Royal Academy in 1806 with the exhibition of his picture *Village Politicians* (fig.37), showing a ploughman, a weaver and a soutar (shoemaker) engaged in passionate political debate. Turner's picture thus covers the same ground as Wilkie's, examining the impact of politics at a local level, and he does so in direct competition with Wilkie's Dutch-inspired genre painting.

Turner's professional pride may have been piqued by Wilkie's meteoric rise to fame, which was already resulting in his acquisition of distinguished patronage from connoisseurs such as Sir George Beaumont. Indeed, as if to rub salt in the wound, a review of the 1806 exhibition favourably contrasted the naturalism and attention to detail of *Village Politicians* with Turner's neglect of nature and truth in his *Fall of the Rhine at Schaffhausen*.[23] The rise to prominence by Wilkie and his contemporary the genre painter Edward Bird certainly preyed on Turner's mind, even after he exhibited *A Country Blacksmith*. In his 'Hastings' sketchbook of 1809–11 he wrote a fragmentary poem on the contemporary enthusiasm for Wilkie and Bird and the dangers they faced of succumbing to ignorant praise:

Coarse [?] Flattery, like a Gipsey came
Would she were never heard
And muddled all the fecund brains
Of Wilkie and of Bird
When she call'd ... a Teniers
Each ... stopt contented
At the alluring half-way house
Where each a room hath rented.
Renown in vain taps at the door
And bids them both be jogging

For while false praise sings ...
call for ... nogging[24]

With *A Country Blacksmith* Turner effectively squared up to Wilkie and his admirers. It was reported that he deliberately heightened the warmth of his pictures to eclipse the more muted tones of Wilkie's *Blind Fiddler*, also in the 1807 exhibition. Moreover, when Sir John Leicester asked the price of the painting, Turner insisted that he receive no less than Wilkie was asking, 100 guineas.

Turner's rivalry with Wilkie never descended into outright hostility and although they were never close friends, by the later 1820s Turner regarded him with great respect. Wilkie's death in 1841 was marked by Turner with a magnificent tribute to his passing, *Peace. Burial at Sea* (1841, fig.79).

37
David Wilkie
Village Politicians. Vide
Scotland's Skaith (1806),
oil on canvas
572 × 750
The Earl of Mansfield

36
A Country Blacksmith Disputing upon the Price of Iron, and the Price Charged to the Butcher for Shoeing his Poney 1807
Oil on pine panel
55 × 78
Tate

Turner had patrons and critics who supported
him at different stages in his career and he was
almost always able to secure good prices for
his work. Nevertheless, throughout his
maturity his art, specifically his work in oils,
was subjected to critical attack. From
fragmentary remarks recorded in letters or
conversations we know that he was keenly
aware of his critical reception, but for the
most part he did not modify his production
in response to criticism. Turner's belief in his
technical prowess, coupled with his ambitions
for landscape itself, sustained his innovatory
practice over the course of his career. This
chapter looks at aspects of that self-belief as
it is manifested in his behaviour, his handling
of paint, his development of light and colour
and his surpassing of esteemed old masters.

Academic tensions

Flushed as he was with his early success,
Turner's behaviour in the Royal Academy was
causing some concern and in May 1803 he was
singled out for his 'arrogant manners ... more
like those of a *groom* than anything else: no
respect to persons or circumstances'.[1] These
were unusually febrile times in the Academy's
affairs. In 1803 it contained two factions: one,
supporting the President, Benjamin West,
valued its autonomy and defended its
privileges against outside interference;
the other disliked West and used its influence
with King George III to manipulate the
Academy's affairs, sometimes in opposition
to the decisions of its appointed officers. West
and his supporters were considered to be
'democratically' biased, not least because

of West's visit to Paris in 1802 and his praise
for Napoleon, and this underlined the court's
willingness to intervene in the affairs of the
Royal Academy

Turner sided with the Academy and at the
general meeting of 24 December 1803 was rash
enough to query the taste of a member of the
court faction, the portrait painter Sir Francis
Bourgeois, questioning his ability to judge
the premiums for painting or figure drawing.
Joseph Farington, who was also present,
noted that Bourgeois called Turner '*a little
Reptile*, to which Turner replied by telling
Bourgeois that he was *a great Reptile*, with
ill manners'.[2]

In May 1804 it was Farington's turn to have
words with Turner, who had arrived late at an
Academy Council meeting and then reproved
those who had temporarily left the room:

he had taken my Chair and began instantly with
a very angry countenance to call us to account for
having left the Council, on which moved by his
presumption I replied to him sharply and told him
of the impropriety of his addressing us in such a
manner, to which he answered in such a way, that
I added his conduct as to behaviour had been cause
of complaint to the whole Academy.[3]

If Turner was behaving abrasively, it may
be that he felt no need to ingratiate himself
with the power brokers of the Academy after
his election to full Royal Academician in 1802.
Perhaps, too, his visit to France and
Switzerland in 1802, and the experience
of both the grandeur of nature in the Alps
and the achievements of the old masters in

3 The Intransigent Artist

the Louvre, had prompted his impatience with the established art world in Britain. His collegial relationships would never be as fraught as this again, but his innovations as a painter would continue to antagonise his critics.

Early critical misgivings

Although his watercolours were always widely admired, and through engraving became some of his most widely known images, Turner's oil paintings were the source of a great deal of critical disquiet, especially towards the end of his life. Indeed, his oil paintings had occasioned critical remarks about the breadth of his handling from the beginning of his career. As early as 1799 one reviewer, while full of praise for Turner's originality, had observed that he should guard against getting into lax habits:

The Landscape, though it combines the style of CLAUDE and of our excellent WILSON, yet wears an aspect of originality, that shows the painter looks at Nature with his own eyes. We advise MR. TURNER, however, with all our admiration of his works, not to indulge a fear of being too accurately minute, lest he should get into a habit of *indistinctness* and *confusion*.[4]

Another writer, in 1801, complained of Turner's lack of finishing, his free touch betraying him into 'carelessness and obscurity' instead of the firm outlines one might have expected.[5] On 16 May 1803 the *True Briton*'s critic went further: 'A certain artist has so much debauched the taste of the young artists in this country by the empirical novelty of his style of painting that a humorous critic gave him the title of *over-Turner*.' Looking back to Turner's work of the early 1800s, some of these comments may seem to us exaggerated, but our reaction is obviously coloured by what we know of his mature style and the work of those artists working after him. The obscurity and carelessness detected by some critics may well have seemed novel, even radical, at the beginning of the nineteenth century.

Boats Carrying out Anchors and Cables to Dutch Men of War, in 1665 (1804, fig.38), for example, was poorly received when exhibited in 1804, for the vigorous handling of the sea, which caused one critic to declare that it had been painted 'with *birch-broom* and *whitening*'.[6] The idea that Turner's facture was too coarse is understandable when one looks at the treatment of the water here, where white pigment has been obtrusively worked up to become a breaking sea. For Turner's critics and his older contemporaries in the Royal Academy such an approach was tantamount to breaching the decorum of painting, substituting for skill and dexterity an extravagant chasing after effects, coupled with a negligent attitude to the niceties of painting that bordered on arrogance.[7]

The title also caused puzzlement: 'Why the scene before us should be pushed so far back as in 1665, it is difficult to conceive, except by referring to that affectation which almost invariably appears in the work of the Artist.'[8] In fact, the date makes perfectly good sense but the picture's title is too imprecise to

38
Boats Carrying out Anchors and Cables to Dutch Men of War, in 1665
1804
Oil on canvas
101.5 × 130.5
Corcoran Gallery of Art
(W.A. Clark Collection),
Washington, DC

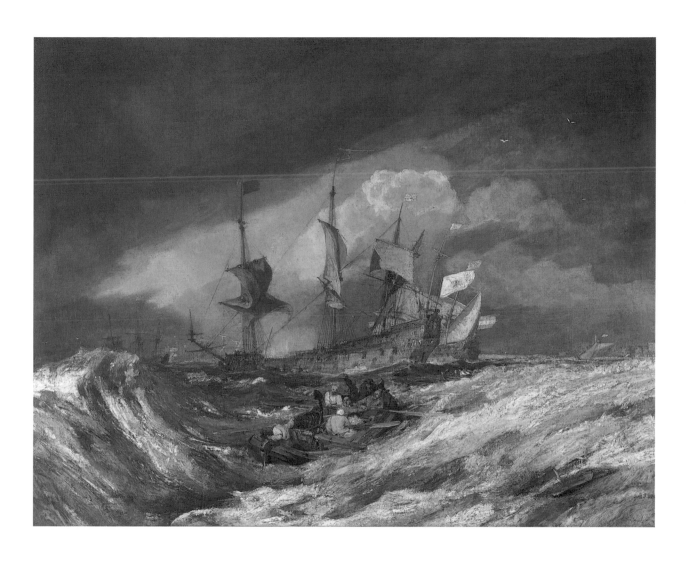

elucidate it. Turner shows the Dutch refitting their boats, perhaps after their recent defeat at the Battle of Lowestoft in June 1665. The picture therefore alludes to a moment in the nation's history when naval control of the seas was aggressively pursued by rival British and Dutch fleets in a series of engagements but with no decisive battle or knock-out blow. This suggests that Turner intended this reminder of old Anglo-Dutch hostilities as a comment on the need for preparedness against current threats from the French, Dutch and Spanish navies. Until Nelson's overwhelming victory at Trafalgar in 1805, the year after this picture was exhibited, there was every reason to remain vigilant.

Stylistic departures

Turner is primarily remembered for his treatment of light and colour. What allowed him to succeed in this was not merely his willingness to work with bright, prismatic colours but also his absolute control of tone. The basic building block of any tonal system is the opposition between darkness and light and Turner's experience in this matter was profound. Close examination of his work in watercolour reveals his ability to gradate colour, from a lighter to a darker hue, with the utmost subtlety and without sacrificing luminosity.

His experience of engraving also proved beneficial. As noted in the previous chapter, Turner's zealous involvement with the artists charged with translating his work into another medium helped to foster a new school of British engravers, especially in the 1820s

and 1830s, whose extremely proficient standards of work were brought on by their experience of responding to his exacting demands. From the early 1800s increasing numbers of his works had been reproduced in engraving and he himself had worked closely with the engravers of his own *Liber Studiorum* (1807–19), providing the etchings that underlay their engraved work in mezzotint. Turner enriched his understanding of tonality from seeing colour transposed into black and white. As his career developed he redefined the principle of chiaroscuro, to work within a tonal range that did not require deep shadow for the impact of light to be felt. In this way his pictures became increasingly luminous, characteristically deploying a relative scale of tonal contrast within an essentially prismatic pictorial environment, as opposed to one where darkness means the absence of colour.

Apollo and Python (1811, fig.39) is an important work in this respect, for it announces Turner's move away from the relatively sombre canvases of his early career. It has also been regarded, since Ruskin's day, as a key moment in the enunciation of Turner's symbolic understanding of light. Apollo, associated in Greek myth with the sun, with the arts and with his prowess as an archer, is shown killing Python, the huge dragon who lived close to Delphi, which Apollo had chosen as the site for his oracle. The verses with which Turner accompanied the picture in the Royal Academy catalogue derive from the *Hymn to Apollo* of the Hellenistic poet Callimachus, which the artist

39
Apollo and Python 1811
Oil on canvas
145.5 × 237.5
Tate

knew of in two eighteenth-century English translations. In them the god's 'golden arms' are contrasted with the darkness of the dragon and its lair and Turner's verses likewise underline the association of the dragon with darkness and the earth, speaking of how the 'earth absorbing, blacken'd with his gore'. Apollo, the emissary of light and of the arts, is light itself vanquishing darkness. As the verse indicates, the blackened earth makes of darkness something heavy and material; light and colour occupy a different realm.

Turner's use of light also freed him to reconsider the articulation of space, most famously in the deployment of a vortex for some of his compositions. Rather than organising space as a series of parallel planes or through the imposition of a linear framework, both of which tend to control spatial recession as a measured transition from foreground to background, Turner increasingly opted for a more dynamic presentation. Instead of the foreground being marked off from the background, a spiralling vortex connects them in a relay of energies. Likewise, giving prominence to the sun, through intensifying its colour or lightening its tone, tends to bring it forward, so that it participates actively in the foreground rather than merely illuminating it.

We can see elements of both of these devices in *Snow Storm: Hannibal and his Army Crossing the Alps* (1812, fig.40). This is a noteworthy picture for a number of reasons: as well as having a vortex as the basis of its composition, it is the first to include lines from Turner's poem *Fallacies of Hope* and the first to treat a Carthaginian theme. As with *Apollo and Python*, Turner made use of literary sources to research the history of the enmity between Carthage and Rome. He owned Oliver Goldsmith's *The Roman History* and turned to it for his account of Hannibal's expedition. The *Fallacies of Hope* verses point the moral:

Craft, treachery and fraud – Salassian force,
Hung on the fainting rear! Then Plunder seiz'd
The victor and the captive, Saguntum's spoil,
Alike, became their prey: still the chief advanc'd,
Look'd on with hope; – low, broad and wan;
While the fierce archer of the downward year
Stains Italy's blanch'd barrier with storms.
In vain each pass, ensanguin'd deep with dead,
Or rocky fragments, wide destruction roll'd.
Still on Campania's fertile plains – he thought,
But the loud breeze sob'd, 'Capua's joys beware!'

The scene depicted shows the Carthaginian army, burdened with booty from the sack of Saguntum, struggling through the Alps in a furious snow storm while harassed by Salassian Swiss tribesmen, who are seen in the foreground organising rock slides and butchering the Carthaginian rearguard. The composition contrasts the darkness of the army, weltering in blood and confusion, with the sun's glow up ahead. But whereas such a vision of light might normally be considered as almost redemptive, for Turner's purposes the sun is 'low, broad, and wan', signalling not an end

40
Snow Storm: Hannibal and his Army Crossing the Alps
1812
Oil on canvas
146 × 237.5
Tate

41
*Dort or Dordrecht: The
Dort Packet-Boat from
Rotterdam Becalmed* 1818
Oil on canvas
157.5 × 233
Yale Center for British Art,
Paul Mellon Collection

to the Carthaginians' plight but a ghastly prelude to their corruption by the decadent pleasures of Italy. Hannibal's optimism about Campania will prove to be sadly misplaced.

Turner was evidently well aware that what he had achieved with this composition was remarkable, for he went to great efforts to ensure that it was hung 'below the line' at the Royal Academy, threatening to withdraw it from display altogether if his wishes were denied. In the Academy exhibition the Great Room at Somerset House was the place most keenly desired in which to show one's work. The walls of the exhibition rooms were divided by a dado rail and the usual preference was to hang pictures with the lower edge of the frame touching this rail, or 'on the line'.[9] Hung 'below the line', a picture could be obscured by the crush of visitors, which was the case with *Hannibal*. Nevertheless, Turner was adamant, reckoning no doubt on the impact of his work somehow clearing a space in front of it for its proper contemplation, and rather than see it hung above a door in the Great Room agreed on its display in an adjoining room.[10] This lower placement appears to have been calculated to position spectators so that the picture's foreground seemed an extension of their own space, putting them almost literally into the picture.

Overcoming predecessors
Turner was increasingly confident of his ability to stand comparison with the old masters. As we have seen, *Macon* (fig.14), *The Deluge* (fig.12) and the *Bridgewater Seapiece*

(fig.21) emulated the work of Claude, Poussin and van de Velde, respectively. Other pictures of the 1800s and 1810s continued this deliberate trespassing on the heights occupied by the luminaries of art. One of Turner's most successful demonstrations of his ability to master the Dutch tradition came in his large oil painting *Dort or Dordrecht* (1818, fig.41). He had visited the Netherlands and the valley of the Rhine in 1817 and stopped in Dordrecht for a day and a half in mid-September. The picture was bought from the Royal Academy for 500 guineas by Turner's friend and patron Walter Fawkes and can be seen hanging over the fireplace in Turner's watercolour, painted in the autumn of 1818, of the drawing room at Fawkes's Yorkshire residence, Farnley Hall (fig.42).

Dort or Dordrecht's golden tonality and serenity of mood deliberately suggest a comparison with the Dutch seventeenth-century landscape painter Aelbert Cuyp, whose home town was Dordrecht and who was widely admired by British connoisseurs. Indeed, as early as 1810 the critic Anthony Pasquin had noted that Turner could emulate and go beyond Cuyp in his treatment of light and aerial perspective.[11] Yet, perhaps as a measure of Turner's growing maturity, the picture bids to surpass Cuyp in its overall luminosity and tonal contrast, to produce a much more emphatic effect than the reticence and serenity traditionally associated with much of Cuyp's art. If Turner's greatest contribution to landscape lies in his treatment of light and colour, then paintings of the 1810s such as *Dort or Dordrecht*

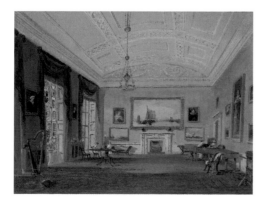

42
Drawing-room, Farnley
1818
Body-colour on grey paper
31.5 × 41.2
Private collection

43
*Bridge of Sighs, Ducal
Palace and Custom-
House, Venice: Canaletti
Painting* 1833
Oil on mahogany panel
51 × 82.5
Tate

can be regarded as the first mature demonstrations of that contribution.

Turner's *Bridge of Sighs, Ducal Palace and Custom-House, Venice: Canaletti Painting* (1833, fig.43) is also a homage with a point. Canaletto is visible in the bottom left of the picture, painting on a wooden platform above the water and hemmed in by barges. The easel on which his picture is placed faces the wall and, in any case, the barges occlude the view across the canal to the sunlit façades beyond. A couple of figures take a rather detached view of the artist at work. The fact that the canvas on which he is painting is framed might suggest that Canaletto, rather than attempting to paint the view he cannot properly see, is touching up a completed picture to help it harmonise with its surroundings. And as he is working in shadow, the eighteenth-century painter's renditions of Venice will never deal adequately with its quality of light, that same light that Turner captures so brilliantly here and in his other treatments of Venice. The title is, of course, a pun: 'Canaletti Painting' means both a painting of Canaletto at work and a painting in his style. The critic of the *Athenaeum* took the second option, describing Turner's picture as 'more his own than he seems aware of: he imagines he has painted it in the Canaletti style: the style is his, and worth Canaletti's ten times over'. [12]

Experiments in light and colour

The power of light to erode structures is an optical effect we have all experienced: the halation that occurs when the solar disc seems to eat away the contours of objects in front of it. Turner was one of the first artists to record this phenomenon. He received two commissions from William Moffatt to paint his house, The Limes, at Mortlake, on the Thames. The first of them shows the house on a summer's morning; the second, exhibited a year later in 1827, reverses the view to show the effect of evening light. Compared with traditional topography, where the owner would have expected his property to be prominently displayed, Turner's paintings concentrate more on the play of light at morning and evening. The house itself is not the centre of attention in the first picture and is absent altogether in the second, *Mortlake Terrace, the Seat of William Moffatt, Esq., Summer's Evening* (1827, fig.44), where our attention is concentrated on the intensity of the light eating into the parapet.

Turner's use of collage in this picture is also noteworthy. The dog is a cut-out silhouette, stuck on to the canvas on Varnishing Day and then painted over and varnished. The dog's function is to provide a dark accent at that point in the composition, improving the sense of recession. Turner added other collaged details to two further paintings, *Childe Harold's Pilgrimage – Italy* (1832) and *The Golden Bough* (1834), as temporary expedients during Varnishing Days. His willingness to experiment in this way is of a piece with his exploration of new pigments and experimental techniques, sometimes to the detriment of the long-term survival of his paintings.

44
Mortlake Terrace, the Seat of William Moffatt, Esq., Summer's Evening 1827
Oil on canvas
92 × 122
National Gallery of Art, Washington, DC

THE TURNER BOOK

45
Boccaccio Relating the Tale of the Bird-Cage 1828
Oil on canvas
121.9 × 89.9
Tate

The work of the later 1820s and 1830s shows Turner experimenting with increasingly rich effects of colour, drawing on both his wide experience of the European tradition and his own practical experience. Two examples, painted within a couple of years of each other, may stand for this tendency. The first, *Boccaccio Relating the Tale of the Bird-Cage* (1828, fig.45), is a good example of Turner's propensity to play fast and loose with orthodox meaning. There is no such tale in Boccaccio's *Decameron* and Turner's reference to it may owe more to a misremembered association than anything more determinate. In any event, the subject matter is less important than the picture's brilliant, jewel-like appearance, calling to mind Watteau's paintings, and in this respect it is something of a new departure.

The taste for ornamental genre scenes of this kind was developed especially in illustrated volumes, such as the *Keepsake*, which began to appear in the later 1820s.[13] Turner had already begun to explore this sort of anecdotal territory with his Shakespearian scene *What You Will!* (1822), following the lead of Thomas Stothard (1755–1834), who had begun painting a series of works on subjects derived from Watteau in 1817. *Boccaccio*'s debt to both Watteau and Stothard is obvious, and Turner declared to C. R. Leslie during the 1828 Varnishing Days that 'if I thought [Stothard] liked my pictures half as well as I like his, I should be satisfied. He is the [Watteau] of England.'[14] Turner's respect for Watteau was equally sincere; as we have seen, he exhibited *Watteau Study by Fresnoy's Rules* in 1831 (fig.33) and is reported to have said that he had learned more from Watteau than any other painter.[15] His interest in Watteau may partially be explained by his own exploration of a more forceful use of colour in the 1820s, in response to his experience of Italian light after his first trip to Italy in 1819. Watteau's use of relatively pure colour and the addition of white highlights to enhance it further produced scintillating effects that enliven his picture surfaces and intensify their impact on the eye.

In 1830 Turner exhibited *Jessica* (fig.46), accompanied by a Shakespearean reference: 'Shylock – "Jessica, shut the window, I say" – *The Merchant of Venice*.' In fact, this line is Turner's invention but he seems to have meant a reference to Act II, scene v, where Shylock asks Jessica for his doors and windows to be closed, while his servant, Lancelot, recommends instead that she look out of the window: 'There will come a Christian by Will be worth a Jewess' eye.' The origins of the picture are obscure but one anecdote concerning it claims that Turner undertook it as a challenge while staying with Lord Egremont at Petworth. Knowing Turner's predilection for yellow pigments, some artists staying there had claimed that while a yellow background was admissible in landscape, it would not be possible in a subject picture. There may be some truth in this story, but if so, it perhaps owes more to a discussion originating from Egremont's collection of portraits, including some then attributed to Holbein. In the notes for his 'Backgrounds'

lecture, given as part of his Perspective series, Turner observed of the portrait of Edward VI at Petworth:

Holbein has had the hardihood, the worthy daring of a great mind, to relieve the Head and shoulders on a gilt double cube of tapestry and to my eye he has succeeded. The remainder of the ground is quite dark, occupying nearly a third of the picture on each side [of] this gilded tapestry which fills the middle ground, while the figure is relieved on the gold by its colour... However dissonant the use of gold must strike every one it required only the eye to view the whole Picture in the possession of the Earl of Egremont and to judge its value.[16]

The painting was exhibited at the Royal Academy to a storm of criticism about its quality, and it occasioned cheap jibes about mustard pots and jaundice. The picture is certainly bold in its extravagant use of yellow, and the placement of Jessica against the golden background gives the image an almost hieratic quality, reminiscent of the Byzantine mosaics Turner would have seen in St Mark's, Venice, in 1819.

Although the picture was technically daring, it is of a piece with Turner's work of the 1820s, when he was achieving effects of colour orchestration that rethought the traditional use of chiaroscuro to produce pictures where even the darks were brilliant. In this respect, as scholars have noted, *Jessica* is rather like an approach to Rembrandt via Watteau, using Watteau's jewel-like colour and liveliness of surface to rephrase Rembrandt's chiaroscuro in a higher key. Important Rembrandts, such as *The Jewish Bride*, were passing through the London art market at the time and Turner's long-standing interest in the great Dutch artist, first evident in some of his landscapes of the 1790s, would have received confirmation in the public appreciation of Rembrandt's life and works in the 1820s.

In his Perspective lectures Turner had spoken of Rembrandt's use of colour and chiaroscuro with great enthusiasm, pointing out that for Rembrandt chiaroscuro was more than simply a compositional device, but carried an emotional charge: 'Rembrandt depended upon his chiaroscuro, his bursts of light and darkness to be *felt*.' As for Rembrandt's use of colour, Turner considered it something 'on which the Eye dwells so completely enthrall'd, and it seeks not for its liberty, but as it were, thinks it a sacrilege to pierce the mystic shell of colour in search of form'.[17] He owned a copy of John Opie's *Lectures on Painting* (1809), where he would have read Opie's judgement on Rembrandt that 'it mattered not what he painted, his pencil, like the finger of Midas, turned everything it touched to gold'. Opie, while acknowledging Rembrandt's 'most glaring faults', also celebrated his 'richness and truth of colouring', which, with his use of chiaroscuro were among his 'most transcendent merits', concluding that Rembrandt 'seemed born to confound all rules and reasoning'. It is tempting to think

that Turner found some justification here for his own advancement of the art and some comfort for the critical drubbing he so often received.

Colour and symbolism

The union of light and colour was made almost programmatic in two paintings Turner exhibited in 1843: *Shade and Darkness – The Evening of the Deluge* (1843, fig.47) and its companion, *Light and Colour (Goethe's Theory) – The Morning after the Deluge – Moses Writing the Book of Genesis* (1843, fig.48). John Martin had exhibited *Eve of the Deluge* and *The Assuagement* at the Royal Academy in 1840, the first of which had entered Prince Albert's collection. Perhaps Turner, looking for royal patronage, was prompted by Martin's success to exhibit his own version of the biblical story. *Shade and Darkness* treats the story fairly conventionally, showing the animals on the right moving in procession to Noah's ark, almost dissolved in light at the centre of the composition. A blackening sky is poised to overwhelm the scene, its gathering darkness feebly opposed by a lantern-lit encampment in the foreground.[18] The inhabitants of this dwelling are identified as the victims of divine retribution in Turner's accompanying lines from *Fallacies of Hope*:

The morn put forth her sign of woe unheeded:
But disobedience slept; the dark'ning deluge closed around,
And the last token came: the giant framework floated,

The rous'd birds forsook their nightly shelters screaming
And the beasts waded to the ark.

The companion picture, *Light and Colour*, demonstrates in its title that Turner's intentions were deeply considered, but its meaning is complex and difficult to discern. As a straightforward narrative, the picture reveals a complication with regard to the compression of time. Moses was traditionally identified as the author of the Pentateuch (the first five books of the Bible), but to portray him writing Genesis on the morning after Noah's flood is to telescope events separated by centuries. Moreover, although Turner's verses allude to the Ark, secure on Mount Ararat, there is no sign of it here. Likewise, the rainbow God set in the sky, as a testament to his new covenant with man, is absent, figuring instead in prismatic colours reflected in the watery world below. Moses, pen in hand, writing perhaps on the Tablets of the Law, seems to hover in the radiant sky. Beneath him a coiled snake is hanging from a staff, alluding to the incident in Exodus when the bronze serpent was lifted up in the wilderness.[19] To the right of the serpent, in the bottom-right quadrant of the circle of light, can be discerned a throng of small figures who seem to well up from the receding waters of the deluge. Before them, in the darker foreground, appear to be the bones and carcasses of drowned creatures; the dark mass at the centre of the composition perhaps also represents the rotting cadavers of men and beasts who had

perished in the flood. The nude figures rising from the waters may owe something to Turner's experiences in Italy of, for example, the frescos by Signorelli in the Capella Nuova of Orvieto Cathedral, showing the dead rising from their tombs at the Last Judgement, which Turner discussed in a letter of 1828.[20] More generally, the circular composition, crowded with figures, has been compared to the ceiling paintings in the domes of Italian churches, where angels or putti crowd the sky in a vision of heaven.

However, whatever feelings we might have that this picture is an optimistic representation of God's covenant with man, with humanity born again in the radiance of grace and ultimately heaven-bound, are qualified by the quotation from *Fallacies of Hope*. Here a very different message seems to be in play:

The ark stood firm on Ararat; th'returning sun
Exhaled earth's humid bubbles, and emulous of light,
Reflected her lost forms, each in prismatic guise
Hope's harbinger, ephemeral as the summer fly
Which rises, flits, expands, and dies.

Some of the individual figures swarming into life seem to be emerging from bubbles and the overall circular composition of the painting swells outwards like the surface of a bubble, capturing the prismatic reflections referred to in the poem. At the symbolic level, Turner's identification of Hope with a bubble or a short-lived insect like the mayfly need not be understood as world-weary

pessimism, but it does bring out the sense of his wariness about human endeavour. Extracts from *Fallacies of Hope* had first appeared in 1812, with the exhibition of *Hannibal*, and had accompanied many of his pictures over the next thirty years, reminding his audience again and again of the vanity of human wishes. In this latest picture Hope is fragile, precarious, but, we might surmise, still precious for all its brevity of existence.

The traditional biblical rainbow, symbolising Hope, has been replaced in Turner's vision with reflected colour on the surface of bubbles. The association of Hope with prismatic colour takes us back to the non-biblical elements of the picture's title: *Light and Colour (Goethe's Theory)*. Turner owned and annotated a copy of Charles Eastlake's *Theory of Colours* (1840), a translation of Goethe's *Farbenlehre* (1810). Goethe's views on colour were contentious and Turner's response to them was mixed, but the key issue here seems to be Goethe's belief that the colour-circle could be divided into two major polarities: 'plus' colours, associated with happiness (red, yellow and green), and 'minus' colours, associated with anxiety (blue, purple). The choice of colours in *Shade and Darkness* shows 'minus' colours overwhelming 'plus' colours, while in *Light and Colour* the palette is predominantly on the 'plus' side. This contrast would seem to accord with the idea of God's covenant with man after the flood, but Turner's quotation from *Fallacies of Hope* resists such easy optimism. For Turner, reduction to system

47
*Shade and Darkness – The
Evening of the Deluge*
1843
Oil on canvas
78.5 × 78
Tate

48
Light and Colour (Goethe's Theory) – The Morning after the Deluge – Moses Writing the Book of Genesis 1843
Oil on canvas
78.5 × 78.5
Tate

was always simplistic, and here both Goethe's colour theory and any eschatological comforts afforded by the Bible story are held in tension with other, less blithe assessments.

Lack of finish

Reviewing Turner's progress over his career, there is no doubt that the difficulties surrounding the acceptance of his work of the later 1830s and after were real, given the very different practice of other painters. An oblique light is thrown on his predicament in the deliberations of the 1841 Commission of the Fine Arts, which was charged by Parliament to examine the decoration of the rebuilt Palace of Westminster. Although more concerned with history painting than landscape, the Commission's discussion included consideration about the place of breadth in painting and its tendency to generalise form. Noting that, at a distance, sharpness, focus and gradation diminish, the Commission agreed that the larger the painting, and the greater the consequent distance from which it was viewed, 'the more abstract must be the representation and the more it requires to be reduced to expressive essentials'. Works viewed from a much shorter distance, however, needed 'a greater fullness of parts and more gradation'.[21] Thus any acceptance of 'abstraction', by which the Commission meant less closely defined form, was not easily extended to cabinet-sized pictures, most obviously because 'the more abstract style appears to disadvantage' when hung next to more minutely handled pictures. Moreover, although the Commissioners recognised that one might paint broadly on a cabinet scale when adopting what they called a 'picturesque' approach to the subject, 'nevertheless the abstract breadth of imitation which is indispensable in elevated subjects is ... a kind of contradiction [in cabinet-sized pictures], inasmuch as the vague generalisation of a distant or ideal effect is submitted to close inspection, and can only be so viewed'.[22]

The Commission's secretary was Charles Eastlake, who was a keen admirer of Turner and had known him from at least 1811; twenty years later he would give important evidence to the 1861 Select Committee of the House of Lords that looked into Turner's Bequest and on that occasion he spoke up eloquently in support of the artistic merits of Turner's unfinished pictures.[23] Here, though, at a time when Turner was still actively exhibiting, it is clear that the relatively 'abstract' nature of his paintings would have been susceptible to the same aesthetic judgement that prompted the Commission's findings.

A number of critics had come to similar conclusions, recommending that Turner's paintings be seen at a distance if they were to make any sense. The art critic of the *Spectator*, for example, said this of *Regulus* (fig.53), painted in 1828 and reworked in 1837:

Turner is just the reverse of Claude: instead of the repose of beauty – the soft serenity and mellow light of an Italian scene – here all is glare,

turbulence, and uneasiness. The only way to be reconciled to the picture is to look at it from as great a distance as the width of the gallery will allow of, and then you see nothing but a burst of sunlight. This is scene-painting – and very fine it is in its way.[24]

More generously, when reviewing Turner's Venetian scenes at the Royal Academy in 1842, the *Athenaeum*'s critic declared that they were

among the loveliest, because least exaggerated pictures, which this magician (for such he is, in right of his command over the spirits of Air, Fire, and Water) has recently given us. Fairer dreams never floated past poets' eye; and the aspect of the City of Waters is hardly one iota idealised. As pieces of effect, too, these works are curious; close at hand, a splashed palette – an arm's length distant, a clear and delicate shadowing forth of a scene made up of crowded and minute objects.[25]

Today we would argue that Turner's 'abstract breadth', which had preoccupied his critics from almost the beginning of his career, was one of his greatest gifts to posterity. This is not, however, to make him an abstract artist in our modern sense. Turner's imprecision of form comes from the profound understanding that the operation of light is the bedrock of vision; his dissolution of material qualities is thus repaid with a strong commitment to the reality of human observation and the power of the mind to engage with the world.

THE TURNER BOOK

Crossing the Brook

This ambitious painting was developed from Turner's experiences in Devon, which he first visited in 1811, and whose landscape was regarded at the time as distinctive.

Turner was keenly aware of the range of landscape. In his *Liber Studiorum* he codified landscape into six categories: MS (Mountainous), M (Marine), H (Historical), A (Architectural), P (Pastoral) and E.P. (probably Elevated Pastoral).[26] Those plates concerned with Pastoral or Elevated Pastoral were clearly indebted to the authority of Claude, regarded by artists and connoisseurs alike as the supreme landscape painter. We know from the 'Backgrounds' lecture that Claude's example was central to Turner's understanding of landscape painting (see 'Turner's Writings'). Claude, however, had been based in Italy and if Turner was to emulate his achievement he could do so only by transmogrifying English landscape to produce approximations to Claude's example, as he had done in a number of Claudean reworkings of the Thames valley in the early 1800s. By the 1810s, however, Turner's approach to painting was more naturalistic, investigating the particularities of British light and landscape.

In 1811, then, on the verge of Turner's departure for the West Country, the contrary pulls of the real and the ideal must have seemed irreconcilable. Near Plymouth, however, he would have encountered not only landscapes that were routinely compared to Italian scenery but, more importantly, qualities of light that were described as Italian or Mediterranean by tourists and locals alike. Here was a locale that would allow him to work as he believed Claude had worked, making studies of light and landscape in readiness for combination in pictures of idealised landscape – the essence of Elevated Pastoral. His return to Plymouth in 1813 saw him making numerous oil studies *en plein air* (fig.96) and a number of other sketching expeditions on foot or by boat to investigate the area thoroughly

Crossing the Brook is the most obvious product of these preparations. It shows the River Tamar, with Gunnislake Bridge, the last river crossing above Plymouth, in the middle distance. The overall view includes accurate details of the Tamar valley and its industrial activities (copper mining), but it is essentially capricious, including an invented foreground and a background prospect of the hills near Plymouth taken from another vantage point. In combining different perceptions into one organised composition, Turner was working analogously to Claude, making studies of details or 'parts of nature' and combining them, as opposed to simply taking nature as he found it, being 'pleased with simple subjects of nature'.[27] The resulting picture presents a Devon landscape in explicitly Claudean terms, but goes beyond Claude in its exemplary handling of light and the control of atmospheric recession achieved by the manipulation of tone. By choosing a generic, as opposed to a topographical title, Turner seems to have wanted to demonstrate that his art could indeed produce Elevated Pastoral of the sort associated with Claude.

Turner was under increasing attack in the 1810s from Sir George Beaumont for the errors of his practice and his inferiority to Claude. The landscape artist Augustus Callcott complained to Farington about how much damage Beaumont's sniping was achieving and the 'virulence of criticism' Turner had endured was remarked upon in the *Catalogue Raisonné*'s attack on the British Institution, published in 1815. In this light it is tempting to see *Crossing the Brook* as an outright riposte to Beaumont. Its vertical format and its composition of framing trees, with a bridge in the middle distance, call to mind the favourite Claude in Beaumont's collection, *Landscape with Hagar and the Angel* (1646/7, fig.50), a picture so dear to him that it sometimes accompanied him when on lengthy visits to other properties.

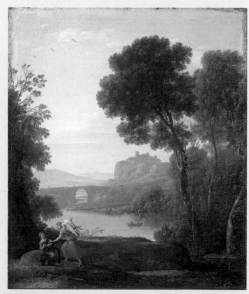

50
Claude Lorrain
Landscape with Hagar and the Angel 1646
Oil on canvas
52.7 × 43.8
National Gallery, London

49
Crossing the Brook
1815
Oil on canvas
193 × 165
Tate

Turner's view of landscape always encompassed its potential to embrace considerations wider than simply the depiction of nature. One of the categories in the *Liber Studiorum* was 'Historical', by which Turner and his contemporaries meant the treatment of narratives or incidents taken from the Bible, national history, classical myth or Greek and Roman history. Sometimes his historical subjects were chosen to make oblique comments about contemporary events, sometimes they opened out into more general intellectual considerations, but what they were not were genre-like illustrations of narratives, merely tricking out a story with pleasing combinations of colour and a dash of sentiment. History painting for Turner was still imbued with the philosophical and ethical qualities that made it a purposeful activity, one that placed serious demands on those who attended to it.

Prospects for historical landscape

As we saw in Chapter 2, there was a great deal of anguished comment in the nineteenth century that history painting was insufficiently supported in Britain. The record was certainly not promising. James Barry (1741–1806) was the most convinced adherent of the Grand Style in history painting and was the Royal Academy's Professor of Painting from 1782 to 1799. Turner joined the Academy just before Barry was expelled in 1799, but he owned a copy of his *Works* and certainly heard him lecture, for he reminisced in a letter of 1817: 'Barry's

words are always ringing in my ears "*Get home and light your lamp.*"'[1] Barry's career ended in poverty and squalor and he was widely regarded by sympathetic artists, for example William Blake, as something of a martyr to the cause.[2] Henry Fuseli (1741–1825) took over Barry's office at the Royal Academy and achieved a fair amount of success as a history painter, but his choice of subjects, his erotic sensibility and his enthusiasm for *Sturm und Drang* excess were all departures from the Grand Style history painting advocated by Reynolds. Among Turner's contemporaries the cause of history painting was most tragically associated with Benjamin Robert Haydon (1786–1846), a combative and often irascible talent, whose attempts to found a school of history painters in Britain ended in poverty, paranoia and suicide.[3]

Although history painting was poorly supported, Turner's great predecessor in landscape, Richard Wilson, had attempted to paint pictures in which idealised landscape was married to mythological incident (fig.15). Wilson's example offered the most immediate stimulus, but his endeavours to fuse history with landscape had not always received approbation. Reynolds, indeed, had suggested in his fourteenth *Discourse* that Wilson's landscapes were 'too near common nature' to serve as settings for history painting.[4] As a landscape painter himself Turner would not accept this verdict. He had studied Wilson's work with some care in the 1790s and made a pilgrimage to his birthplace on his Welsh

4 History – Ancient and Modern

tour of 1798. He alluded to Wilson's final years in the 'Backgrounds' lecture he gave in his Perspective series, and deprecated the fact that the preference shown for meretricious painters such as Zuccarelli

defrauded the immortal Wilson of his right and snatched the laurel from his aged brow. In vain did his pictures of Niobe in the possession of Sir George Beaumont and the Duke of Gloucester flash conviction of his powers, or Ceyx and Alcyone and Celadon and Amelia display contending elements or the Cicero at his Villa sigh for the hope, the pleasures of peaceful retirement, or the dignified simplicity of thought and grandeur, the more than solemn solitude that told his feelings. In acute anguish he retired, and as he lived he died neglected.[5]

In 1822 Turner corresponded with the print seller and publisher J.O. Robinson about the possibility of having four of his historical landscapes engraved.[6] He explicitly compared this endeavour to the engraver William Woollett's production of plates after Wilson's paintings in the 1760s for the entrepreneur John Boydell:

four subjects to bear up with the 'Niobe', 'Ceyx', 'Cyledon', and 'Phaeton' (in engraving as specimens of the British school). Whether we can in the present day contend with such powerful antagonists as Wilson and Woollett would be at least tried by size, security against risk, and some remuneration for the time of painting. The pictures of ultimate sale I shall be content with; and if we fall, we fall by contending with giant strength...[7]

Turner's characterisation of Wilson's 'giant strength' can be understood as his recognition of the magnitude of the task that faced him: to elevate and aggrandise British landscape painting through the incorporation of history. It would mean not merely emulating the acknowledged achievements of Claude and Poussin but also attempting to renovate landscape for the modern age without in any way diminishing its potential to offer serious reflections on human endeavour.

Carthage in fact and fiction

The subjects Turner recommended to Robinson were all Carthaginian and one of the artist's most persistent historical themes concerned the fate of Carthage in its struggle with Rome. Turner's overall narrative is founded upon the history of the Punic Wars, recounted in Livy and retold in Oliver Goldsmith's *The Roman History*, both of which were in his library.[8] Turner's first exhibited picture to explore that conflict was *Snow Storm: Hannibal and his Army Crossing the Alps* (fig.40), shown in 1812, which dealt with a real incident in the second Punic War, the Carthaginian army's crossing of the Alps in 218 BC. His reason for choosing Carthaginian subjects in the 1810s can probably be explained by the general comparisons being made at the time between England's contemporary struggle with France and this classical precedent. Although French and English authors were not at all agreed about which country should be associated with Rome and which with Carthage, the sense of a historical parallel was widely accepted.

Turner was also interested in the legendary material in Virgil's *Aeneid* describing the foundation of Carthage by Dido, the arrival of Aeneas from Troy, their love, his betrayal and departure to found Rome and her resultant suicide. He began sketching out possible treatments of the Dido and Aeneas myth in sketchbooks of *c*.1804–7, but his first exhibited picture on this subject was *Dido and Aeneas* of 1814, showing the pair out hunting, surrounded by an elaborately kitted-out retinue with half-built Carthage providing a silvery backdrop. His next treatment followed a year later: *Dido Building Carthage: or the Rise of the Carthaginian Empire* (1815, fig.51). Contemporary critics were full of admiration for this picture, although some were struck by Turner's use of intense blues and yellows in the sky and their reflection on the water. Beaumont complained that 'the picture is painted in a false taste, not true to nature; the colouring discordant, out of harmony, resembling those French Painters who attempted imitations of Claude, but substituted for His purity & just harmony, violent mannered oppositions of Brown and hot colours to Cold tints, blues & greys'[9]

The picture shows Carthage in its first glory, rising into the morning light as Dido discusses the plans for her new city with her architects. The wall nearest to us on the left is inscribed with the picture's title, while in the Royal Academy catalogue Turner added the further reference '1st book of Virgil's Aeneid'. In these titles and hints to viewers Turner seems to be attempting to guide the experience of his painting, to help avoid the

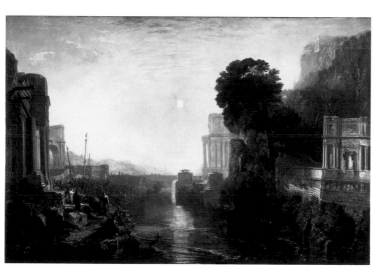

51
Dido Building Carthage; or the Rise of the Carthaginian Empire – 1st Book of Virgil's Aeneid
1815
Oil on canvas
155.5 × 232
National Gallery, London

critical misconstruings that had increasingly dogged his work. And in yoking together a fabulous narrative from Virgil (the story of Dido and Aeneas), a symbolic morning of empire (the rising of the sun) and a historical truth (the rise of the Carthaginian empire) he indicates that serious historical painting is always concerned with more than description, that its discursive potential allows a register of feeling and understanding which incorporates connotation, symbolism and the poetic.

In Virgil's account Dido's husband, Sychaeus, was murdered by his brother, Pygmalion. Advised by her husband's ghost, Dido steals Pygmalion's fortune and makes her escape, wandering the Mediterranean before establishing Carthage on the north African coast opposite Sicily. On the right of the scene Turner shows Sychaeus' monumental tomb, with a sculpted boatman, presumably Charon, at its left edge and the inscription 'SICHAEO' on the curving wall below. A series of relief panels seem to show ritual processions moving in from the left to a sea voyage, represented by a galley, and what must be the scene of Sychaeus' murder in the reliefs directly below the tomb's entrance.[10] If the right-hand side of Turner's picture represents the past, the left represents the future. In the foreground a group of boys has launched a toy galley into the waves and the gentle ripples of the incoming tide propel it towards us, as a symbol of Carthage's maritime strength and the commercial prosperity that will develop from its sea empire. The dark-robed figure between us

and Dido is presumably Aeneas himself, literally casting a shadow over these optimistic proceedings; for it will be Dido and Aeneas' doomed love affair that will provoke Dido's death and her dying curse that will sow the seeds of enmity between Carthage and Rome.

The Decline of the Carthaginian Empire (fig.52) complements *Dido Building Carthage* and was exhibited two years later, in 1817. Turner considered the later picture to be the better of the two, but felt that the public did not understand it. He also indicated on a number of occasions that he wanted to be buried in it.[11] Clearly this proposition was never to be taken entirely seriously, but it does indicate that Turner conferred some special value on the painting and originally it was to have joined *Dido Building Carthage* as one of the two pictures left in his will to hang alongside paintings by Claude in the National Gallery.[12] The picture has an exceptionally long title that reads like a history lesson: *The Decline of the Carthaginian Empire – Rome Being Determined on the Overthrow of her Hated Rival, Demanded from her Such Terms as Might either Force Her into War, or Ruin her by Compliance: The Enervated Carthaginians, in their Anxiety for Peace, Consented to Give up even their Arms and their Children.* As the picture was exhibited two years after the fall of Napoleon, one might have expected Turner's use of the standard transhistorical comparison to buttress the idea of England/Rome's success over France/Carthage, as many authors had already done, but his use of the lesson from antiquity seems to have been much less

52
The Decline of the Carthaginian Empire – Rome Being Determined on the Overthrow of her Hated Rival, Demanded from her Such Terms as Might either Force Her into War, or Ruin her by Compliance: The Enervated Carthaginians, in their Anxiety for Peace, Consented to Give up even their Arms and their Children 1817
Oil on canvas
170 × 238.5
Tate

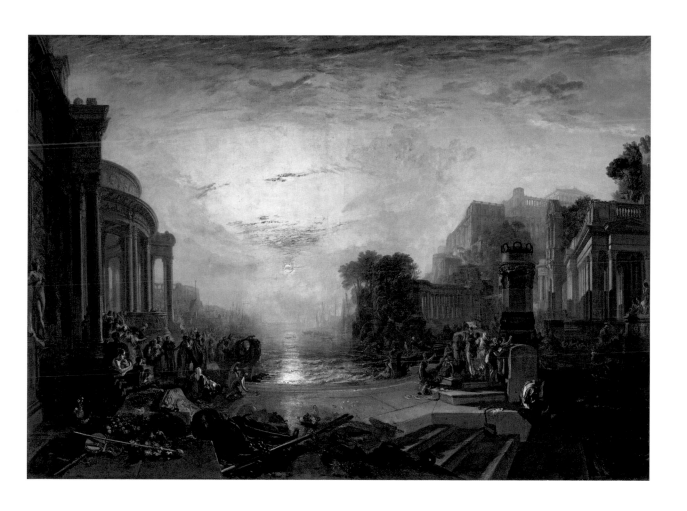

straightforward. If anything, the example of Carthage stood not for defeated France but for the perils of victory and the complacency it might engender in England. His first biographer, Walter Thornbury, noted that: 'Turner seems to have considered the fate of Carthage as a moral example to England; ascribable as it was to the decline of agriculture, the increase of luxury, and besotted blindness, too prolonged, to the insatiable ambition of Rome.'[13]

To understand how Turner's painting might be linked to such sentiments, we need to examine it with some care. At one level it is remarkably easy to understand. The setting sun symbolises the city's decline, while the taking of hostages and the discarded weapons tally with the historical incidents mentioned in the title. The flower garlands entwined about the thyrsus in the left foreground disguise the presence of a snake coiled among them, which Turner intended as a comment on Rome's deceitful terms. As some verses in one of his sketchbooks of the time declared: 'Perfidious Rome, the Myrtle proffers still But round its branch insidious entwined the asp...'[14]

The picture is studded with detail and contains a multitude of figures, some forty individuals in the foreground and middle distance groups alone. It is also a studiously researched picture, offering hints about Carthage's difference from Rome. The buildings bear inscriptions alluding to Carthaginian leaders of the first and second Punic Wars and the rich wall decoration on the left suggest a more oriental form of classicism, perhaps inspired by Turner's awareness of the ruins of Palmyra.[15] For details of dress, musical instruments and war gear Turner turned to another book in his possession, Thomas Hope's *Costume of the Ancients* (1809), copying details from its engravings.

The fragment of relief sculpture in the foreground combines Turner's knowledge of the Bassae Frieze, housed in the British Museum from 1815, and the Elgin Marbles, first seen by Turner in 1806 and on show at the British Museum from 1816.[16] Like the triple layer of meaning in *Dido Building Carthage*, this relief symbolises in one emblematic presentation the past, present and future of the Carthaginian empire. With respect to the past, the sculpture alludes to Dido's mythical founding of Carthage, for the goddess Juno had directed that the city be established where the sculpted head of a war horse was unearthed; indicating the present, the outflung arms of the woman on the horse show that this is a scene of abduction, just as Carthage's children are being taken away as hostages; as for the future, Carthage is not a ruined city, yet this sculpture is a fragment of a ruin, alluding to the destruction that will soon overwhelm the town. The discarded flowers, pipes and tambourines reinforce the poignancy of the relief's message. Carthage, once the seat of a mighty empire, has degenerated into hedonism and luxury and, as a result, has become Rome's slave.

This message is confirmed by the statue on the left, which is closely based on a classical sculpture of Mercury, now in the Uffizi

53
Regulus 1828, reworked
1837
Oil on canvas
91 × 124
Tate

museum. Mercury plays two roles here, both of them destructive. He it was, in Virgil's *Aeneid*, who was sent to remind Aeneas of his destiny, to abandon Dido and Carthage so that he might found Rome, the very power that now subjects Carthage to humiliation. Mercury was also the god of commerce and it is the pursuit of commerce that has brought the Carthaginians to their present predicament. As Goldsmith pointed out, good living born of commerce made Carthage soft, hiring mercenaries rather than defending itself with its own forces: 'all the grandeur of Carthage was founded on commerce alone, which is ever fluctuating, and, at best, serves to dress up a nation, to invite the conqueror, and only to adorn the victim for its destruction.'[17]

As we saw in Chapter 2, a general ambivalence about the place of commerce in society, whether it be a force for good or ill, can be detected in comparisons between the support for the arts in contemporary Britain and in Renaissance Italy. And, as we shall see in Turner's treatment of Venice, that city was widely accepted to have lost its independence for much the same reasons as Goldsmith suggested Carthage had suffered the same fate: it had grown soft on a surfeit of luxury. Following Thornbury's account of the meaning of this picture, Turner's admonition to England, now the supreme power in Europe and in command of a vast trade network, was not to rejoice in the defeat of France but to guard against the corruption that victory might bring.

Turner returned to mythical Carthage

again in 1828, exhibiting at the Royal Academy *Dido Directing the Equipment of the Fleet, or The Morning of the Carthaginian Empire*, a picture which has deteriorated so badly over the years that its modern restoration has yet to be undertaken. Judging from the critics' reactions, it offered a representation of very bright sunlight and was saturated with colour when first displayed. The intense glare of the centrally positioned sun in *Regulus* (1828, reworked 1837, fig.53) extends this approach, for it is one of the most uncompromising depictions of light Turner ever attempted. Its subject concerns a Roman patriot whose example was held up as a supreme example of loyalty to the state. Charged with negotiating a settlement between Rome and Carthage, Regulus had deliberately recommended that Rome reject Carthaginian terms and then returned to Carthage knowing that Rome's refusal would mean his execution. As punishment his eyelids were cut off and he was exposed to the sun to blind him, before meeting his death in a barrel studded with nails. The almost painful dazzle of the sun alludes to his fate, as do the figures at bottom left manipulating a barrel, but the protagonist himself is no more than a brilliantly lit detail, the tiny figure descending the steps on the right of the composition.[18]

When Turner exhibited the painting at the British Institution in 1837 he took the opportunity to heighten its impact on the spectator by repainting it. As the artist Sir John Gilbert later recalled:

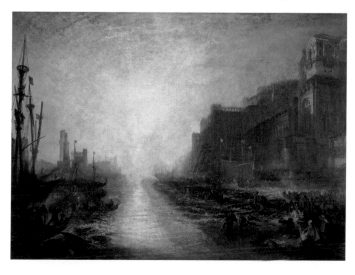

He had been there all the morning, and seemed likely, judging by the state of the picture, to remain for the rest of the day. He was absorbed in his work, did not look about him, but kept on scumbling a lot of white into his picture – nearly all over it… The picture was a mass of red and yellow in all varieties. Every object was in this fiery state. He had a large palette, nothing on it but a huge lump of flake-white: he had two or three biggish hog tools to work with, and with these he was driving the white into all the hollows, and every part of the surface. This was the only work he did, and it was the finishing stroke. The sun … was in the centre; from it were drawn – ruled – lines to mark the rays; these lines were rather strongly marked, I suppose to guide his eye. The picture gradually became wonderfully effective, just the effect of brilliant sunshine absorbing everything, and throwing a misty haze over every object. Standing sideway of the canvas, I saw that the sun was a lump of white, standing out like the boss of a shield.[19]

Turner's final treatment of the Carthaginian theme was the quartet of pictures he exhibited at the Royal Academy in 1850, the year before he died. Three of them survive. Yet again he returned to Virgil to probe the cruel entanglement of Dido and Aeneas, playthings of the gods, whose joyous encounter was doomed to end in tragedy.[20] Turner accompanied each picture with lines from *Fallacies of Hope*, adding its doleful commentary to a story that had maintained its hold over him for some forty years. Although he could not have known that these would be the last works he exhibited at the Academy, this return to Dido and Aeneas at the close of his life emphasises how important the subject of Carthage was for him.

Greek myths and Roman history

Turner's other explorations of classical history were wide-ranging, incorporating variously the same interest in myth, history and transhistorical comparisons seen in the Carthage pictures. On his second visit to Italy he arrived in Rome in October 1828 and stayed there until early January 1829. There he painted a number of studies and finished a landscape and three subject pictures, one of which, *Regulus*, he exhibited at the Palazzo Trulli at the turn of the year. All were painted on coarse canvas, fastened to their stretchers with upholsterer's sprigs and framed with a rope painted in yellow ochre.

Among them was *Vision of Medea* (1828, fig.54), which alludes to one of the most violent stories in classical literature. Medea was the daughter of King Aetes of Colchis, who had set Jason seemingly impossible tasks to undertake if he was to win the Golden Fleece. Aided by Medea's arts, Jason gained the fleece and fled with her, Medea delaying her father's pursuit by cutting up her brother and dropping pieces of him into the sea. Jason's union with Medea was not to last, however, and he abandoned her and their children for a Corinthian princess. Medea gave Jason's betrothed a dress that burst into flames and killed her, then slaughtered her own children and left for Athens in a chariot drawn by winged dragons.

In Turner's picture Medea is shown attended by the Fates, raising a poisonous

54
Vision of Medea 1828
Oil on canvas
173.5 × 241
Tate

snake on high and performing an incantation, with the ingredients for her foul magic displayed in the foreground. She is shown again, in the sky at top left, in her dragon chariot, throwing her children's bodies over the side. Jason, who had slain a serpent, will be undone by serpent power, his bride and his children destroyed. The smoke that rises from Medea's fire supports phantasms of children and translucent bubbles that seem to refer to Jason's voyage. In 1831, when Turner exhibited the painting at the Royal Academy, he included verses from *Fallacies of Hope*, describing Medea as 'infuriate in the wreck of hope'. Like Dido, she is betrayed; unlike Dido, she can exert revenge; but in both cases the course of action leads to death and despair.

As with his pairing of mythology and history in his treatment of Carthage, so in 1831 Turner complemented Medea's story with an exhibit derived from Roman history. *Caligula's Palace and Bridge* (fig.55) explores the vanity of human wishes and was accompanied with lines from *Fallacies of Hope*:

What now remains of all the mighty Bridge
Which made the Lucrine Lake an inner pool,
Caligula, but massy fragments left,
Monuments of doubt and ruined hopes
Yet gleaming in the Morning's ray, that tell
How Baia's shore was loved in times gone by.

Turner's intentions here are clearly expressed and, yet again, he turned to Goldsmith's *The Roman History* for inspiration. A prophecy had declared that

Caligula had as much chance of becoming Emperor as of driving his chariot across the Bay of Baiae. He therefore ordered a bridge of boats to be constructed, the most spectacular example of his megalomania. Popular legend believed it to be a real bridge, as is shown here. Yet, for all its magnificence, the world of classical antiquity moulders into ruin and the ambition that brought these marvels into being is exposed for the vainglorious thing it is. But, Turner proposes, the wreck of Caligula's hopes is somehow transfigured by the beauty of the scene, touched by the rising sun. Certainly the reviewers of this picture were prepared to praise Turner extravagantly for the poetic quality of the light and atmosphere exhibited here and the brilliance of his colour. The conjunction of this picture with *Medea*, over and above both having an epigraph from the *Fallacies of Hope*, suggests some sort of interplay: the overcoming of seemingly impossible tasks, the use of chariots, the magic of incantations and prophecies, associations with cruelty, and the ultimate pointlessness of the protagonists' actions.

Past and present

History painting for Turner was not inevitably concerned to explore history and mythology as routes back into the past; it also allowed him, as with *Caligula's Palace and Bridge*, to consider the transition in national histories from past to present. In Italy the relics of antiquity could be understood as poignant witnesses of the country's decline

55
Caligula's Palace and Bridge 1831
Oil on canvas
137 × 246.5
Tate

from its past glories to its modern situation. No longer the master of the known world, nineteenth-century Italy was politically divided, a patchwork of smaller states subservient to foreign control or military occupation. Its picturesque charm existed in direct proportion to its economic and political weakness, as Mazzini and other Italian nationalists were concerned to point out. Like most British artists, Turner saw in Italy a country whose history still exercised a hold over its modern identity, and he found it worthwhile to play on the contrast between the two.

In 1838 *Modern Italy – The Pifferari* (fig.56) was exhibited as a pendant to *Ancient Italy – Ovid Banished from Rome* (fig.57). In the modern subject Turner depicts an idealised view of Tivoli, with the campagna in the background. The *pifferari* of the title, shepherd bagpipers hailing from the Abruzzi mountains, are in sight in the left foreground, where Italian peasants pay their devotional respects to wayside shrines. A religious procession approaches another shrine on the right. The scene is obviously a summer one, with the slender trees in full leaf and boys bathing in the river, yet the *pifferari* were known for journeying to Rome at Christmas-time, to worship the Virgin Mary. Turner's point here, however, is probably intended to be more general. He owned a copy of the Revd J. J. Blunt's *Vestiges of Ancient Manners and Customs Discoverable in Modern Italy and Sicily* (1823), in which he would have found Blunt's conjecture that contemporary Italian peasants piping before

images of the Madonna is a custom comparable to ancient pagan rites honouring the gods, which also were accompanied by music. Turner was evidently fascinated by the idea of cultural continuities of this kind and in 1826 had shown Catholic worship among the ruins of classical Rome, as if to underline the point.[21]

Ancient Italy, in contrast, shows a declining sun sinking into night, as one of the lights of classical Rome is also extinguished. Ovid was banished from Rome in AD 8 and required to live in exile at Tomis, a Scythian settlement on the Black Sea coast, where he died nine years later. The offence for which he was charged was never made explicit but may have been connected with his outraging public morals by publishing his *Ars Amatoria* or even with a private scandal involving Julia, the daughter of the Emperor Augustus. The figure being arrested on the left of the composition could be Ovid, although he looks considerably younger than the fifty-year-old poet. In the foreground are strewn the contents of a strongbox, with the jemmy that forced it open still under the lid. The shape of the strongbox is reminiscent of a book, so that Turner's image of physical violation also connotes the assault on Ovid's literary craft. At the centre a woman grieves, with two others at bottom right looking on. Rome in all its glory is presented as a phantasmagorical spectacle, combining a medley of different buildings, rearing up on top of one another with no respect for topography.

Ovid was one of Turner's favourite poets

56
Modern Italy –
The Pifferari 1838
Oil on canvas
92.5 × 123
Art Gallery and Museum,
Glasgow

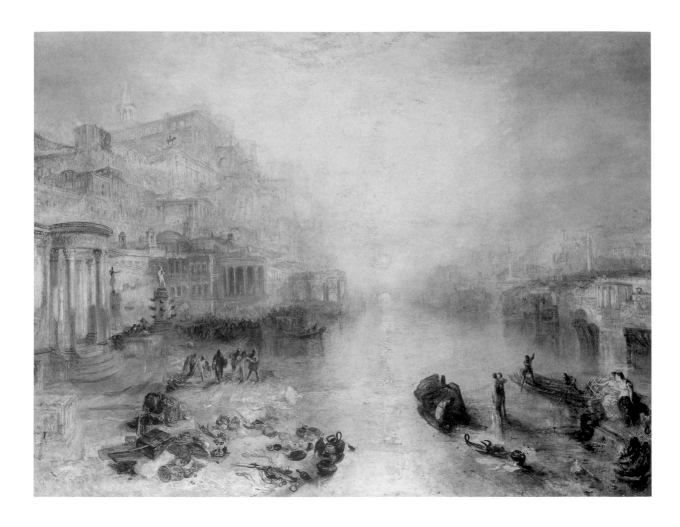

and the artist borrowed incidents from his works, especially his *Metamorphoses*, for a number of paintings throughout his career. Given that Ovid's exile could be understood as personifying the idea of the misunderstood artist, perhaps there is also an autobiographical element here. The hostility Turner had received from numerous critics of his paintings was not tantamount to banishment, but it may well have disposed him to consider Ovid's plight as an exaggerated version of his own situation. Ultimately, however, the pairing of these two pictures reasserts the point made in *Caligula's Palace and Bridge* (fig.55), that beauty is in itself a positive value and that no amount of grandeur can compensate for tyranny. The world of the *pifferari* may seem to have declined from the glory of Ovid's day, but their art is welcomed to Rome while his was banished. The light and lyricism of *Modern Italy* is thus deliberately opposed to the sunset and oppression of *Ancient Italy*.

British history and contemporary politics

Turner's use of history was not restricted to the classical world and the Mediterranean, for a number of pictures explore themes in British history. Earlier in this book we have seen his engagement with the reign of Edward I and the Anglo-Dutch wars of the seventeenth century (figs.16,17,19,38). Another painting devoted to national history is *Lucy, Countess of Carlisle, and Dorothy Percy's Visit to their Father Lord Percy, when under Attainder upon the Supposition of his Being Concerned in the Gunpowder Plot* (1831, fig.58). Petworth House had belonged to the Percy family until the end of the seventeenth century and this picture makes use of portraits by van Dyck and/or his imitators in Lord Egremont's collection at Petworth, Lord Percy and Lucy Percy being based on their seventeenth-century originals. The picture has darkened over time, and the play of light that was evidently such a feature when it was first exhibited has largely disappeared. Its small size and concentration on this period in history is reminiscent of the work of Richard Parkes Bonington (1802–28), who had died three years earlier, having developed historical genre scenes as a distinctive contribution to the art of his time, influencing artists on both sides of the Channel.[22]

On the right-hand wall of *Lord Percy under Attainder* Turner includes a picture of the Angel releasing St Peter from prison and a view labelled 'Tower of London'. Given the association of Percy with the Gunpowder Plot of 1605 and all its constitutional implications had it succeeded, it is tempting to link this picture with the increasingly strident demands for political reform that would result in the passing of the Great Reform Bill in 1832. Indeed, if *Lord Percy under Attainder* suggests Turner's concern to link seventeenth-century politics with current affairs, another painting detailing events of that century reinforces the connection. *The Prince of Orange, William III, Embarked from Holland, and Landed at Torbay, November 4th, 1688, after a Stormy Passage* (1832, fig.59) may

57
Ancient Italy – Ovid Banished from Rome 1838
Oil on canvas
94.6 × 125
Private collection

58
Lucy, Countess of Carlisle,
and Dorothy Percy's Visit
to their Father Lord Percy,
when under Attainder
upon the Supposition of
his Being Concerned in the
Gunpowder Plot 1831
Oil on oak panel
40.5 × 70
Tate

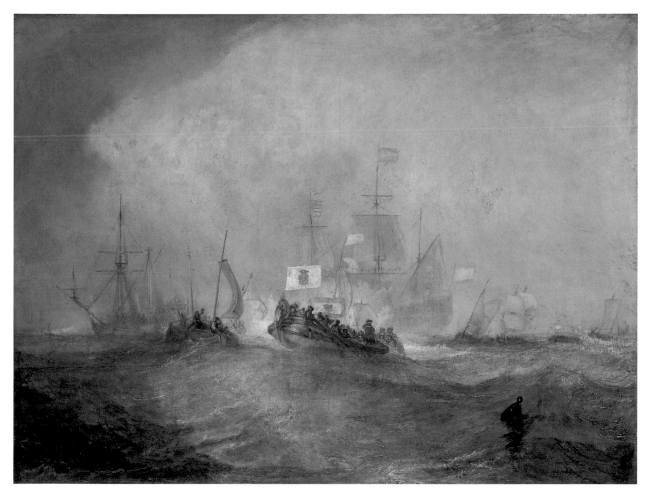

59
*The Prince of Orange,
William III, Embarked from
Holland, and Landed at
Torbay, November 4th,
1688, after a Stormy
Passage* 1832
Oil on canvas
90.5 × 120
Tate

be understood as Turner's tribute to the passing of the Great Reform Bill, linking the extension of the franchise in his own time to the return of constitutional liberty with the Glorious Revolution of 1688.

Certainly Turner had made reference to the urgency of political reform in two watercolours of the early 1830s, *Northampton* (1830–1,) and *Nottingham* (*c*.1831, fig.61), both of which included references to the violence that attended thwarted bids for constitutional change. In the first Turner shows an election scene to commemorate the return of the progressive Whig, Lord Althorp, as the county member for Northamptonshire in 1830. In the foreground sits a man in a tricorn hat, an antiquated piece of headgear that signals a reactionary political position; he is tapped on the shoulder by Marianne, the emblem of France, as though to remind him of the need for reform if revolution, such as had occurred in France in 1789 and 1830, is to be averted.

Nottingham shows barge traffic entering a lock under a clearing sky with a double rainbow, the traditional symbol of hope. To the left can be seen Nottingham Castle. This was the seat of the Duke of Newcastle, who in 1829 and 1830 had evicted those of his tenants who supported constitutional change. When the Reform Bill was defeated in the House of Lords in October 1831 an angry mob attacked and burnt Nottingham Castle and Turner alludes to this by depicting fires burning on the slopes below. As if to underline the point, he includes a Greek flag on the mast of the barge, which has its sails set and is therefore

making headway. The implication seems to be that Greece, the birthplace of democracy and currently fighting for its independence, is naturally allied with the agitation for political democracy in Britain.[23]

In this context, what should we make of Turner's pictures of the burning of the Houses of Parliament? The fire that swept through the Palace of Westminster on 16 October 1834 was watched by thousands on the banks of the Thames, on the bridges and in the immediate neighbourhood; the sight of the seat of political power being utterly consumed was evidently a compelling spectacle. Turner was one of a number of artists recorded at the scene and had a vignette illustration published in *The Keepsake* in 1836, as well as two major oil paintings exhibited in 1835, one at the Royal Academy, showing the fire from Waterloo Bridge, the other at the British Institution, with a viewpoint close to Westminster Bridge: *The Burning of the House of Lords and Commons, 16th of October, 1834* (fig.62). None of these images appears to have any political message, although given Turner's friendship with the politically radical Walter Fawkes, and the febrile atmosphere of the 1830s, we cannot be absolutely sure that he did not intend some underlying comment about the success of the 1832 Reform Bill and the destruction of old privileges. What is more likely is that Turner was attracted by the sublime experience provided by the blaze. Not only was this a subject akin to some of his other explorations of natural cataclysms and human disasters, it also

60
*Northampton c.*1830–1
Watercolour
29.5 × 43.9
Private collection

61
*Nottingham c.*1831
Watercolour
30.5 × 46.3
City Museum and Art
Gallery, Nottingham

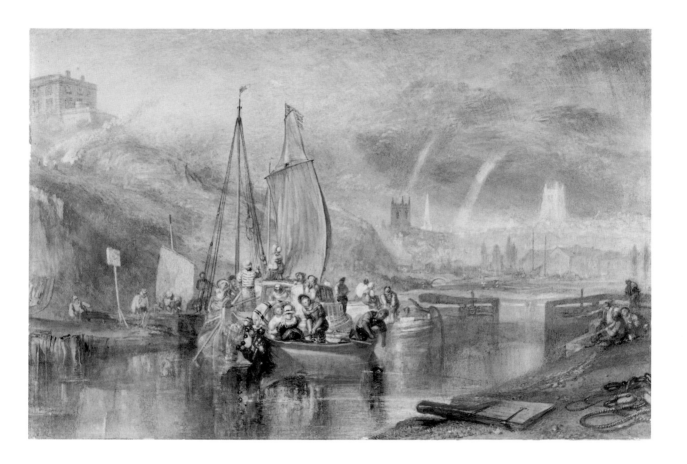

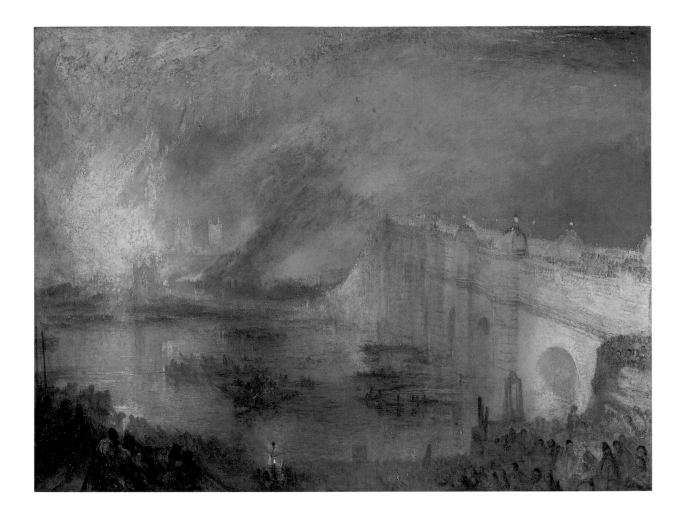

THE TURNER BOOK

offered a ready subject for the exploration of light and colour, contrasting the intense heat of the fire, with its powerful reds and yellows, with the silvery moonlight and deep-blue night sky. In the view from Westminster Bridge, Turner has exaggerated the bridge's curvature so that its northern end seems to have collapsed, as though even man-made structures must give way to the inferno that is carving out space, leaving only light and colour where architecture once stood.

The artist E.V. Rippingille reported how Turner used Varnishing Days to bring this picture to completion in an extraordinary feat of controlled creativity. Turner sent in the unfinished picture as 'a mere dab of several colours, and "without form and void," like chaos before the creation', but because of his reputation the managers of the British Institution were prepared to accept what was effectively a lay-in. Rippingille observed how Turner worked incessantly and without distraction, despite the fact that other artists looked on, for 'such a magician, performing his incantations in public, was an object of interest and attraction'. His description of Turner's working methods is revealing:

A small box of colours, a few very small brushes, and a vial or two, were at his feet, very inconveniently placed; but his short figure, stooping, enabled him to reach what he wanted very readily... In one part of the mysterious proceedings Turner, who worked almost entirely with his palette knife, was observed to be rolling and spreading a lump of half-transparent stuff over his picture, the size of a finger in length and thickness... presently the work was finished: Turner gathered his tools together, put them into and shut up the box, and then, with his face still turned to the wall, and at the same distance from it, went sidling off, without speaking a word to anybody, and when he came to the staircase, in the centre of the room, hurried down as fast as he could. All looked with a half-wondering smile, and Maclise, who stood near, remarked, 'There, that's masterly, he does not stop to look at his work; he knows it is done, and he is off.'[24]

Religious subjects

Turner's production of biblical scenes was not as extensive as his other ventures into history painting, but it includes some of his most memorable images (figs.47, 48). *The Angel Standing in the Sun* (1846, fig.63) was the last religious painting Turner completed; it brings to a conclusion his interest in the exhibition of biblical subjects, which had started with the *Fifth Plague of Egypt* (1800) and included a further thirteen works in oils and thirty-three works in watercolour, including twenty-eight designs for William Finden's *Landscape Illustrations of the Bible* (1836).[25] The angel of the title is the angel described in Revelation 19:17–18, which Turner quoted in the Royal Academy catalogue:

And I saw an angel standing in the sun; and he cried with a loud voice, saying to all the fowls that fly in the midst of heaven, Come and gather yourselves together unto the supper of the great

62
The Burning of the House of Lords and Commons, 16th of October, 1834 1835
Oil on canvas
92 × 123
Philadelphia Museum of Art, John H. McFadden Collection

THE TURNER BOOK

God; that ye may eat the flesh of kings, and the flesh of captains and the flesh of mighty men, and the flesh of horses, and of them that sit on them, both small and great.

Turner added to this quotation a second, from Samuel Rogers's poem *The Voyage of Columbus*: 'The morning march that flashes to the sun; the feast of vultures when the day is done.' Both extracts suggest the same humbling of human pomp and self-confidence that animates Turner's *Fallacies of Hope*.

Yet neither Rogers nor Revelation is directly figured in *The Angel Standing in the Sun*. The birds swooping in to surround the angel will feast not on the flesh of kings and captains, but on the bodies of victims from celebrated Old Testament murders. On the right can be seen the decapitated body of Holofernes, with the figure of Judith, sword in hand, and her maidservant, holding up his severed head. In the immediate foreground Delilah stands over Samson, clutching his shorn hair in her hand. On the left can be seen a skeleton, fleeing from the angel's presence, in front of whom are shown Adam and Eve grieving over the body of Abel, while Cain runs off at bottom left. In the foreground directly below the angel writhes a chained serpent.[26]

Turner's image of death and destruction makes no distinction between the innocent (Abel, Samson) and the guilty (Holofernes); all seem subject to the evil associated with the serpent. And if his angel also alludes to the cherubim who expelled Adam and Eve from the Garden of Eden, his vision suggests that mankind's record since the Fall has been conditioned by that same evil, the chronicle of human history being largely written in blood.[27] In one sense, however, the presence of the angel, surrounded by an aureole of golden light, offers a possibility of redemption, for the light that pours from him perhaps operates symbolically. Evil cannot hide in the darkness but is revealed by light: the whole dismal chronicle of bloodshed and betrayal is exposed in the angelic radiance. If light can transfigure what it touches, there remains the possibility that it can expunge the crimes associated with human weakness, venality and ambition.

63
The Angel Standing in the Sun 1846
Oil on canvas
78.5 × 78.5
Tate

Ulysses Deriding Polyphemus – Homer's Odyssey

Turner made use of Alexander Pope's translation of Homer's *Odyssey* (Book IX) and in some instances used the poet's imagery as a stimulus to his imagination. In Pope's version, for example, the Cyclops, Polyphemus, is described as 'the lone mountain's monstrous growth' and Turner's depiction of the giant does indeed present him as indissolubly blended with the heights above the bay. Yet Turner's *Ulysses* is not merely an illustration of Homer (or Pope's version of the *Odyssey*), but instead offers a complex meditation on light, colour and the workings of nature. In Homer the smoke rolling over the island comes from the shepherds' fires, but in Turner's version the shepherds are absent and the smoke streams out of a volcanic crater. As John Gage has shown, the fire burning in the cavern at bottom left reinforces the volcanic origin of the smoke, perhaps alluding to Erasmus Darwin's *Temple of Nature* (1803), which speculates on the idea that volcanoes were originally formed when sea water burst into the molten interior of the earth.[28]

Turner's incorporation of natural contexts alongside mythical events is seen again in the sunrise, where the most observant depiction of the gathering strength of morning sunlight is combined with the outline of rearing horses, the chariot team of Apollo the sun god, derived from an engraving of the horses on the east pediment of the Parthenon. The horses are positioned in such a way that the solar disc can be read as a chariot wheel with the most intense glare of sunlight occupying the position where Apollo might be imagined to stand. Likewise, at the prow of Ulysses' ship can be seen a group of Nereids, riding the bow wave like so many dolphins. Here, it seems, Turner drew on the phenomenon of natural phosphorescence to provide these mythical water sprites with a basis in observation. When preparing his Perspective lectures Turner had made use of Joseph Priestley's *History and Present State of Discoveries Relating to Vision, Light and Colours* (1772), which contains a detailed account of marine phosphorescence and its various forms – globes, points of light or stars – when disturbed by oar strokes, shoaling fish or the forward motion of a ship. Another work by Erasmus Darwin, the *Botanic Garden* (1791), had made use of Priestley's observations when addressing Nymphs, Sylphs and Salamanders.[29] Turner's Nereids, with stars on their brows, are evidently indebted to these observations, fusing myth with natural history.

The picture thus treats different sorts of illumination as it moves from left to right, from the subterranean glow of volcanic fires, always in darkness, to the chemical light of surface phosphorescence, only visible at night, to the celestial light of the rising sun. Ulysses is shown moving forward from darkness into light, leaving behind the pain of the stricken Cyclops, but also, perhaps, the more primitive or originary world Polyphemus inhabits, to receive the blessing of the rising sun. The moral power of light over darkness is here asserted; the gorgeous coloration of the jewel-like sky is not just a superb evocation of the sun's rising but also a celebration of light in all its complexity.

Ruskin considered this picture to be 'the *central picture* in Turner's career ... [the] sky is beyond comparison the finest that exists in Turner's oil-paintings' and this judgement has been widely accepted. His opinion, however, was more than a technical appreciation, for he suggested that the picture could be allied with Turner's personal situation as 'a type of his own destiny'. Turner, he believed, had also been shut up by one-eyed people (critics) in a cave darkened by laurels (the critics' use of his predecessors' achievements) and had seen his companions (fellow artists) destroyed by critical attack, but he had stabbed these critics with a blazing pine-trunk (his profound knowledge of nature and of light) and escaped their clutches.[30]

64
Ulysses Deriding Polyphemus – Homer's Odyssey 1829
Oil on canvas
132.5 × 203
Tate

Turner's ambitions as a painter of historical subjects were founded on the idea that the contemplation of myth and history could provide important lessons for the present. In asserting this notion, through his choice of narratives and his treatment of them, he was arguably the last serious history painter in British art. History painting had been theoretised in the eighteenth century as a mode of engagement with the ethical concerns that should prompt a state's responsible citizens; in the nineteenth century, at a time when revolution and social change had rocked the foundations of all European societies, these normative values no longer seemed so assured.

In Britain the exhaustion of the tradition was revealed in the 1840s, when artists competed to design scenes from national history for the rebuilt Houses of Parliament: the simplistic symbolism and poverty of ideas in the overall scheme suggest that the seam of history painting, as Reynolds and Barry had understood it, had been mined out. The modern age, in all its complex and often bewildering development, seemed to demand another approach altogether, responsive to the immediacy of current events, technological innovation and intellectual development. Not the least remarkable thing about Turner is the fact that here, too, he was able to make a decisive contribution.

Constable, on first meeting Turner in 1813, was impressed by his 'wonderfull range of mind', a comment which other witnesses endorsed.[1] Francis Palgrave met Turner at the close of his life, in 1849, and recorded his impressions of the artist in old age. Turner was shown one of the earliest English Bibles, and his comments on this and other matters impressed Palgrave deeply:

What he said on this and on politics, to which the talk soon turned … impressed me with its eminent sense and shrewdness. Like other men of genius I have known, the mode of its manifestation … was a clear practical view of the subject in hand; an evidence of great mental lucidity. So Turner talked of the mysteries of bibliography and the tangle of politics neither wittily, nor picturesquely, nor technically; but as a man of sense before all things…[2]

Turner's breadth of intellect and his powers of synthetic intuition are readily apparent from careful study of his pictures. Working through connotation and allusion, they combine natural and scientific observations, together with historical and literary references. Their often complex meaning demonstrates his extraordinary ability to forge connections between different areas of human experience, to find creative links to bind together the past and the present, the actual and the symbolic.

Maritime dangers

Turner's paintings of storms at sea are a case in point, as he moves his narratives away from the expected general treatments of men pitted against the elements to pictures with more precise relevance to his contemporaries. Nothing that exists in the older tradition is abandoned, but Turner's insistence on

5 Witnessing the Age

bearing witness to his age allows the struggle with the sea to become an explicitly nineteenth-century affair. His 'Calais Pier' sketchbook (1802) contains drawings of what are presumed to be actual wrecks, abandoned to the sea, and he painted *The Shipwreck* (1805, fig.65) when the recent tragic loss of the *Abergavenny* off the Dorset coast had consumed the nation.[3] The painting's depiction of a mountainous sea, overwhelming the vessel and threatening the small boats attempting to rescue the survivors, can be linked to the reports published shortly after the disaster.

Turner's approach heightens the ferocity of the sea to the point that its heaving waves, boiling and churning in a cauldron of foam, dominate the composition. He showed the painting in his own gallery and it was an immediate success, purchased by Sir John Leicester and engraved in mezzotint by the artist's namesake Charles Turner, the first oil painting by Turner to be reproduced as an engraving. One of the subscribers to the print was Charles Pelham, the son of Turner's early patron Lord Yarborough, who commissioned Turner to paint another painting on the same theme, *The Wreck of a Transport Ship* (*c*.1810, fig.66). Pictures like these can be considered to participate in a sublime aesthetic, portraying the power and vastness of the ocean and the terror it can unleash. Even if Turner's precise subject was not identified by all who saw it, the depiction of savage seas smashing boats to pieces would have resonated with his contemporaries as a real humanitarian and economic concern,

mindful as they were of the toll of shipwrecks around Britain's coasts.

By the middle decades of the century new technologies made their appearance. Turner's *Life-boat and Manby Apparatus Going off to a Stranded Vessel Making Signal (Blue Lights) of Distress* (1831) celebrates the invention of a life-saving device that used mortars to fire a line to a ship in danger of being wrecked, while other canvases show steam ships combating the elements: *Rockets and Blue Lights (Close at Hand) to Warn Steam-Boats of Shoal-Water* (1840) and *Snow Storm – Steam-Boat off a Harbour's Mouth* (1842, fig.90). In the midst of this appreciation of technological progress, *A Disaster at Sea* (*c*.1835, fig.67) records an incident whose tragic outcome was the result of financial imperatives, stupidity and callousness. This unfinished picture has been plausibly identified as Turner's response to the loss of the convict ship the *Amphititre*, wrecked off Boulogne in 1833.[4] Stricken by a violent storm, the *Amphititre* was evidently vulnerable, but the master of the vessel refused to accept French assistance. Fearing that his crew of women convicts would abscond if rescued, he claimed that he was authorised to disembark his cargo only in Australia. Over a hundred people died as the ship broke up.

It has been suggested that this picture also registers Turner's response to Géricault's *Raft of the Medusa*, which had been exhibited in London in 1820. Certainly the pyramidal construction of the wreck, whose foreground is pushed out into the viewer's space, and the gesticulating figures beside the mast at its apex, do bear some similarities to Géricault's

65
The Shipwreck 1805
Oil on canvas
170.5 × 241.5
Tate

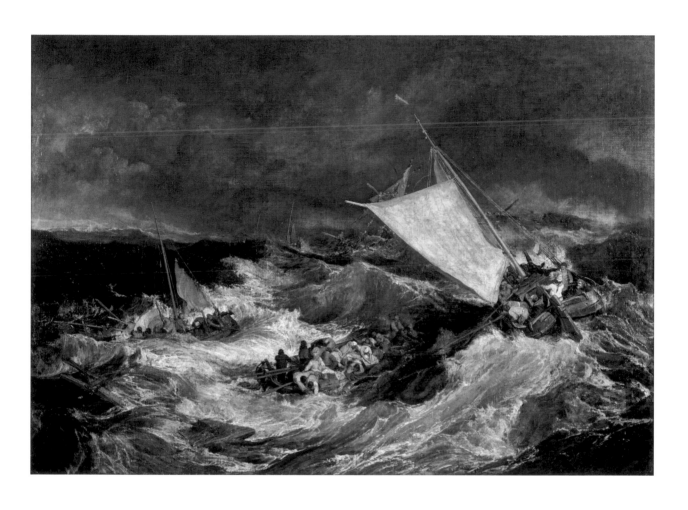

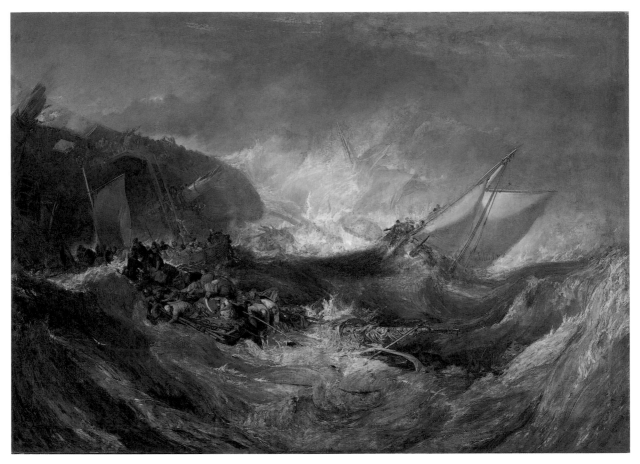

66
*The Wreck of a Transport
Ship* c.1810
Oil on canvas
127.2 × 241.2
Fundaçao Calouste
Gulbenkian, Lisbon

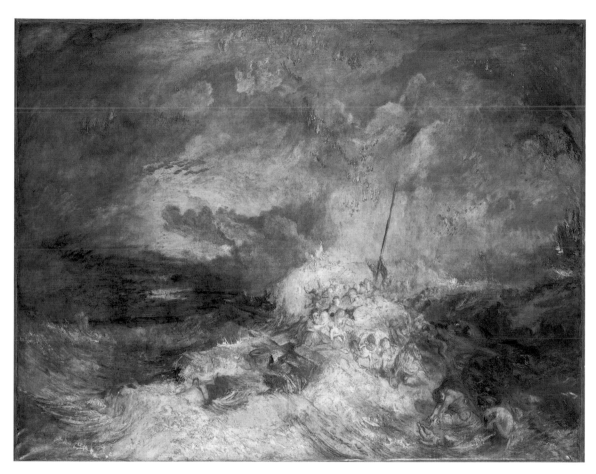

67
A Disaster at Sea c.1835
Oil on canvas
171.4 × 220.3
Tate

colossal masterpiece. But whereas Géricault produced a monumental composition of heroic grandeur, concentrating above all on the psychology of his protagonists, Turner's vision positions this human tragedy in a welter of crashing surf and raging fire, the women clearly at the mercy of the elements and dwarfed by the terror of their situation. There is little individual nobility here; the prospect of mass drowning equalises all these victims as anonymous members of one anguished crowd.

If *A Disaster at Sea* represents Turner's incredulity that such losses could still be sustained when the means to avoid them were at hand, his *Slave Ship* (*Slavers Throwing Overboard the Dead and Dying – Typhon Coming on*) (1840, fig.68) depicts an even more despicable example of suffering brought about by financial greed. The idea of a slave ship overwhelmed by a typhoon can be found in the work of one of Turner's favourite poets, James Thomson.[5] In *The Seasons* the section devoted to 'Summer' describes a typhoon and goes on to consider the fate of a slave ship foundering with all hands as sharks raven the bodies of slaves and slave masters alike.[6] Yet the painting is not merely an allusion to Thomson's lines; it contributes additionally to contemporary concerns, for when Turner exhibited this painting in 1840 the slavery issue was still very much alive. Parliament had abolished slavery in Great Britain in 1807 and slavery in British colonial territories had ended in 1838, following the passing of the Slavery Abolition Act in 1833, but the southern states of the USA and the overseas possessions

of other colonial powers still traded in slaves and relied on their labour for their economies. Thomas Buxton established the Society for the Extinction of the Slave Trade and the Civilisation of Africa in 1839, with Prince Albert as its honorary secretary, and organised the Anti-Slavery League Conference of 1840, which took place in Exeter Hall, in the Strand, a month after the Royal Academy exhibition opened.

Therefore Turner's painting was extremely topical, and its precise subject owes a great deal to current debates. The renewed impetus to rid the world of slavery saw the republication in 1839 of Thomas Clarkson's *History of the Abolition of the African Slave-Trade* (first published 1808), in which is related the story of the slave ship *Zong,* whose insurance stipulated that compensation would be paid out for slaves lost at sea but not for those dead from disease. In 1783, with his human cargo overcome by an epidemic, the master of the *Zong* pitched 132 dead and dying slaves overboard in a bid to capitalise on the terms of his policy. Recent events had shown, tragically, that contemporary slavers were equally callous, throwing slaves into the sea to escape the penalties administered by British ships patrolling the slave ports. (Under the terms of the 1807 Act, British captains were fined £100 for every slave found on board, so jettisoning the cargo was used as a tactic to reduce the financial penalty.)[7]

Turner's title and attendant verses fuse the various sources from which he was working to produce a compelling image of cruelty, which should have been as scandalous to a

68
Slavers Throwing Overboard the Dead and Dying – Typhon Coming on
1840
Oil on canvas
91 × 138
Museum of Fine Arts, Boston

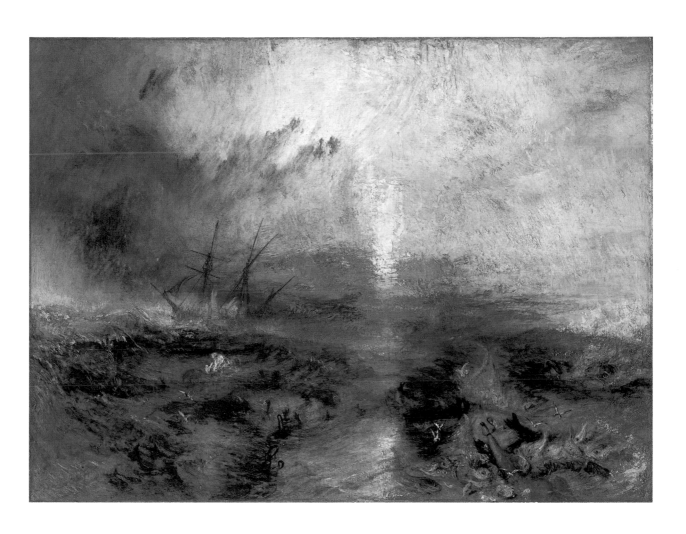

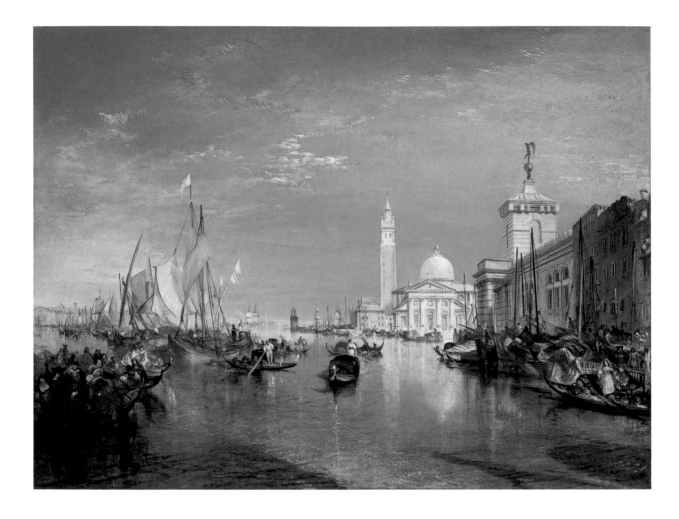

contemporary audience as images of war atrocities are to us. The full title, *Slavers Throwing Overboard the Dead and Dying – Typhon Coming on*, is accentuated by Turner's lines from *Fallacies of Hope*, which end with a bitter indictment of the immorality associated with human trafficking:

Aloft all hands, strike the top-masts and belay;
Yon angry setting sun and fierce-edged clouds
Declare the Typhon's coming.
Before it sweeps your decks, throw overboard
The dead and dying – ne'er heed their chains
Hope, Hope, fallacious Hope!
Where is thy market now?

However, the painting's reception was hostile to an extreme. The picture remained with Turner's dealer Thomas Griffith until the end of 1843, when Ruskin's father bought it for him. It inspired one of Ruskin's most celebrated descriptions of Turner's painting and he considered that the artist's entire reputation could be justified by this one work alone: 'I believe, if I were reduced to rest Turner's immortality upon any single work, I should choose this. Its daring conception, ideal in the highest sense of the word, is based on the purest truth.'[8]

The rise and fall of commercial empires

Other paintings of Turner's maturity explored aspects of trade and commerce, but without this sense of moral outrage. Turner paid his second visit to Venice in 1833 and shortly after his return painted *Venice (the Dogana and San Giorgio Maggiore)* (1834, fig.69) and *Keelmen*

69
Venice (the Dogana and San Giorgio Maggiore)
1834
Oil on canvas
91.5 × 121.9
National Gallery of Art, Washington, DC

Heaving in Coals by Night (1835, fig.70). The two paintings were first owned by Henry McConnel, who bought the first from the Royal Academy exhibition and commissioned the second as its pair. McConnel was a Manchester mill owner and industrialist who produced fine yarns for the luxury market throughout Europe. The mid-1830s were boom years for the cotton trade and McConnel used some of his profits to build up an outstanding collection of contemporary art. He is therefore a typical example of the kind of patron Turner attracted in the 1830s and 1840s, the beneficiary of new money stemming from Britain's industrial success. Contemporary commentators were in no doubt that, rightly directed, this new wealth could stimulate cultural change and needed to be understood and applauded as a new form of social achievement.

Venice may have had a proud tradition of wealth and culture, but in the middle of the nineteenth century its faded glories were no match for Britain's industrial might. Turner's paintings accentuate the difference. The Venetian scene is simply described by its title as a view of a place, whereas *Keelmen Heaving in Coals by Night* is a title that describes an activity rather than a location, which is, in fact, Shields on the River Tyne.[9] And indeed, the more we look at these two pictures the more obvious it is that they are offering quite distinctive experiences. In the picture of Venice the serene Adriatic light bathes the whole atmosphere in a warm glow. The shadows falling on the water indicate that the scene is set close to the middle of the day and there is an easy,

THE TURNER BOOK

languorous feeling to the image. The gondolas and cargo boats that fill the composition give a certain sense of picturesque bustle, the boats moored by the Dogana (Customs House) perhaps hint at the import-export side of Venice's economy, but overall this appears to be a place where pleasure rather than toil is the appeal. Under a serene sky the city goes about its business with no urgency or driving ambition to improve itself.

In *Keelmen Heaving in Coals by Night* everything is energetic. The silvery track of the full moon illuminates the left-hand side of the picture but it is challenged by the artificial light of the torches on the right, where workmen on the night shift busy themselves around the colliers moored at the bankside. Moreover, fully rigged ships move on the river, emphasising the point that industry never sleeps. In Venice the population seem to have been seduced by a life of *dolce far niente*, idling away their day in an increasingly frivolous city, isolated from the modernising tendencies of industrial Europe. Their picturesque attire, which could as well be historical as contemporary, suggests that the city is out of time. On the banks of the Tyne, in contrast, no matter that Newcastle or Shields have no artistic and architectural heritage that might compare with Venice, nor the compensation of a benign climate, the population understands what the modern age requires. They are part of the new industrial paradigm; they will work around the clock; their energy, their muscle, will secure Britain's economic vitality.

Having been an independent and powerful state for well over a millennium, Venice had declined rapidly in modern times and finally lost its independence to French revolutionary armies in 1797, when it capitulated to Napoleon. It was briefly run as a puppet regime under French control until being ceded to the Austrians under the Treaty of Campo Formio of October 1797. Thereafter it became something of a political pawn until 1814, when it was incorporated once more into the Austrian empire as one half of the Kingdom of Lombardy-Venetia. As one British resident noticed: 'Venice indeed appears to be at her last gasp, and if something is not done to relieve and support her, must soon be buried again in the marshes from which she originally sprang. Every trace of her former magnificence which still exists serves only to illustrate her present decay.'[10]

Here, then, we return to Turner's considerations of commerce, culture and the rise and fall of empires, explored seventeen years earlier in his *Decline of the Carthaginian Empire* (fig.52). The vitality of a state, even one as rich as Venice had once been, is no guarantee against corruption.

Turner made a final trip to Venice in 1840 and produced two further pictures which may also be understood as meditating on the city's decline. *Campo Santo, Venice* (fig.71) was exhibited in 1842 with a companion picture of *The Dogano* [sic], *San Giorgio, Citella, from the Steps of the Europa* (fig.72) and both were presumably intended to function as pendants. If so, the Campo Santo cemetery on the island of San Michele offers an association of death and decay to contrast with the former economic strength of Venice symbolised by the Customs

70
Keelmen Heaving in Coals by Night 1835
Oil on canvas
92.3 × 122.9
National Gallery of Art, Washington, DC

71
Campo Santo, Venice 1842
Oil on canvas
62.2 × 92.7
Toledo Museum of Art,
Ohio

72
The Dogano, San Giorgio,
Citella, from the Steps of
the Europa 1842
Oil on canvas
62 × 92.5
Tate

House. Two details help to reinforce this message: on the steps at bottom right of *The Dogano* can be seen luxury imported porcelain, tokens of an extensive trading network, whereas close attention to the foreground of *Campo Santo* reveals rotting vegetables floating in the water, hinting at the decay lying behind the cemetery walls. Turner's use of light works in subtle counterpoint to this theme. In *The Dogano* lengthening shadows suggest the coming of evening, the dusk gathering and the mist rising from the waters, as though Venice has already passed its zenith as a power. In *Campo Santo* the serene blue sky and radiant daylight that illuminates the cemetery is a good example of Turner withholding conventional symbolism, to have the presence of death figure as an ironic element within an ostensibly optimistic scene, just as the brilliantly illuminated sails of the craft in the middle distance, in their allusion to angels' wings, combine thoughts of death with light, not darkness.

Greek independence

Turner's interest in Mediterranean politics was at its most explicit from the 1810s to the early 1830s, when he produced a number of treatments in oil and watercolour alluding to the Greeks' struggle against Ottoman rule.[11] The two earliest are the pictures of *The Temple of Jupiter Panellenius* exhibited in 1816. The temple had been the subject of interest following the archaeological survey of the island of Aegina in 1811, which excavated the site, and Turner knew the architect

C.R. Cockerell (1788–1863) who led the investigation, later contributing a watercolour for the official account of the expedition. Although based on sketches by the amateur artist Henry Gally Knight, the oil paintings are not intended to be archaeologically precise and are better understood as motivated by Turner's interest in the Greek War of Independence.

One shows the temple restored to its original state, to emphasise the integrity of Greek civilisation before its present subjection to Turkish control. The other offers a complex meditation on the current situation of Greece. The intellectual resources Turner drew on to inform this painting of the Temple of Jupiter Panellenius help explain why Palgrave and others were so struck by his breadth of knowledge. The painting's full title is *View of the Temple of Jupiter Panellenius, in the Island of Aegina, with the Greek National Dance of the Romaika: the Acropolis of Athens in the Distance. Painted from a Sketch Taken by H. Gally Knight, Esq. in 1810* (1816, fig.73). The picture owes a debt to Byron's sympathy for the Greek cause as outlined in Canto II of *Childe Harold's Pilgrimage*, published in 1812, which had inspired Gally Knight to write the poem *Phrosyne: A Grecian Tale* in 1813, from which Turner took the idea of the dancing figures. In Knight's poem the dance provides 'one glimpse of ancient Greece and Liberty'. Moreover, in 1813 or 1814 Turner seems to have encountered F.S.N. Douglas's *Essay on Certain Points of Resemblance between the Ancient and Modern Greeks* (1813), which, among other things, compared the Romaika with an ancient Greek wedding dance.[12] Turner couples this

73
View of the Temple of Jupiter Panellenius, in the Island of Aegina, with the Greek National Dance of the Romaika: the Acropolis of Athens in the Distance. Painted from a Sketch Taken by H. Gally Knight, Esq. in 1810 1816
Oil on canvas
118.2 × 178.1
The Duke of Northumberland

with a view of the Acropolis, whose capricious presence here symbolises all that modern Greeks were striving to attain in their fight against oppression. The echoing of the past in the present is deployed not merely to prompt a sad reflection on Greece in its present situation but also to assert the reality of cultural survival and the possibility of Greek recovery.

Napoleon

Turner's treatment of Napoleon is complex, sometimes documenting the impact of his policies, sometimes offering a detached view of his actions and at others producing something closer to a critical comment, but this ambiguity mirrors British reactions to Napoleon's achievements, which ranged from hero-worship to utter hatred. In 1819, for example, Richard Whately published a pamphlet entitled *Historic Doubts Relative to Napoleon Bonaparte* 'proving' that Napoleon himself did not exist but was the product of a competitive discourse, an imaginary figure, a fabrication, embodying the political hopes and fears of his generation.[13] Whately's satire was effective precisely because the range of opinions surrounding Napoleon, his career and his impact on European life did so polarise British opinion.

Turner's first journey to the Alps, in 1802, took place when the impact of Napoleon's recent campaigns in the mountains was still tangible. He was also witness to the social and economic impact of the Napoleonic conflict on Britain. *St Mawes, Cornwall* (*c*.1823, fig.74), for example, produced for *Picturesque Views on the Southern Coast of England*, refers back to Turner's experiences in 1811, when he had witnessed the disruption to the Cornish pilchard fishery as a result of the blockade of the English Channel. Pilchards were a staple of the Cornish economy, caught in their millions, preserved and exported primarily to continental Europe. With that market now cut off, what was usually a major economic asset could only be sold at rock-bottom prices as manure and Turner shows the new catch being dumped on the beach for sale to farmers. Other watercolours depict the disruption of military preparations, recording the unavoidable presence of the army garrisoning the south coast. As an artist of liberal sympathies, insofar as we can judge from the evidence, Turner sided with those protesting at the loss of civil liberties occasioned by the state of emergency resulting from Napoleon's threatened invasion.[14]

In addition to these pictures documenting the repercussions of Napoleon's ambitions on the home front, Turner also produced oils, watercolours and engravings of military actions, most notably Trafalgar and Waterloo, but also other battles on land and sea. In addition he contributed the illustrations to Sir Walter Scott's *Life of Napoleon Buonaparte*, published in the mid-1830s. The total of Turner's works inspired by Napoleon's career is quite sizeable, amounting to some fifty images. In addition to about a dozen subjects exploring Napoleon's biography, there are some twenty watercolours exploring aspects of the social and economic impact of the Napoleonic wars on England, two oil paintings

74
*St Mawes, Cornwall c.*1823
Watercolour and
scraping-out
14.2 × 21.7
Yale Center for British Art,
Paul Mellon Collection

CCLXXX—146

THE TURNER BOOK

of Trafalgar, an oil, a watercolour and three engravings of Waterloo, and at least a dozen images of other battles and their aftermath.

In one of the watercolours Turner produced around 1827 to illustrate an edition of Samuel Rogers's poem *Italy*, he depicts Napoleon at *Marengo* (fig.75) in deliberate emulation of Jacques-Louis David's painting of Napoleon crossing the St Bernard Pass, a version of which he had seen in the artist's studio some twenty-five years earlier when he was in Paris in October 1802. In David's picture Napoleon is the embodiment of military prowess, courage and daring, and the crossing of the Alps links him firmly with two of the greatest commanders in history, Hannibal and Charlemagne, whose names are inscribed next to Napoleon's on a rock in the foreground. Turner, on the other hand, purges the image of these transhistorical associations and his inscriptions remind the viewer only of battles in Napoleon's Italian campaign: Lodi and Marengo. The French general, in Turner's interpretation, will be bound by his historical achievements rather than elevated above them.

Turner's most extended treatment of Napoleon, carried out some six years after *Marengo*, dates from the early 1830s, when he was commissioned to supply watercolour designs for an illustrated edition of Scott's *Life of Napoleon Buonaparte*. Scott had completed this monumental biography in 1827: over a million words spread across nine volumes, much of it based on first-hand research. As a Tory, Scott was not likely to treat Napoleon uncritically and his account stressed how his subject's ambition and egotism had led to his overthrow. Scott was prepared to pay tribute to Napoleon's bravery, his military genius, his legal reforms and administrative skill, his patriotism and even his humane temperament, but he was also at pains to document his ruthlessness and the brutal impact of his decisions. Although poorly received by the critics, the biography was a commercial success. Robert Cadell planned a new edition of all Scott's prose works in 1831 and commissioned Turner to provide forty illustrations as an inducement to attract sales: a frontispiece and a title-page vignette for each of the proposed twenty volumes. *The Life of Napoleon* was published in 1834–5, as the first nine volumes of the series, with sixteen designs by Turner and two others.

To prepare new sketches for this work, Turner explored sites associated with Napoleon when travelling in France in 1832. In a letter to Cadell he described at length the difficulties he encountered in tracking down all the locations he needed.[15] In the designs he produced on his return he took care to make these recently reconnoitred details tell and to enhance their effect where necessary. The vignette showing *Fontainebleau: The Departure of Napoleon* (1833, fig.76) links Napoleon's abdication in 1814 with the waning moon above him. Napoleon's isolated figure at the top of the steps receives the full benefit of this light, in contrast to his general staff grouped anonymously in the shadows. Given their refusal to follow him in an attack on Paris, he alone would have to make the necessary sacrifice to save France from the wrath of the

75
*Marengo c.*1827
Pencil, body-colour and
watercolour with pen
21.4 × 29.8 (vignette)
Tate

allied powers, by surrendering his authority. Napoleon's isolation is therefore caught at the moment it changes from that of the commander to that of the condemned man.

Turner seems to have rued the cost in bloodshed that Napoleon's ambition had made necessary. Sixteen years earlier, en route to the Rhine in 1817, he had visited Waterloo and wandered across the battlefield, drawing the terrain from a number of positions and covering seventeen pages of his sketchbook with drawings and diagrams. He was armed with one of the popular guidebooks to the site then available, and pencil notes on some of his sketches record, among other details, the horror of the encounter: 'hollow where the great carnage took place of the Cuirassiers by the Guards', '1500 killed here', '4000 killed here'.[16] In a watercolour of 1817, *The Field of Waterloo* (fig.77), and an oil painting of 1818 Turner took pains to reveal the human cost of military glory, concentrating not on Wellington's victory but on death, destruction and the futility of war. French and British troops, identified by their uniforms and insignia, are tumbled together in a heap of corpses. The tempestuous sky reflects the fury of the battle just ended. For all his avoidance of simple-minded patriotism, Turner does declare something about the nature of England's vanquished foe: this confused and bloody mayhem is where Napoleon's destiny has led Europe.

Napoleon in exile
Turner's painting *War. The Exile and the Rock Limpet* (1842, fig.78) is his most famous

meditation on Napoleon. The picture shows Napoleon musing on the visual similarity of a rock limpet's shell to a soldier's bivouac tent. The prisoner compares his own fate, his inability to leave the island of St Helena, with the limpet's fixity on its own rock, in its rightful place in its colony. Verses from *Fallacies of Hope* accompanied the picture's exhibition at the Royal Academy:

Ah! Thy tent-formed shell is like
A soldier's nightly bivouac, alone
Amidst a sea of blood –
 – but you can join your comrades.

The traditional association of red with blood and fire appears to have been deployed with a vengeance here. This painting was exhibited as a companion to another, *Peace. Burial at Sea* (1842, fig.79), Turner's tribute to the artist David Wilkie, buried at sea off Gibraltar on his way back from a sketching trip to the Holy Land. The pictures are almost the same size and both were originally framed octagonally. The pairing implies a comparison between two reputations and the means taken to achieve them. The tranquillity of the silvery light at Wilkie's end makes a forceful contrast with the spectacular sunset behind Napoleon. Turner is reported as intending the silhouetted sails to represent mourning, wishing he could have made them blacker still, so it seems reasonable to infer that the crimson behind Napoleon should also be understood in a connotative sense, to stand for blood.[17] Indeed, at bottom right of *War.*

76
Fontainebleau: The Departure of Napoleon
1833
Watercolour, pen and sepia ink
17.4 × 14.8 (vignette)
Indianapolis Museum of Art, Gift in memory of Dr and Mrs O. Pantzer, by their Children

77
The Field of Waterloo
*c.*1817
Watercolour
28.8 × 40.5
Syndics of the Fitzwilliam
Museum, Cambridge

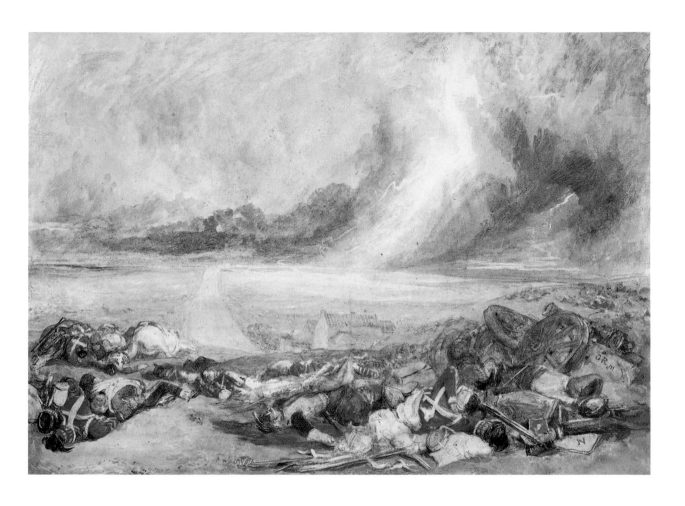

The Exile and the Rock Limpet a wooden object (possibly part of a sluice gate) is positioned in such a way as to represent a butcher's cleaver.

Napoleon himself, overlooked by a British sentry and the garrison's cannons, is shown subjected to the close regime of scrutiny of the governor, Sir Hudson Lowe, which required that Napoleon be always accompanied by an officer when moving about St Helena. At a time when many in England considered Napoleon to be the greatest of men, Turner portrays him as a prisoner, bereft of all the trappings of glory. His decision to exhibit in 1842 a painting which seems to present Napoleon as an unheroic bloodletting scourge should probably be understood as his contribution to the renewed discussion of Napoleon's achievement, following the removal of his body from St Helena and its ceremonial reception and interment at Les Invalides in Paris in December 1840.

Turner's acquaintances differed in their views of Napoleon. Samuel Rogers, for example, was part of the Holland House set, whose admiration for Napoleon would not accommodate demonising him.[18] Turner was on good terms with Rogers and had illustrated his poems. Equally, Turner's long-standing friendship with Walter Fawkes exposed him to extreme liberal thinking and in those pictures where his politics can be detected he evinced liberal sentiments. These factors suggest that Turner's liberal disposition could have encouraged a relatively benign view of Napoleon. Yet that very liberalism, shown in Turner's support

for Greek independence, religious toleration, electoral reform, the suppression of slavery and the defence of freedom of speech, may well have positioned him in opposition to Napoleon as the latter's imperial ambitions developed.

Moreover, around 1806 Turner had become friendly with his neighbour at Twickenham, Louis-Philippe, the eldest son of the Duc d'Orléans, who would accede to the French throne after the 1830 revolution as the so-called 'Citizen King'.[19] Louis-Philippe was no Bourbon absolutist, but his attempts to contain Bonapartism in the 1830s and his initial reluctance to see Napoleon's remains returned to France indicate that he was not persuaded by the Napoleon cult. In 1837 Louis-Philippe presented Turner with a gold snuff box as a testament to their friendship and had Turner to stay with him at Eu, in Normandy, in 1845. It is hard to imagine Turner's view of Napoleon being entirely unaffected by this personal connection with French politics.

The Battle of Trafalgar

The Napoleonic wars did result in Turner's only success with securing royal patronage, the commission he received from George IV in 1822 to paint *The Battle of Trafalgar* (1822–4, fig.80).[20] The picture was required to hang in St James's Palace as one of a series commemorating British victories on land and sea against the French. Turner had already exhibited two oils of the *Victory* in his own gallery, shortly after the battle, which took place on 21 October 1805: *The Battle of*

78
War. The Exile and the Rock Limpet 1842
Oil on canvas
79.5 × 79.5
Tate

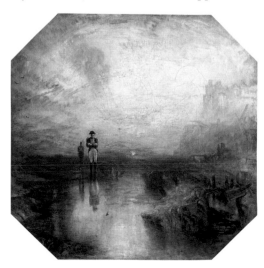

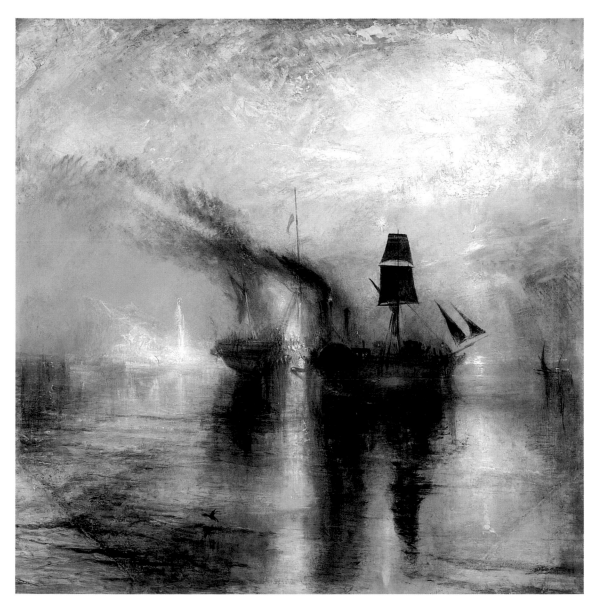

79
Peace. Burial at Sea 1842
Oil on canvas
87 × 86.5
Tate

Trafalgar, as Seen from the Mizen Starboard Shrouds of the Victory (1806, reworked 1808) and *The Victory Returning from Trafalgar* (1806). He boarded *Victory* as she entered the Medway on her return from Trafalgar, and made a number of detailed pencil studies of the ship, but his first version of the battle did not find a buyer. Given the importance of the new 1822 commission, Turner again went to considerable trouble to get the details right, asking the marine painter J.C. Schetky to provide him with sketches of some of the ships involved in the action.[21]

Turner's patriotic celebration focuses primarily on the *Victory*, with the French ship *Redoubtable* to the right flying a Union Jack to signify its capture. The sailors in the foreground raise their arms in triumph and the huge flag in the water seems to symbolise Britain's command of the seas as it covers the waves with this national emblem. The Spanish flagship *Santissima Trinidad* and the French flagship *Bucentaure* can be glimpsed behind the *Victory*, while to the left are shown the English *Temeraire* with the French ship *Achille* on fire. The clash of masts and spars between the *Victory* and the *Redoubtable*, with Nelson's personal flag as vice-admiral on the *Victory*'s foremast, is echoed by the transition from light to dark and stability to destruction; the *Victory* is like a rock on which French hopes have foundered. The flags flying from her spell out the last words of Nelson's famous signal, 'England expects that every man will do his duty', while his personal motto is inscribed in the water: '*Palmam qui meruit ferat*', or 'Let he who earned

it bear the palm [of victory].'

Despite Turner's incorporation of numerous changes to the ships' rigging and other details at the behest of some senior naval officers, the picture proved unpopular and was taken to task for its inaccurate portrayal of the battle, not least because Turner compressed time to show simultaneously events that in reality were separated by some hours. The painting did not suit George IV's taste and was removed from St James's Palace to the Naval Hospital at Greenwich in 1829. The debacle surrounding Turner's *Trafalgar* was perhaps inevitable: for all his willingness to incorporate detail he was not a documentary painter. His belief that painting should not be content with depiction of the immediately visible, but should combine experiences to produce works of art, could not be reconciled with the demands from his naval detractors for prosaic literalism.

Steam versus sail

The battle of Trafalgar was remembered on one further occasion in Turner's career. *The Fighting 'Temeraire', Tugged to her Last Berth to Be Broken up, 1838* (fig.81), exhibited in 1839, has become Turner's best-known painting and he himself referred to it as 'my Darling'. Yet the facts surrounding its production and his intentions for its meaning were for many years obscured by a number of misleading anecdotes and interpretations. It was variously stated that Turner was returning to London on the Margate steam packet and saw the *Temeraire* at sunset, or he was on a

80
The Battle of Trafalgar
1822–4
Oil on canvas
259 × 368.5
National Maritime
Museum, Greenwich

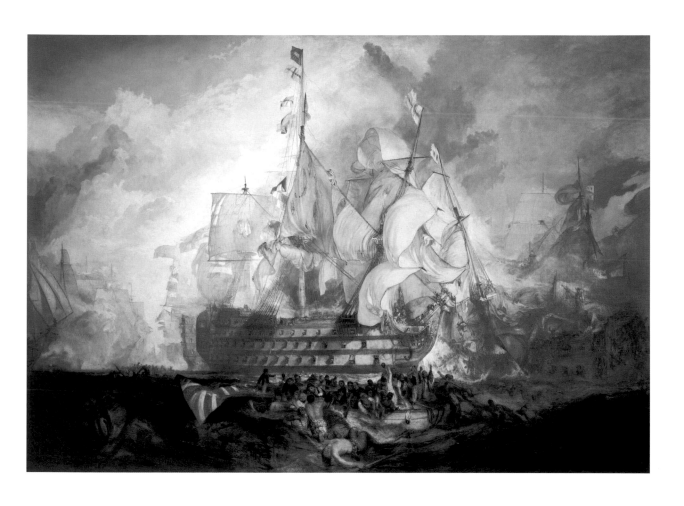

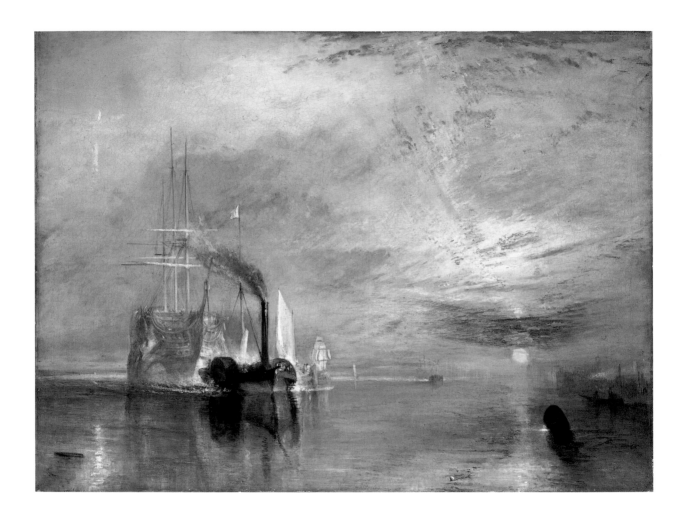

pier at Bermondsey as she passed by, or on the river bank at Greenwich, yet no sketchbook survives recording his reactions and recent scholarship has indicated that he may even have been abroad at the time.[22] Similarly, much debate has been occasioned about Turner's intentions here, whether the picture is a lament for a passing age and thus a pessimistic view of the future or is perhaps a more autobiographical reflection of change and decay from an artist in his mid-sixties.

The factual basis for the picture is, however, retrievable. The *Temeraire* had been built in 1798 as a second-rate ship of the line, carrying ninety-eight guns; she fought at Trafalgar and, as we have seen, is visible in the background of Turner's *The Battle of Trafalgar*. The ship had been used for various purposes following its decommissioning and ended up as a floating victualling depot at Sheerness, in the Thames estuary. From there it was towed upriver to Beatson's ship-breaking yard at Rotherhithe on 6 September 1838.

When Turner exhibited this picture he appended some lines from Thomas Campbell's poem 'Ye Mariners of England': 'The Flag which braved the battle and the breeze, No longer owns her.' These lines, together with the setting sun and the contrast between the steam tug and the warship, helped contemporary critics to grasp the symbolic implications of the painting as the old order gives way to the modern world. The picture was extravagantly praised, even by reviewers

normally prone to attack Turner, and many of them, then and subsequently, used it to offer nostalgic tributes to the age of sail and the patriotic associations of the *Temeraire* with Trafalgar. Turner's intentions are not clear, however. Certainly the picture is more than a simple documentary record. Although it is conceivable, given the southward looping of the Thames from Rotherhithe to Greenwich, that a setting sun could appear in what would seem to be the wrong quarter of the sky and therefore need have no symbolic meaning, the association of a setting sun with death or decline cannot be denied.

Similarly, Turner's deliberate error in placing the tug's funnel ahead of its mast, and his exaggeration of the smoke and fire pouring from it, suggest that he wanted to emphasise the power of the new technology. Indeed, the prominence of the funnel belching smoke might trigger associations with the *Temeraire*'s guns, as the destructive power of war gives way to the advances in engineering of the new age. Any attempt to decode the artist's intentions as nostalgic or optimistic about the transition to modernity is frustrated by Turner's approach to the subject, which provides no doctrinaire answers. What can be said is that Turner's record of his age was intended to bear witness, to record how things are, sometimes dispassionately, observing the workings of everyday life, sometimes with a palpable sense of indignation or anger at human folly. What he does not seem to have offered is any regret that history moves on.

81
The Fighting 'Temeraire',
Tugged to her Last Berth
to Be Broken up, 1838
1839
Oil on canvas
91 × 122
National Gallery, London

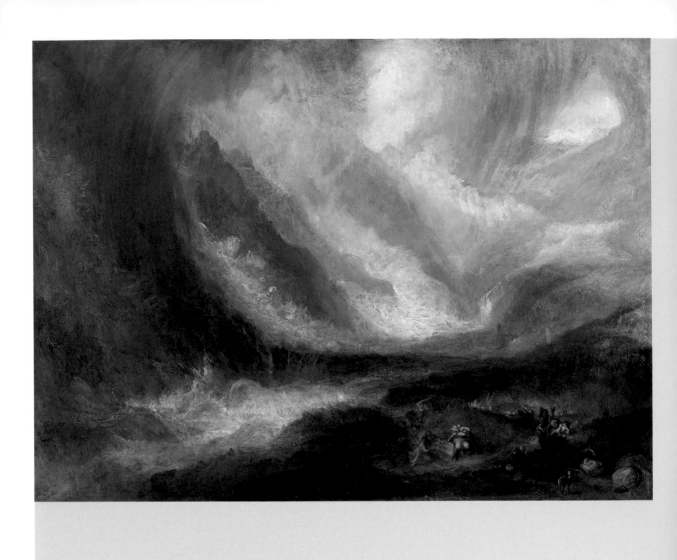

THE TURNER BOOK

Snow-storm, Avalanche and Inundation – A Scene in the Upper Part of Val d'Aouste, Piedmont

Turner had a rich and varied circle of acquaintances, not just in the worlds of art and architecture but also in the sciences. He was a founder member of the Athenaeum Club, established in 1824 for 'Literary and Scientific men and followers of the Fine Arts', and visited the club regularly, especially in the 1840s. His scientific acquaintances were wide-ranging, including Michael Faraday and Mary Somerville, with whom he discussed magnetism, and Sir David Brewster, whose research on optics was of obvious interest to Turner.[23] His manifold curiosity allowed him to invest seemingly straightforward depictions of nature with understandings gained from new research in the natural sciences.

On its exhibition this picture was derided by the critic of the *Art Union*, who declared that it 'would be equally effective, equally pleasing, and equally comprehensible if turned upside down',[24] but Turner has, in effect, returned to the same territory he explored in 1812 with *Hannibal* (fig.40), depicting the destructive power of nature in the Alps. The snow storm that beat down so viciously on the Carthaginian army here returns in a landscape that shows at once how Turner has lightened his palette over the intervening twenty-five years. Indeed, there is a striking contrast between the relatively serene golden light of the middle and background and the dark heart of the blizzard. The combination of a snow storm with its immediate effects of avalanche and flood dwarfs the puny inhabitants at bottom right who try to flee from this awful cataclysm. The storm clouds rear up, ripped and tattered by the wind, to hover over a pitiful humanity like scorpions' tails.

The very excess of the atmospheric effects, especially the powerful vortex spiralling into depth, the fury of the avalanche in the background and the raging torrents in the foreground, seems of a piece with those extravagant landscapes of overwhelming destruction painted by Francis Danby (1793–1861) and John Martin in the 1820s and 1830s (fig.83). Yet, whereas Danby and Martin exaggerated scale, providing an experience akin to the popular panorama displays of the day, and tended to heighten cataclysmic events to the point almost of caricature, Turner's avalanche and flood, for all their excess, are firmly rooted in the observation of nature. What he presents may be vastly exaggerated, but it is physically conceivable. This is no scene of divine judgement, but a response to the actual forces at work in the material world.

Turner's knowledge of geological change may well have prompted his approach here. He was aware of the work of the writer Granville Penn, who had studied Alpine rocks for clues about the biblical flood, and it is conceivable that he was also aware of opposing theories, such as those expounded by Charles Lyell in his extremely influential *Principles of Geology* (1830–3), in which it is demonstrated that observable processes in nature are sufficient explanation for the geological record.[25] If so, Turner's image of the operation of natural forces in the Alps can be understood as presenting a Lyellian and scientific view, as opposed to the divine agency invoked by Martin and Danby in their explorations of cataclysmic change.

83
John Martin
The Deluge 1834
Oil on canvas
167.6 × 259.1
Yale Center for British Art,
Paul Mellon Collection

82
Snow-storm, Avalanche and Inundation – A Scene in the Upper Part of Val d'Aouste, Piedmont 1837
Oil on canvas
91.5 × 122.5
The Art Institute of Chicago

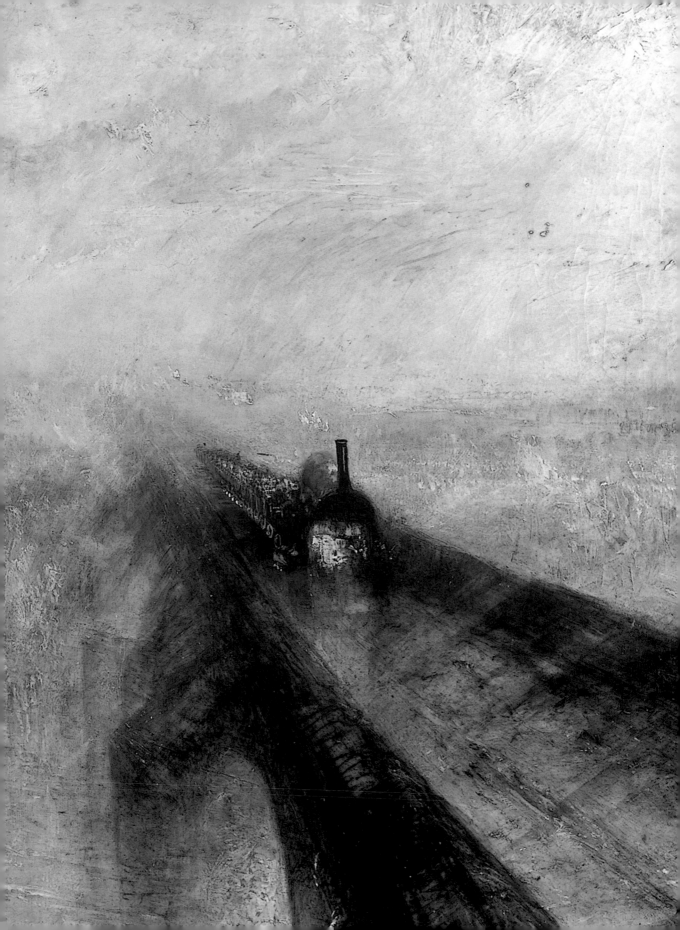

When Turner died in 1851 the art world we associate with Victorian Britain was reaching its early maturity, but certain features of that world were already clearly defined: genre painting had developed from the sorts of subject tackled by Wilkie to range over literary subjects, the animal kingdom and the world of fairies, to become one of the mainstays of Victorian art, often mawkish and sentimental but occasionally moving beyond the anecdotal to make social observations too. Landscape painting included not only the taste for giganticism associated with John Martin and Francis Danby but also a relish for generic pictures of rural pursuits and unassuming representations of picturesque countryside. The Pre-Raphaelite Brotherhood's obsessive naturalism and commitment to accuracy was, in part, a reaction to a perceived loss of integrity in British art as genre painting and landscape became increasingly routine products for an undemanding market.

Yet, despite Ruskin's belief that Turner and the Pre-Raphaelites shared common ground in their refusal to compromise and in the ethical seriousness of that position, Turner's impact on artists of the later nineteenth century was indirect. In British art of the decades following his death, from the Pre-Raphaelites and their followers to later painters such as William Waterhouse, George Frederic Watts, Lord Leighton, Albert Moore and Lawrence Alma-Tadema, it tends to be figural subjects rather than landscape that predominate as examples of its most serious achievements. This is not to suggest that the place for landscape painting had diminished, for it remained extremely popular, nor that it had become inescapably trivial, for some painters were clearly capable of serious work in that genre; but it is to propose that the inclusive nature of landscape, as Turner had understood it, was no longer appropriate in Victorian Britain.

Turner's will

Although he was the most respected landscape painter in England, Turner never received a knighthood, unlike many of his artistic colleagues.[1] Moreover, he received no patronage from Queen Victoria and Prince Albert, despite producing work associated with Albert's interests.[2] He had, however, amassed a considerable fortune from his profession and intended to use it, not only to establish a charity for male artists who had fallen on hard times but also to ensure lasting recognition for his achievement. Turner's intentions regarding his posterity were expressed in his will, which he first drew up in 1829, replacing it with another in 1831, which was itself amended in five codicils added between 1831 and 1849. Unfortunately, these attempts at clarification and revision only made his intentions more opaque. The will was contested by his relatives and the attempted bequest was entangled in legal arguments which required a court settlement to resolve; to this day the debate continues about what he really intended. Nevertheless, with respect to his artistic legacy it is clear that he valued the idea of his works being kept together for the benefit of the public. One

6 Turner's Place in Art History

codicil talks of the idea of showing his work in a schedule of rotating exhibitions, including the occasional exhibition of unfinished work, another mentions only finished pictures, and it is not at all clear whether Turner expected the mass of works on paper to be included in the bequest or not.

Amid all this uncertainty can be found Turner's desire that his works would be displayed in 'Turner's Gallery'. In the event, the National Gallery took possession of the Turner Bequest, including 100 finished oil paintings, 182 unfinished and some 19,000 works on paper. The bequest was first sorted by Ruskin, who had been Turner's ablest champion since 1836 and whose writings on Turner in *Modern Painters* (1843–60) and elsewhere dominated the artist's posthumous reputation. Ruskin was acutely aware that Turner's achievement needed to be properly displayed if his assessment of the work was to be shared.

However, the sheer size of the Turner Bequest caused a major problem for any art institution in Victorian Britain. Artists and members of the public who wished to see Turner's work in the years after his death would have viewed it in less than ideal conditions, whether at the National Gallery and its annex, Marlborough House, or in the South Kensington Museum (now the Victoria and Albert Museum) or the British Museum. The opening of the Tate Gallery (now Tate Britain) in 1897 offered a solution and in 1910 a new suite of galleries, financed by Joseph Duveen, was added to the original structure as a purpose-built home for most of the Turner Bequest. This was itself superseded by the Clore Gallery at Tate Britain, which opened in 1987. As we shall see, the way Turner's work was displayed at the Tate is indicative of his changing critical fortunes.

Turner's followers

No school formed around Turner, perhaps because his virtuosity made emulation a perilous business. Those whose work betrayed their admiration, such as James Baker Pyne (1800–70), ran the risk of losing their own individuality in pastiche approximations of Turner's work. In watercolour, technical expertise approaching Turner's and influenced by his example can be found in the work of three British artists in particular: Alfred William Hunt (1830–96), Albert Goodwin (1845–1932) and Hercules Brabazon Brabazon (1821–1906). No important English oil painter can be said to have followed Turner, with the exception of Philip Wilson Steer (1860–1942), who moved away from the influence of French Impressionism to a closer affinity with the English school, especially Turner and Constable, in the early 1890s.[3] Abroad, probably the most direct influence can be found in the work of the French landscape painter Félix Ziem (1821–1911), whose pictures of Venice are often compared to Turner's.

Other artists responded to Turner's achievement by translating it into their own terms. This was especially true in America, with the development of landscape painting in the nineteenth century.[4] Thomas Cole (1801–48) visited Turner's gallery in 1829 when

touring England and scholars have noted the debt his famous cycle *The Course of Empire* (1833–6, fig.84) owes to Turner's treatment in the 1810s of the rise and decline of the Carthaginian empire. A significant number of the artists who followed Cole in the development of the Hudson River School and other tendencies in American landscape were influenced by Turner's example, among them Jasper Francis Cropsey (1823–1900), Frederick Edwin Church (1826–1900) and Thomas Moran (1837–1926) (fig.85).

It is not so much stylistic affinities that one finds here, but rather an attitude of mind, using Turner's achievement as inspiration not just for an approach to the American landscape but also for the dignity of landscape painting itself. Cropsey, for example, wrote in 1858 of the intellectual depths of Turner's art having the power to 'abstract the mind' because of its philosophical and emotional range.[5] Church studied engravings after Turner in the 1850s, perhaps finding inspiration in them for his explorations of panoramic views structured by light, and he had his work explicitly compared to Turner's when exhibiting in London in 1859.[6] Moran studied works by Turner when first visiting England in 1862, made copies after his oils and watercolours and owed a profound debt to his example in his career as a landscape painter, not only adopting a version of the Turnerian sublime for the American wilderness but also, late in his career, emulating Turner's example in his pictures of Venice.[7]

Turner's impact on Australian art was late in coming and was less widespread, but on

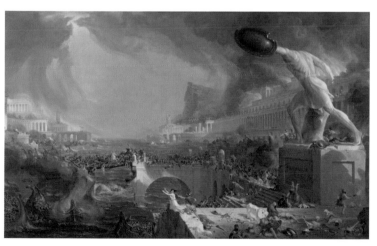

84
Thomas Cole
The Course of Empire: Destruction 1836
Oil on canvas
84.5 × 160.6
The New York Historical Society

travelling to England at the beginning of the twentieth century, two members of the Heidelberg School of landscape, Arthur Streeton (1867–1943) and Frederick McCubbin (1855–1917), were also inspired by Turner and altered their styles under his influence. Having hitherto only known Turner's work through black and white engravings, McCubbin described the impact of seeing actual canvases in the Tate Gallery in 1907 in ecstatic terms: 'they are mostly unfinished but they are divine – such dreams of colour – a dozen of them are like pearls – no theatrical effect but mist and cloud and sea and land drenched in light – there is no other master like him.'[8]

Critical responses in England and France

McCubbin's reactions were not isolated, for many found Turner's later work, especially his unfinished canvases, the most intriguing. The free handling and gestural vigour of these unfinished paintings had, of course, been unknown during his lifetime and came to light only as the Turner Bequest was cleaned and put on display. The first exposure of relatively unfinished work occurred in 1857, when some examples of almost completed work were exhibited at Marlborough House. A French critic then in London was surprised to note that the public preferred these canvases and that they saw them as properly expressive of the artist's intentions, despite their obviously unfinished state.[9] By the 1890s Turner's incomplete canvases had become relatively popular and their exposure helped pave the way for the exposure of more radically unfinished work, which was responded to with great enthusiasm when displayed at the Tate Gallery in the early 1900s.

Waves Breaking against the Wind (c.1835, fig.86) is unfinished and is one of a number of similar studies depicting the action of waves, probably observed at Margate, whose harbour wall and lighthouse can perhaps be discerned in the background. What made paintings like this especially attractive was their seeming modernity; the lack of finish that Turner's contemporaries would have reprobated looked increasingly attractive at a time when the Impressionists and artists such as Whistler and Steer were investigating light, colour and vision and altering their handling to a freer style.

Morning after the Wreck (c.1835–40, fig.87) is a good example of the way in which some of Turner's work appealed to a modern sensibility increasingly accustomed to French painting. It was bought in 1910 by Gwendoline Davies, who with her sister Margaret had inherited money from their grandfather and began collecting modern European art in 1908. Turner, Corot and Millet were their first enthusiasms and even when their taste moved on chronologically to include work by the Impressionists and Post-Impressionists, the Turners in their collection could be regarded as participating in the same aesthetic. Indeed, the sisters spent more money on Turner than on any other artist, buying eight oils and twelve works on paper between 1908 and 1926. All of these oils were products of Turner's old

85
Thomas Moran
Fiercely the Red Sun Descending Burned his Way across the Heavens
1875–6
Oil on canvas
84.5 × 160.6
The North Carolina Museum of Art, purchased with funds from the North Carolina Art Society, Robert E. Phifer Bequest

86
Waves Breaking against
the Wind c.1835
Oil on canvas
58.5 × 89
Tate

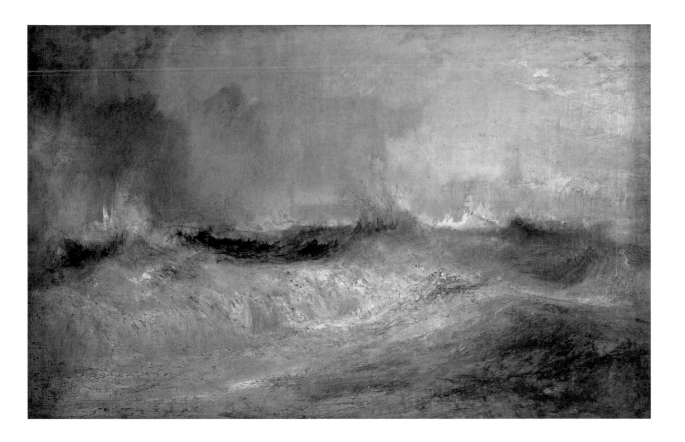

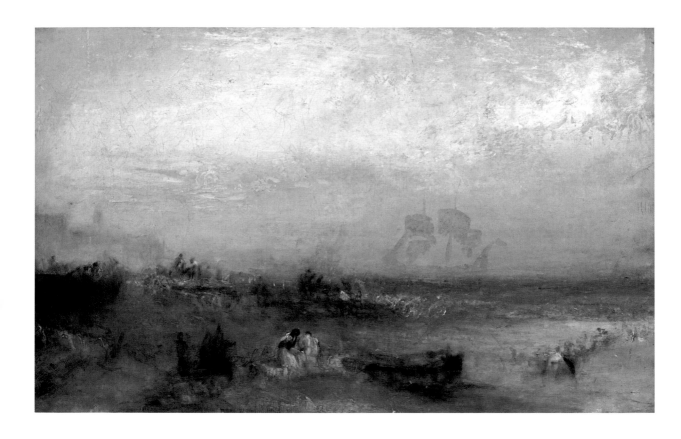

age, c.1835–45, and were unfinished. Their reduction of pictorial meaning to abbreviated marks and a concentration on form and colour could be easily understood as a congenial preamble to the Davies sisters' interest in French painting of the second half of the nineteenth century.[10]

Yet appreciation of Turner in France itself was slow to form. One of the earliest appraisals of his work published in France, Ernest Chesneau's *L'Art et les artistes modernes en France et en Angleterre* (1864), offered a rather cool reaction. Chesneau saw Turner's early development, up to about 1815, as creditable, but found that after the 1820s his promise had been vitiated by extravagance. The desire to capture light and produce a general pictorial effect had distanced Turner from reality, for he was painting out of his own imaginative resources what his eyes had long ceased to observe properly. His bad figure drawing was the first casualty of this flight from observation; his tendency to succumb to meretricious effect when his genius didn't support him was the other.

Twenty years later Chesneau's account of British artists was extended and published in English, with a preface by Ruskin. The book was evidently popular, running to a third edition by 1887.[11] Despite the passage of time between the French and English versions, Chesneau's judgement on Turner remained effectively unaltered, namely that his promise as a naturalist painter was overwhelmed by his need to seek after pictorial effects. By the 1880s much had changed in French art and Chesneau, who had previously seen no

connection between Turner and French art, now saw links between his art and that of the Symbolist Gustave Moreau. According to Edmond de Goncourt, Moreau did indeed become an admirer when he saw the Turners in Camille Groult's collection in Paris in 1891.[12]

Responses from French artists

Today the affinity between Turner and the Impressionists is often taken for granted but, in fact, it is a highly complex relationship which says as much about those promoting it as it does about Turner's art. One of the most important points to bear in mind is that, without travelling to England, it would have been extremely difficult to gain any profound understanding of his art. Although engravings after Turner's work circulated widely, few French artists would have known of his achievement at first hand. Monet and Pissarro, however, were in London in 1870 during the Franco-Prussian war and had the opportunity to study the Turners on display. Their experience of his art suggested to them that he had arrived independently at similar, if not identical, conclusions to their own regarding the importance of light and colour.

Thus, when Félix Bracquemond exhibited an unfinished etching of *Rain, Steam and Speed* (fig.88) at the first Impressionist Exhibition in 1874 it was something of a tribute to Turner's pioneering efforts in advancing the cause of contemporary art. Similarly, when angling for an exhibition in London's Grosvenor Gallery in 1885, Renoir, Monet

87
Morning after the Wreck
c.1835–40
Oil on canvas
38 × 61
National Museum of
Wales, Cardiff

and Pissarro wrote to the director to claim that they had, as it were, inherited Turner's dedication to the study of light and also his refusal to be cowed by convention. Their enthusiasm was genuine, as can be seen from Pissarro's advice to his son, Lucien, in the 1880s: 'You have been to the National Gallery, you have seen the Turners, yet you don't mention them. Can it be that the famous painting, The Railway, The Burial of the Painter Wilkie, the astonishing Seascape, at the Kensington Museum, the View of Saint Mark in Venice, the little sketches touched with water-colours of fish and fishing equipment, etc., did not impress you?'[13] Pissarro also advised the young Matisse, on honeymoon in London in 1898, to study Turner. Although Turner had no discernible influence on Matisse's development, Matisse saw similarities between Turner's watercolours and Monet's paintings, insofar as both were constructed with colour, and he in turn advised André Derain to look at the Turners when he was in London in 1906. Derain's letters from London to his fellow Fauves Matisse and Vlaminck show that he was studying Turner with some assiduity.[14]

Matisse's mentor, Paul Signac, had also visited London in 1898 to examine Turner's work and in the same year he published *D'Eugène Delacroix au néo-impressionisme* in *La Revue Blanche*. Taking Ruskin as his authority for Turner's use of broken colour, Signac attempted to demonstrate how Turner's development anticipated the discoveries of Seurat and his followers. Signac's technical interest in Turner's application of colour was echoed in other, more general responses. Robert de la Sizeranne, in *La Peinture anglaise contemporaine* (1894), saw Turner as a great intuitive artist, open to sensation and with a feeling for colour and form, but closed to everything else. Echoing but exaggerating Chesneau's conclusion, but now with a positive evaluation of Turner's seeming flight from reality, he declared that Turner belonged as much to one region of the earth as a comet belongs to one region of the sky.[15] Besides these effusions, however, a more determinate claim was made, that Turner had anticipated Pointillism.[16] By the late 1890s, then, some advocates of Turner's art were able to argue that his example had anticipated all three of the major developments in painting of the time: Symbolism, Impressionism and Pointillism.

Pissarro's understanding of the importance of English art was relayed in an English journal, *The Artist*, in 1892: 'It seems to me that we are descended from the English Turner. He was perhaps the first to make his colours shine with natural brilliancy. There is much for us to learn in the English School.'[17] The English painter and critic Wynford Dewhurst was also prepared to make a strong case. Dewhurst was a landscape painter who had trained in Paris in the 1890s and whose mature work employed a style that owed a lot to Monet's work of the 1880s.[18] He contacted Pissarro in 1902 for corroboration of the argument that Turner anticipated Impressionism, but Pissarro's reply was equivocal: 'The water-colours and paintings of Turner and Constable, the canvases of Old

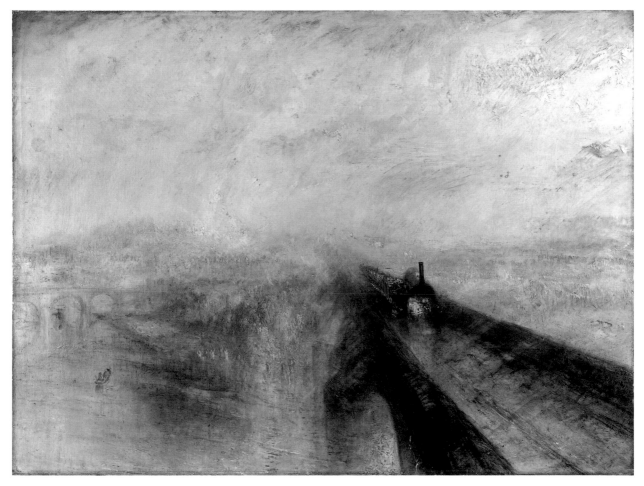

88
Rain, Steam and Speed –
The Great Western Railway
1844
Oil on canvas
91 × 122
National Gallery, London

Crome, have certainly had influence upon us. We admired Gainsborough, Lawrence, Reynolds, &c. but we were struck chiefly by the landscape-painters, who shared more in our aim with regard to "plein air," light and fugitive effects.'[19]

Dewhurst, understandably, took this as confirmation of his opinion and in the summer of 1903 he published his thesis in the art journal the *Studio*, that the origins of Impressionism lay in the British landscape tradition of the early nineteenth century: Constable, the Norwich School, Bonington and Turner.

Pissarro, however, was clearly irritated by Dewhurst's views; as Dewhurst was preparing his first article for publication, Pissarro's real opinions were forcibly expressed to his son, Lucien. He objected to the idea that Turner's example had introduced himself and Monet to the painting of light and insisted that

Turner and Constable, while they taught us something, showed us in their works that they had no conception of the *analysis of shadow*, which in Turner's painting is simply used as an effect, a mere absence of light. As far as tone division is concerned, Turner proved the value of this as a method, among methods, although he did not apply it correctly and naturally[20]

Pissarro wrote at some length to Dewhurst to attempt to clarify what he regarded as Dewhurst's travesty of the relations between Turner and the Impressionists, but Dewhurst was not dissuaded from his argument; in 1904 he published his ideas in *Impressionist Painting:*

Its Genesis and Development, dedicated to Monet.[21]

Monet, however, was also growing lukewarm about Turner's importance for Impressionism and was keen to indicate the differences between his conception of art and Turner's. Speaking to Georges Bernheim and René Gimpel in 1918, he pointed out that he had indeed studied Turner's work with some care but was now less enthusiastic than he had been: 'at one time I greatly admired Turner; today I care less for him, he didn't shape his colours sufficiently, and he put on too much.'[22] There is no doubt that Turner's understanding of colour and his manipulation of pigments to achieve new colour harmonies did produce in some paintings colouristic effects that share some of the concerns of the Impressionists. This would have been particularly observable in the later finished and unfinished watercolours, as well as in some of the oil paintings. Even so, Pissarro and Monet's reservations about Turner's technique stand forth clearly, and it is more likely that what they learned in 1870, and what others after them learned, was more in the way of a confirmation of their direction than a strong influence on their practice.

The idea that Turner was the godfather of the Impressionists was immune from these kinds of reservations, however. Whereas in 1894 Robert de la Sizeranne had merely suggested that Turner promoted tendencies leading towards neo-Impressionsim, in an essay of 1903 he quite emphatically made Turner into the inspiration for all recent French painting. Turner becomes the *fons et origo* of everything that the most advanced art has accomplished: 'All the torches which have shed a flood of new

light on Art – that of Delacroix in 1825, those of the Impressionists in 1870 – have in turn been lit at his flame.'[23] This was a bold claim that warranted further discussion, especially as regards the technical innovations that had brought painting to the point at which de la Sizeranne was writing. Taking his cue from Signac and Dewhurst, de la Sizeranne launched into an extensive recitation of Turner's modern credentials:

Turner was the first of the Impressionists, and after a lapse of eighty years he remains the greatest, at least in the styles he has treated. Turner is the father of the Impressionists. Their discoveries are his. He first saw that Nature is composed in a like degree of colours and of lines, and, in his evolution, the rigid and settled lines of his early method gradually melt away and vanish in the colours. Turner's next discovery was that shade is a colour like the rest, and that it is not necessary to represent it by a sombre rendering of the tone. Perceiving that Nature could produce light, without having recourse to sombre contrasts, he, imitating her, sought to dispense with them. He evolved from the luminous effects by contrast, that is to say from opposing black to white, to the effect by *duplication, i.e.*, by coloured opposings. Of each shade he made a quick colour which he brought out more strongly by contrast. He conceived the idea of laying it on in its entire purity, by imperceptible dots or lines, dividing the same tone into an infinity of diversations juxtaposed with so great a skill that, however glaring they may be when viewed at close range, blend in perfect harmony on being looked at from a certain distance. 'Tis the division of colour, and the optical blending.

Here we have, not only prophesied, but applied, the three discoveries of Impressionism: Nature, rather colour than lines; shades themselves, colours; colour expressed by the division of tone. Thus does Turner, emanating from Claude, become the founder of Impressionism.[24]

Such a statement is different only in its extremity from what was becoming a critical orthodoxy in some quarters. Lewis Hind's full-length study of Turner, published in 1910, is equally emphatic about the artist's modernity and his contribution to the foundations of Impressionism, singling out *Rain, Steam and Speed* (fig.88), 'that masterpiece in Impressionism', as the epitome of his links with the modern French school: 'Has Claude Monet, who acknowledged the impulse he received from studying Turner in 1870, ever visualised movement, light and atmosphere in one impression, as did this wonderful Turner in his seventieth year?'[25] Hind also cites one of the Petworth interiors as an 'astonishing foreshadowing of Impressionism' and *Interior at Petworth* (*c*.1837, fig.89) is a good example of the kind of painting regularly used to advocate Turner's stylistic affinity with Impressionism. The title and date are conventional, for the identity of this location, if indeed based on a real building, remains uncertain and an alternative suggestion has been made that it should be called *Study for the Sack of a Great House* and dated to *c*.1830.[26]

The pictorial cues show that this is the

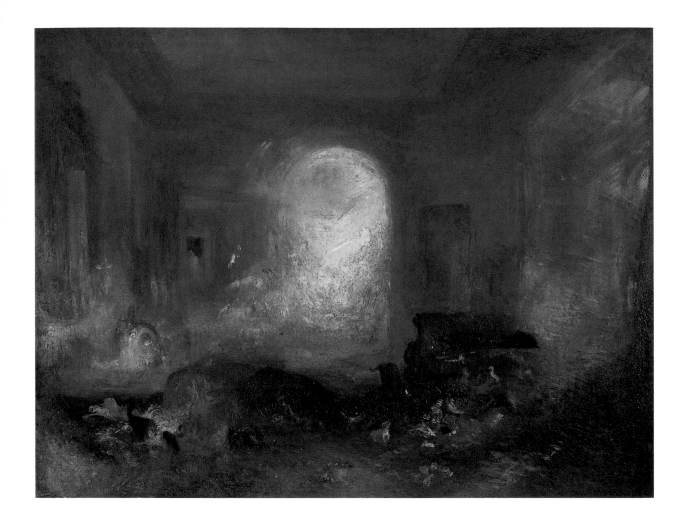

interior of an imposing building with portraits on the walls and a collection of sculpture, an elaborate mirror over a fireplace and luxurious fittings. The chaos of the foreground, with its often indecipherable details, suggests at the very least a disturbance in the customary round of activities one might associate with such a space. The difficulty of interpretation, the sense in which technique seems to assert its priority over subject matter, caused some critics to use this painting and other works of the later 1830s and 1840s to demonstrate Turner's anticipation of Impressionism. But that understanding of Impressionism, regarding it as essentially the dominance of formal qualities over subject matter, is no longer orthodox. Nor indeed is such an understanding an orthodox reaction to Turner. Now, whether looking at Monet or Turner, our reading of the image is concerned to pay equal attention to both the means and the object of representation. In Turner's case, we do not consider his subject matter incidental or irrelevant, or as an unfortunate distraction from the 'real' meaning of his art. We have, in short, moved away from the Modernist emphasis on formal development. If Turner anticipates Impressionism the argument for it needs better grounds than this.

In fact, even on a formal level there is much to separate Turner's pictures from later nineteenth-century work. His whole approach to art was different, for he rarely painted *en plein air* and, even when he did so, he used such activity merely as preparatory work for finished compositions. Unfinished pictures, left in his studio on his death, were likewise in arrested development, showing only the lay-in of colour that underpinned all his finished work. Yet, in the wake of Impressionism, such paintings had an immediacy that Turner's considered exhibition pieces could not exhibit; oil studies and unfinished canvases began to take on an importance that he would not have condoned.

The ample space for exhibition in the new Duveen wing at the Tate meant that unfinished work was on almost permanent display from 1910. Compared with the poor state of repair of many of Turner's finished canvases, the victims of his experimental technique and also the slovenly conditions in which they had been kept towards the end of his life, these studies and lay-ins would have looked fresh indeed. In addition, because they had never been exhibited they had not been covered with a varnish that was prone to discoloration and darkening. Many of them would also have displayed qualities of handling that were closer to modern application, lacking the superimposed layers of glazes that distinguish Turner's technique.

Turner and modern art

Small wonder, then, that when in 1926 the Tate added another suite of galleries beyond the Turner wing, for the Modern and Foreign collections, Turner's work was positioned as a bridge between British art and European Modernism. The Turner Bequest now sat as an offshoot of the chronological sequence of

89
Interior at Petworth
(alternatively known as
*Study for the Sack of a
Great House*) *c.*1830–7
Oil on canvas
91 × 122
Tate

rooms showing the development of British art and was reached after the Pre-Raphaelites, as though Turner's paintings, uniquely, could be shown independently of the work of his contemporaries. Turner's institutional positioning as an honorary modern artist was underlined in 1928 when the Trustees of the Tate Gallery removed the original wall-covering from the last room in the Turner wing, the room where his unfinished oils and sketches were displayed and from which visitors entered the Modern and Foreign collections. In place of the red brocade that had served as the backdrop for this work since 1910 was the same fawn fabric as was used for the Impressionist pictures hanging in the adjoining gallery, to provide a satisfactory background for the later Turner oil sketches and, most memorably, to give 'continuity of effect' with the Impressionist galleries beyond.[27]

At one level, this was no more than a decision about interior décor, but in the context of Turner's presumed affiliation with Impressionism and Post-Impressionism the historical development from Turner oil sketches to Impressionist painting was made all the more convincing by the replication of the same decorative surroundings for each of them. As one stepped from a room hung in sumptuous red damask, displaying Turner's more 'conventional' paintings, into a room clothed in an appropriately 'modern' fabric, showing his unfinished works, one would have passed from the world of the old masters into the world of modern art. The belief in Turner's historical foreshadowing of French painting of the late nineteenth century was now incarnated in the Tate's displays.

Turner and abstract art

As new art movements emerged in the twentieth century, the appraisal of Turner shifted again. His presumed link with abstract artists was, in retrospect, a development from the position of those who had attempted to find anticipations of Symbolism in his art. Alongside Paul Signac and Robert de la Sizeranne, Joris-Karl Huysmans and Paul Gauguin had also recruited Turner as a precursor to the art of the 1890s. Huysmans and Gauguin celebrated what they considered to be the indistinctness of Turner's style because in it they found the opportunity either, in Huysmans' case, to expatiate on the imaginative freedom of Turner's formlessness or, in Gauguin's, to debate whether or not Turner was attempting to let his colour work 'musically', independent of his subject matter. Certainly, as regards the unfinished work in oils, more of which was discovered at the beginning of the Second World War, it was tempting to talk of Turner's 'chromatic symphonies', as though he had shared the same impetus as had propelled Kandinsky and others towards abstraction in the 1910s and afterwards.

The idea that Turner's maturity might have seen him preoccupied with colour harmony and other formal values, to the neglect of subject matter, makes a curious parallel to the idea of Turner the Impressionist. In both cases, one suspects, a certain amount of national pride was involved: Turner's example could

be used to show that British art, was not, in fact, behind contemporary taste but had already anticipated it.

In recognition of this relationship, the organisation of Turner's work at the Tate in the 1960s included one experiment with the 'white cube' surroundings deemed appropriate for modern art. The most spectacular assertion of Turner's modernity, however, occurred not in London but in New York, at the Museum of Modern Art in 1966. The British artist, curator and critic Lawrence Gowing persuaded MoMA that a show devoted to an artist born in 1775 was an appropriate endeavour for an institution whose whole *raison d'être* was predicated on exhibiting the most advanced modern art and design. The exhibition *Turner: Imagination and Reality* comprised 99 paintings and watercolours, the vast majority of them dating from after 1828 and many of them unfinished. Gowing's exhibition was provocative; it suggested that Turner's art could be approached with the same Modernist sensibility that dominated understanding of twentieth-century art. The concentration on colour structures, sketches and lay-ins produced a mesmerising effect whose cumulative result was to suggest strong affinities with the work of some of the Abstract Expressionists.

The modern sublime

It is clear that some American artists of the 1940s and after were investigating the notion of the Sublime, as outlined by Burke two hundred years earlier, and saw in romantic art possibilities for the expression of thought and feeling that more recent developments had ignored. Turner was one of the few artists for whom Clyfford Still expressed admiration.[28] Still's artistic personality, his uncompromising seriousness and the draconian conditions of his will, that his work be kept together and shown on its own, are reminiscent of Turner's example. Jackson Pollock, at the outset of his career, also seems to have been interested in Turner, and Robert Motherwell was clearly motivated by Turner's achievement. Mark Rothko visited the MoMA show with the Tate's director, Sir Norman Reid, and joked that 'this chap Turner, he learnt a lot from me'. More significantly, Reid claimed that Rothko's later decision to donate his *Seagram Murals* to the Tate was prompted by the prospect of having them hang in the same institution as the Turner Bequest.[29]

A journalist covering Gowing's exhibition contacted Barnett Newman to ask him his opinion of Turner. Newman replied: 'The only link I can realize with Turner is that when Turner strapped himself to the mast in an attempt to paint the storm, he was trying to do the impossible. And to the extent that I feel that's what a man's ambition should be, I'm linked that way, in trying to paint the impossible.'[30]

The work to which Newman was referring is *Snow Storm – Steam-Boat off a Harbour's Mouth* (fig.90), which Turner painted and exhibited in 1842 and around which a certain amount of anecdotal detail has collected. Looked at through modern eyes, its radical dissolution of form and the prominence of its centrifugal

90
*Snow Storm – Steam-Boat
off a Harbour's Mouth
Making Signals in Shallow
Water, and Going by the
Lead. The Author Was in
This Storm on the Night
the Ariel Left Harwich* 1842
Oil on canvas
91.5 × 122
Tate

energies seem to point prophetically towards those kinds of expressive abstractions we associate with some of the painters of the New York school. Newman, however, avoids any stylistic connection, neatly sidestepping the formalist trap; instead, he thinks more about the largeness of Turner's ambition as an artist, that sort of heroic endeavour which he himself felt was a worthwhile goal for the most serious sort of painting.

The full title of the picture is *Snow Storm – Steam-Boat off a Harbour's Mouth Making Signals in Shallow Water, and Going by the Lead. The Author Was in This Storm on the Night the Ariel left Harwich*. By giving such a long and autobiographical title Turner seems to have intended that his accusers could not lay the charge of fantasy upon him, the 'author' insisting that the picture was based on his direct experience. Yet diligent research has failed to produce any corroborating evidence for Turner's story; no ship called *Ariel* can be associated with Harwich in this period. One suggestion is that he misremembered the name of the ship *Fairy*, which left Harwich on 12 November 1840 and foundered with all hands in the violent storm that blew for the next week.[31] However, there is no evidence that Turner was in Harwich in November 1840 and so talk of being in the storm could only refer to him witnessing it from another location, perhaps at Margate, or en route to Margate on a Thames packet steamer. Ruskin recorded Turner's reaction to criticism that the sea in this picture looked like 'soapsuds and whitewash, muttering to himself "soapsuds and whitewash! What would they have? I wonder what they think the sea's like? I wish they'd been in it."'[32] He also noted the Revd William Kingsley's report of a conversation with Turner, in which the artist declared: 'I got the sailors to lash me to the mast to observe it; I was lashed for four hours, and I did not expect to escape, but I felt bound to record it if I did.'[33]

Both of these assertions, if accurately recorded, seem too forceful to be dismissed. However, and whether Turner was or was not in any storm, the idea of being lashed to the mast may be an intended allusion to the history of art. It is possible that Turner would have been aware of the story of Joseph Vernet, the French eighteenth-century artist, being tied to a mast to observe a storm.[34] He may also have remembered the association drawn eight years earlier between his own art and the Dutch seventeenth-century painter Ludolf Bakhuizen, who was 'in the habit of putting to sea in the most tempestuous of weather, that he might behold the waves mounting to the clouds, or dashing against the rocks'.[35]

Yet, amid all the uncertainty surrounding the picture's title and subsequent anecdotes of varying trustworthiness, the picture itself demands attention. The twisting vortex of competing energies, wind, water, smoke and light, spirals around the steam ship, placed precariously on a tilted horizon as if to accentuate the sense of rotation around this central point. The spectator's position is, if anything, even less secure, hovering amid the sea surge with a mountainous wave rearing up in the left foreground. Adrift in this chaos, we find that the disinterested contemplation

of terror associated with the eighteenth-century Sublime has been replaced by a much more immediate encounter with danger, as though the pictorial structures of Turner's vortex had the power to suck us into that depicted world. And indeed this is of a piece with Turner's other reconsiderations of what painting can achieve, how the use of colour can, as it were, generate light rather than merely copying its effects. If this was an impossible ambition, as Barnett Newman implied, Turner came as close as any artist to achieving it. He reconfigured how painting is to be understood: as a stable representation of an ordered world or as a dynamic exploration of a world in transition. By choosing the latter path he gave to painting a vitality that it had not had before.

The arts in 1851, and the social and political world of which they were part, had little in common with the art world Turner had first experienced in the 1790s; had his art not developed he would have been incapable of making a full response to the circumstances in which he found himself. In choosing to reconsider how art might make its contribution to understanding, Turner's approach to painting presented a profound shift in sensibility, which opened on to a new field of possibilities for the pictorial arts. Those who came after him did not so much inherit his mantle as share his need to renovate painting for the exigencies of the contemporary age. Yet, for all Turner's stylistic individuality, it would be anachronistic to think of him as an avant-garde or radical artist, committed to abandoning the precepts

he had so eagerly imbibed as a student in the Royal Academy Schools. As this book has shown, his art underwent a steady evolution, with many of his seemingly more 'modern' devices already present embryonically very early in his career. His paintings demonstrate that tradition was not to be ridiculed but to be honoured, even when broaching experiences that his predecessors had not encompassed.

Turner's art was in constant dialogue with old masters and contemporary artists, with established learning and with new discoveries. In addition, he never lost that eighteenth-century belief in the social responsibility of art, that painting could encompass the whole range of human achievement and offer useful lessons for those with eyes to see. Turner's industry is legendary: his willingness to subject himself to the discipline of drawing and painting day in, day out. But the commitment that kept him at it, his constant 'damned hard work', was underpinned by a belief in the cause of art itself.[36] As he said in a bantering letter to Charles Eastlake on the latter's election to Royal Academician, it was important for professional artists to advance the cause of art, through a combination of their own effort and encouragement for others: 'Active abilities and Institutions like ours requires constant support mutual exertions and strenuous endeavers and my dear Charles you are now a complete brother labourer in the same Vineyard and England expects every Man to do his duty.'[37]

For some sixty years Turner most certainly did his.

The Sun of Venice Going to Sea

Given the arguments made for Turner's anticipation of modern art, *The Sun of Venice Going to Sea* would seem to be a wholly inappropriate choice to advance such a claim, for, irrespective of its current condition, with some of its original colour degraded, it is manifestly legible to our eyes. Yet a caustic exhibition review of Turner's work in the 1843 Royal Academy exhibition specifically singled out this picture as utterly at odds with the art world of the day:

The most celebrated painters have been said to be 'before their time', but the world has always, at some time, or other, come up with them. The author of the 'Sun of Venice' is far out of sight; he leaves the world to turn round without him: at least in those of his works, of the light of which we have no glimmering, he cannot hope to be even overtaken by distant posterity; such extravagances all sensible people must condemn.[38]

Turner had no reason at all to abandon his own time and intended the picture as another meditation on human endeavour and its frustration. He accompanied it with lines from *Fallacies of Hope*.

Fair Shines the morn, and soft the zephyrs blow,
Venezia's fisher spreads his painted sail so gay,
Nor heeds the demon that in grim repose
Expects his evening prey.[39]

Venice lies astern, its roofs and bell-towers catching the morning sun as the fishing boat sails across the lagoon towards us. On its sail can be discerned the words 'Sol de Veneza' and below them a painted scene of the sun rising over a harbour, presumably Venice herself. If so, the boat stands for the republic whose bright early history had ended in military impotence, occupation and foreign control. As we have seen, by the 1840s it was something of a commonplace that Venice's decline was irreparable, but Turner's compression of that consensus into one almost emblematic image is at once economical and powerful. Indeed, when considering the flags fluttering from the mast it is tempting to look back to some remarks made in his Perspective lectures, where he discusses the association of heraldic colours with sentiments, such as green for servitude.[40] Turner was not before his time; his problem lay in the fact that his vision of nineteenth-century culture, in all its complex ramifications, simply escaped many of his critics.

This painting was John Ruskin's favourite of all Turner's productions and it is a nice coincidence that it was exhibited in the same year that Ruskin's *Modern Painters* began publication.

That book, which saw Turner's cause championed by the most important art critic of the Victorian era, had its origins seven years earlier. A vicious review of Turner's *Juliet and her Nurse* (1836), written for *Blackwood's Magazine* by the amateur artist and critic the Revd John Eagles, provoked Ruskin, then only a teenager, to compose a lengthy defence. Turner dissuaded him from proceeding with it but Ruskin's enthusiasm for Turner's achievement led to his writing *Modern Painters*. Although it now operated on a vastly extended stage, examining the whole history of Western art, the same passion that lay behind Ruskin's defence of Turner in 1836 runs through *Modern Painters*, published in five volumes between 1843 and 1860.

Turner, in Ruskin's characterisation, was the greatest landscape painter of all time because his knowledge of nature was so profound. This, for Ruskin, was not merely an empirical benefit. In its highest reaches the contemplation of nature should equip the mind with profound thoughts about the nature of the cosmos and man's place in it; an art of integrity would be one that represented nature in such a way as to stimulate that kind of contemplation. Because of its ability to look deeply into natural phenomena and to represent natural processes without falsifying them, Turner's art possessed a spiritual intensity unknown to his predecessors and contemporaries. For Ruskin, viewers of Turner's paintings, if they understood them aright, would be put in touch not just with observations of material reality but also with the spiritual and ethical truths immanent in the natural world. In the first edition of *Modern Painters* Ruskin reached heights of hyperbole that Turner must surely have felt to be excessive, declaring that the artist 'was sent as a prophet of God to reveal to men the mysteries of the universe, standing, like the great angel of the Apocalypse, clothed with a cloud, and with a rainbow upon his head, and with the sun and stars given into his hand'.[41]

91
The Sun of Venice going to Sea 1843
Oil on canvas
61.5 × 92
Tate

Turner's Technique

Unlike Turner's contemporaries, modern spectators have access to the full spectrum of his creative abilities, from sketch to finished picture. This is because the complex settlement of his will resulted in his entire stock of some 300 sketchbooks and individual drawings being deemed as bequeathed to the nation, a total of some 19,000 works on paper.[1] Therefore it makes sense, in the discussion below, to follow Turner's working methods, beginning with his sketchbooks and moving on to his exhibited work.

As a young artist learning his craft, Turner was schooled in the academic precepts governing the making of sketches, regarding them as part of the necessary training of eye and hand. He would also have accepted that sketches were not works of art, complete in themselves, but stages in the elaboration of a design fit for exhibition or sale. What mattered was always the finished picture. He used sketching for academic purposes and the Turner Bequest includes drawings of the nude, copies after Richard Wilson and studies after some of the old masters he saw in the Louvre in 1802 (figs. 2, 10). Naturally, however, his activities as a sketcher of landscape dominate the studies left to the nation. Of the sketches in the Bequest, there are three broad categories to consider: studies from the motif; technical experiments in media and handling; and compositional sketches in which the imaginative possibilities of subjects were tested out. We can review each of these in turn.

For Turner, sketching from the motif was never simply the means of acquiring a subject, to be worked up in a more finished state for sale or exhibition. The place of the imagination in the production of landscape art was always a priority. Therefore the original pencil sketch marked only the beginning of a road of invention and technical manipulation that would produce a work of art. This distinction is crucial, given Turner's ambition to wrest landscape from the unimaginative clutches of a merely topographical record. Especially at the outset of his career, the sketchbooks contain drawings of real precision, accurately noting,

say, the intricacies of Gothic architecture (fig.92) or the natural complexity of a specific terrain. Alongside these detailed observations he also developed a much freer drawing style, capturing the essence of what lay before him with the barest minimum of marks, a process that was characterised by an onlooker in 1813 as more like writing than drawing (fig.93).[2] When called upon to develop a watercolour from his travels, often many years after he had visited the location, Turner would no doubt have thumbed through the relevant sketchbooks to refresh his memory, perhaps using his more generalised sketches to provide a holistic approach to the motif itself. This is, indeed, one of the characteristics of his approach to landscape, as seen in the several series of

picturesque views he produced from the 1810s to the 1830s. Whereas most of his contemporaries seem to have been content to present their designs in ways that concentrated attention on the obvious major sights, Turner's treatments offer more detailed representation: portraits of places in all their complexity, as opposed to an enumeration of picturesque features.

A number of sketchbooks contain watercolour drawings and some of these were almost certainly produced in front of the motif, especially but not exclusively at the beginning of Turner's career. In 1798, for example, he showed Joseph Farington 'two Books filled with studies from nature – several of them tinted on the spot, which He found, He said, were much the most

valuable to him'.[3] This was not, however, his characteristic procedure and his use of colour sketching diminished markedly after about 1801.[4] He complained in 1819 that he could make fifteen or sixteen pencil sketches to one coloured and seems to have relied on making pencil sketches, then working up a coloured composition shortly afterwards, either in his lodgings when on tour or at home on his return.[5] Occasionally he would write colour notes on the drawing to remind himself of the effects he had observed.

Technical experimentation in Turner's sketches begins in the late 1790s and covers a wide range of approaches and procedures. When we remember that the traditional practice of watercolour painting had been styled 'tinted drawing', these departures are evidence of Turner's need to enrich the procedure, so that colour and handling contribute more actively to the production of an image almost able to rival painting in oils. These sketches embrace the use of different coloured papers (some bought already tinted, others prepared by Turner himself) and employ various media: pen, chalk, watercolour and gouache, often in combination (fig.92). The variety of effects achieved in these works lead one to imagine their being developed either as oils or as watercolours. As we shall see, Turner's

overall practice narrowed the gap between these two methods of painting, sometimes to the discomfort of his critics.

The final category of sketch is the compositional study. First thoughts for landscapes, marine and subject pictures can be found scattered through the pages of many of the sketchbooks, especially those of the first two decades of the nineteenth century – for example, 'Studies for Pictures' of c.1799–1802 (fig.94) and 'Calais Pier' of c.1799–1805 (fig.95). After the 1820s, however, it is much rarer to find Turner elaborating possible compositions in his sketchbooks, and it is more likely that he adopted a less studious procedure in the production of his finished pictures. If so, we must perhaps consider him in his maturity as having a strong mental image of what he wished to achieve. His preparation would have been chiefly concerned with establishing a composition in terms of colour and light, within which matrix the narrative and incidental details would find their place, and he would have added the requisite details relatively late in the development of the image.

The Bequest also contains a variety of sketches in oils made from the motif (figs.96, 97). Given his reluctance to make coloured watercolour sketches in the open air, it is

94
Study for Dolbadern Castle (compare fig.16)
Chalk on paper
21.5 × 13.8
from 'Studies for Pictures' sketchbook *c.*1799–1802
Tate

95
Studies for Macon (compare fig.14)
Chalk on paper
43.4. × 27.2
from 'Calais Pier' sketchbook *c.*1799–1805
Tate

understandable that oil sketches were not a major preoccupation for Turner. However, his career is punctuated by at least four episodes of oil sketching from nature: he made ten sketches at Knockholt, Kent, *c.*1799–1801, some thirty-five of the Thames and the Wey *c.*1805, fifteen in and around Plymouth, 1813, and nine at Cowes, Isle of Wight, 1827.[6] Sketching from nature in oils was a matter of some interest among British landscape artists of Turner's generation, especially in the first two decades of the nineteenth century. Having met him around 1800, Turner knew William Delamotte, who made oil sketches in the Thames valley from at least 1805, and this may have prompted Turner's own work there. In Devon, it seems, Turner overcame any reluctance because every facility had been provided for him, but despite the accomplishment of much of his oil sketching, he may have felt that this kind of immediate response to the motif was too imitative, a diversion from the business of

using colour compositionally in his exhibited pictures.

Turning to his finished pictures, there is no doubt that Turner's technique was finely attuned to his understanding of pictorial effects, especially the production of light and colour through the interaction of different pigments. His early professional development was as a painter in watercolours; his first signed work is dated 1787 and his first watercolour was exhibited at the Royal Academy in 1790. He did not exhibit his first oil there until 1796, by which time he was already receiving favourable press notices for the strength and vigour of his watercolour painting. It is therefore appropriate to consider his watercolour technique first, before moving on to his oils.

Pure watercolour relies on the whiteness of the support for its lightest light. To this end, either the relevant area of the white paper is revealed or the whole support is painted over with a translucent wash, so as to enliven the overlying colour. Properly

96
Walton Reach c.1807
Oil on mahogany veneer
37 × 73.5
Tate

97
A Quarry 1813
Oil on prepared paper
13.5 × 23.5
Tate

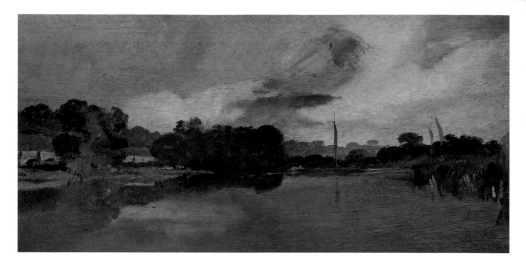

executed and carefully preserved, watercolours can capture a vivacious sense of light and colour that incorporates a wide tonal range and considerable intensity of hue, without any sacrifice of luminosity. A record of Turner's technical advice, set down by an admirer many years after his death, gives us some indication of how he achieved this:

First of all, respect your paper!
Keep your corners quiet.
Centre your interest.

And always remember, that, as you can never reach the *brilliancy* of Nature, you need never be afraid of putting your brightest light next to your deepest shadow, in the *centre*, but not in the *corners* of your picture.[7]

Turner's earliest watercolours, true to his training, were exercises in tinted drawing, with a detailed pencil outline placed on the paper first, to be painted over with coloured washes and the details picked out in local colour (figs.1, 4, 5). Increasingly, however, and certainly with growing regularity during and after the 1800s, he began to dispense with the underlying pencil outline and to compose in colour. Armed with a slight sketch in one of his sketchbooks, he produced the worked-up watercolour by establishing broadly massed areas of colour and overlaying these with the necessary details and colour accents to build

98
A First-Rate Taking in Stores 1818
Pencil and watercolour
28.6 × 39.7
Cecil Higgins Art Gallery,
Bedford

up the motifs. This could be achieved in pure watercolour and also, especially in the 1840s, with additions of detail in pen and ink (figs.26, 28).

In 1799 the landscape painter and Royal Academician Joseph Farington talked to Turner about his methods of making watercolour drawings. Turner evidently disliked the assumption prevalent in some quarters that watercolour drawing could be made a systematic procedure. As Farington reported, 'He thinks it can produce nothing but manner and sameness... Turner has no settled process but drives the colours abt. till He has expressed the idea in his mind.'[8] As Turner's reputation grew, Farington was one of many who realised that watercolour in his hands was becoming a more adventurous art form. Farington's curiosity about how Turner achieved his effects is recorded again in 1804, when the artist William Daniell told him about Turner's watercolour methods:

The lights are made out by drawing a pencil [i.e. brush]with water in it over the parts intended to be light (a general ground of dark colour having been laid where required) and raising the colour so damped by the pencil by means of *blotting paper*: after which with crumbs of bread the parts are cleared. Such colour as may afterwards be necessary may be passed over the different parts. A white chalk pencil (Gibraltar rock pencil) to sketch the forms that are to be light. A rich draggy appearance may be obtained by passing a camel Hair pencil *nearly dry* over them, which only flirts the damp on the part so touched and by blotting paper the lights are shown partially.[9]

As Turner's career developed, his forceful manipulation of the medium was noted by all who witnessed it. The painter James

Orrock remembered what his master, W. L. Leitch, had told him of Turner's approach to watercolour painting:

he stretched the paper on boards and, after plunging them into water, he dropped the colours onto the paper while it was wet, making *marblings* and gradations throughout the work. His completing process was marvellously rapid, for he indicated his masses and incidents, took out half-lights, scraped out high-lights and dragged, hatched and stippled until the design was finished. This swiftness, grounded on the scale practice in early life, enabled Turner to preserve the purity and luminosity of his work, and to paint at a prodigiously rapid rate.[10]

Leitch remembered that each of Turner's drawing boards had a handle screwed to its back for ease of use when plunging the drawing into water. He noted also that Turner worked on four drawings at a time, so that the first would have almost dried by the time he returned to it.[11] Walter Fawkes's daughters, similarly, remembered seeing Turner's bedroom at Farnley Hall in 1816 with 'cords spread across the room as in that of a washer woman, and papers tinted with pink and blue and yellow hanging on them to dry'.[12]

Farnley Hall was also the location for one of Turner's bravura performances in the production of a watercolour painting. As remembered some years later, *A First-Rate Taking in Stores* (1818, fig.98), was produced in response to a request from Walter Fawkes that Turner make 'a drawing of the ordinary dimensions that will give some idea of the size of a man of war', which Turner completed between breakfast and lunchtime. The idea of rapid workmanship was certainly in the air at Farnley Hall, for a few years earlier Turner had copied down an anecdote in one of the sketchbooks he used there concerning Salvator Rosa painting a picture for the Constable of France in one day.[13] Fawkes's request was fulfilled in the presence of his son, Francis Hawkesworth Fawkes, a privilege that Turner afforded because of his close connections with the family. Hawkesworth Fawkes, then a young man of twenty-one, seems to have forged a

Lake Albano ('colour beginning') *c.*1828 (compare fig.28)
Wash and pencil on paper
42.2 × 54.7
Tate

special relationship with Turner; it was he who had shared the artist's enthusiasm for the violent thunderstorm over Wharfedale that reappeared in *Hannibal* (1812, fig.40) and his reminiscences are valuable testimony of Turner's technical procedures:

He began by pouring wet paint onto the paper till it was saturated, he tore, he scratched, he scrubbed at it in a kind of frenzy and the whole thing was chaos – but gradually and as if by magic the lovely ship, with all its exquisite minutiae, came into being and by luncheon time the drawing was taken down in triumph.[14]

Yet, as Eric Shanes has shown, what Hawkesworth Fawkes remembered may have been only the most explosive parts of Turner's procedure, when his rapid, improvisational approach was at its most physical. Careful examination of the watercolour reveals that Turner must have proceeded with some care to prepare a compositional sketch, in pencil or perhaps in watercolour. Using this design as a guide, he would probably have applied stopping-out varnish to protect the paper from the subsequent application of colour washes. Then the wet paint would have been poured on, in three zones: blue pigment for the sky, yellow for the ship and blue-green for the sea. Quickly sponging off any surplus where white would have been required, for example

in the clouds, he would have set the paper aside to dry. When the paper was dry the stopping-out varnish could be removed and fine details added.[15]

The production of what have become known as 'colour beginnings' is perhaps one of the most notable aspects of Turner's practice as a watercolour artist (fig.99). About 400 watercolours fall into this category, named after an inscription on one of them in Turner's hand as 'Beginning for Dear Fawkes of Farnley'.[16] Although not all of these are truly concerned with establishing the underlying colour structures of a composition, what the group as a whole reveals is the extent to which Turner's working processes required him to explore pictorial possibilities (and, if unsuccessful, to abandon compositions and begin again) before elaborating the details of landscape, architecture or human incident that give his finished watercolours their extraordinary impact. The colour beginnings may look 'abstract' to us (and for this reason some modern viewers may prefer them to the finished version of their subjects) but they need to be understood as investigations of the very rudiments of Turner's art: using colour and tone as the building blocks for any composition. It is precisely because Turner took infinite pains to establish these foundations that the finished works succeed as paintings.

Turner's colour massing and improvisatory techniques can be misconstrued, for they may suggest that his procedure was purely expressive and emotional, lacking deliberation and finesse. In fact, the opposite is true. His ability to gradate tone within what appears at first sight to be a single colour wash is remarkable and it required the utmost control of the medium. In his maturity Turner enriched his means with additional techniques. Finished watercolours, on close inspection, reveal a multitude of minute touches and stipplings that produce a densely woven skein of variegated colour across the surface of the picture (fig.28). This painstaking work could be extremely time-consuming, but it helped give Turner's watercolours a depth of colour and richness of effect that few of his contemporaries could approach.

Increasingly, Turner's practice in oil painting borrowed these devices. Although his earliest grounds were not especially reflective, he began to paint over white grounds – most especially in those parts of the canvas reserved for the sky. He had made experiments with white grounds in some of the Thames oil sketches of the mid-1800s, giving them a relatively high key in their overall tonality. Finished oils also began to appropriate these devices from about 1810 – for example, *Petworth, Sussex, the Seat of the Earl of Egremont: Dewy Morning* (1810) (fig.25), *Somer-Hill, near Tunbridge, the Seat of W. F. Woodgate, Esq.* (1811) and *Whalley Bridge and Abbey, Lancashire: Dyers Washing and Drying Cloth* (1811). The idea that Turner was an example for a coterie of easily impressed younger artists, the so-called 'White Painters', is largely due to these developments. Sir George Beaumont is recorded in 1812 as saying that Turner was leading his contemporaries astray by making use of this technique: 'Much harm … has been done by endeavouring to make paintings in oil appear like watercolours, by which in attempting to give lightness & clearness, the force of oil painting has been lost.'[17] Beaumont's attacks were significant, given his reputation as a connoisseur and patron, and his influence as a director of the British Institution, but by the 1810s Turner had secured his independence and was not deflected from his employment of white grounds. His characteristic procedure was to use thinned paint to block in the principal areas of colour and then to add a succession of thinly painted layers of pigment over the blocked-in composition, sometimes using thickly impasted paint, for example on the edges of clouds, and using translucent layers, or glazes, to intensify or modify the local colour. When painting water or other reflective surfaces, he would lay numerous glazes on to the surface, producing a rich effect of colour without sacrificing transparency.[18]

Turner's lasting contribution to British art includes, among other things, a demonstration of the ways in which colour can be successfully orchestrated. His interest in the interplay between 'natural' and 'historical' colour is brought out in the remarks he made on Titian and Poussin in his 'Studies in the Louvre' sketchbook (see 'Turner's Writings'), where he pays particular attention to the possibility of stitching a composition together through the deft repetition of colour accents across the surface of the canvas. This was a lesson that Turner absorbed deeply. As his practice matured, his depth of knowledge of colour led him to employ several devices to make full use of its effects. But, beyond the lessons of the old masters, he was also making discoveries of his own. The way in which the proximity of two colours – for example, red and blue – can heighten the intensity of both is known as simultaneous contrast and can be seen from at least the late 1820s, in, for example, some of the Petworth sketches made on blue paper (fig.100). Turner also seems to have been aware of optical mixture – small touches of pure colour fusing in the eye to make a third; for example, blue and yellow producing green – and from about 1830 seems to have understood the potential of complementary colours to work in concert – for example, red and green – to produce a more forceful colour note.

Turner knew some of the more experimental colour merchants, such as George Field, with whom he may have come into contact in the 1820s.[19] As Joyce

Townsend has shown, he made use of new pigments as they came on to the market and this practice can be traced with some accuracy. For example, cobalt blue appears in his oils within four years of its development in France in 1802; chrome yellow, available from *c*.1814, is found in oils exhibited that year and in watercolours shortly afterwards; emerald green, discovered in 1814, makes its first appearance in oils and watercolours of the 1830s; Chinese white, available in England from 1834, is found in oils from 1835 to 1840.[20] Turner's interest in sunlight caused him to pay particular attention to yellow pigments. He was evidently eager to experiment with a wide variety of yellows as they became available, including smalt, patent yellow, strontium yellow and chrome yellow.[21] Given the blue-yellow opposition that anchors so many of Turner's chromatic compositions (figs.51, 56), it was perhaps prophetic that, when touring Devon in 1813, he included in one of his sketchbooks five pages of recipes for yellow pigments and a note on cobalt blue.[22]

Oil pigments were applied with a variety of brushes, depending on the size of the canvas and the stage reached in the process of working up a picture, ranging in size from two inches to a quarter of an inch and from hog's hair, for laying in, to squirrel hair, for finishing. The effects on each canvas are equally varied, ranging from scumbling (light over dark, as normally practised, but also dark over light) and small touches of pure colour, through transparent glazes, to blended brushstrokes of thinned colour. There is also, in some pictures, obvious use of the palette knife, the brush handle and even the fingers, to manipulate impasted paint as a physical component of the picture.[23] Turner's use of impasto, as was quite typical of his time, included the introduction of megilps to thicken its texture. Based on lead acetate, in his case, megilps could also be used in glazes, where they added a glossy quality to the pigment and enhanced its depth and beauty. Unfortunately, like bitumen, megilps tend to darken with age and can crack when varnished with mastic spirit varnish, which seems to have been Turner's habitual practice.[24] Analysis has shown that his skies were painted in thick paint over a white priming, often with an intermediate blue underpainting. The final glazes on the

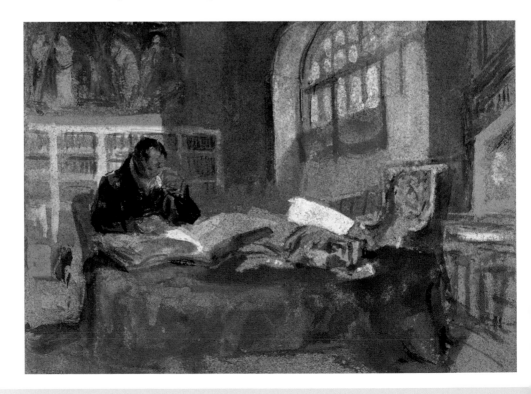

surface of the picture contained very little pigment, being nearly as transparent as their oil medium. Sometimes Turner applied a final layer of dry pigment in a thin layer of size, then varnished over it. It is this practice, perhaps, that caused some commentators to suggest that he had applied watercolour pigment to his surfaces. His finish layer may certainly have been more than usually delicate. He recommended a number of purchasers to do no more than rub his canvases with a silk handkerchief and there are anecdotes about colour coming away when a damp cloth was applied to the surface.

The variety of techniques Turner used to produce his effects is often forgotten when we look at his pictures for subject alone; so compelling is his vision that the means used to realise it are easily overlooked. And yet his mature pictures offer important lessons in how a thorough understanding of art as artifice, the ability to use the medium in all its potential, can produce results which seem entirely natural. This is nicely caught in a review of *Rain, Steam and Speed* (fig.88). The painting shows a locomotive of the Firefly class crossing Brunel's newly designed bridge at Maidenhead, its passengers in open carriages behind and a hare running on the tracks ahead. The firebox is revealed, as though the front of the locomotive were transparent, providing an intense red accent amid the gold, blue and lilac of the landscape and the sky. The picture was reviewed in *Fraser's Magazine* in terms that repay examination. Like his colleagues elsewhere, the critic was concerned to point out that Turner had achieved the seemingly impossible feat of painting motion itself, that the train really was moving at 50 mph, and talked also of his ability to make a picture 'with real rain, behind which is real sunshine... The world has never seen anything like this picture.' Yet, having got over his admiration of what Turner had wrought, the reviewer was struck above all by how these effects had been produced:

the rain is composed of dabs of dirty putty *slapped* on to the canvass with a trowel; the sunshine scintillates out of very thick, smeary lumps of chrome yellow. The shadows are produced by cool tones of crimson lake, and quiet glazings of vermillion[;] although the fire in the steam-engine looks as if it were red I am not prepared to say that it is not painted with cobalt and pea-green.

Although Turner painted some large canvases – *The Festival upon the Opening of the Vintage at Macon* (fig.14), for example, measures 146 × 237.5 cm and his largest, *Rome from the Vatican* (1820, fig.30), 177 × 335.5 cm – his characteristic canvas sizes, especially in his later years, were more modest: typically *c.*92. × 122 cm. This move towards the use of smaller canvases can be explained in part by the changes in patronage in Turner's lifetime, for his pictures came to be destined for the homes of the newly wealthy, associated with industry and commerce, rather than bought with the old money of the aristocracy. Although his new clients were men of substance, some of them owning elaborate and capacious houses in town and country, the taste was waning for large pictures that were capable of holding their own in a state room, perhaps among old masters. A more domestic-sized product was manifestly more likely to find a market and, moreover, would not necessarily jar with the more modestly proportioned paintings of many of Turner's contemporaries. In addition, by working within a smaller compass Turner enhanced the almost jewel-like intensity of some of his work of the 1830 and 1840s, whose strength of colour, concentrated within its gilded frame, could be taken in all at once and so achieve maximum chromatic impact.

Turner's Writings

Turner left no systematic body of writings behind him, with the exception of the manuscripts for his Perspective lectures, now in the British Library.[1] In addition to these manuscripts, there are four other sources of Turner's writings: observations in his sketchbooks, marginalia in books he owned, poetry and correspondence.

In 1807 Turner was appointed Professor of Perspective at the Royal Academy and retained that office until 1838, delivering his course of lectures twelve times.[2] The technical complexity of the subject, together with his often convoluted writing style, makes Turner's lectures a very different reading experience from the polished *Discourses on Art* of Sir Joshua Reynolds, which he greatly admired. The widely reported infelicities of Turner's performance as a lecturer can only have compounded these obstacles to comprehension. The lectures nonetheless provide useful insights into his observations on vision, on light and colour and on his attitudes to tradition and the old masters, genius and creativity, the relationship between the sister arts of painting and poetry, and the proper balance between theoretical rules and practical experience.

Some of Turner's sketchbooks contain drafts of poetry and theoretical considerations about art. On a couple of occasions he used them to make detailed notes on pictures, most extensively when visiting the Louvre in 1802, and these offer valuable testimony of the way in which he approached the old masters.[3]

Turner also wrote in the margins of books in his library, commenting on artistic theory and doctrine, especially when preparing for his Perspective lectures. His engagement with these texts is more than the 'fit of scribbling' he described to A. B. Johns (see letter of 1814 below), and his emendations provide us with crucial insights into his opinions and reactions.[4]

If the lectures, accounts of pictures and critical emendations are essentially analytic pursuits, Turner's more creative side is evident in his poetry. He had a relish for poetry and wrote a great deal of it throughout his career. The quotations from

his *Fallacies of Hope*, which accompanied many of his pictures after 1812, probably do not refer to a major lost poem by Turner but they are the tip of a poetic iceberg, most of which remained submerged in his lifetime.[5] Much of his verse output is fragmentary and, even when complete, is undistinguished as poetry; yet there are several striking passages worthy of reproduction. The 'Verse Book', a notebook in which a great deal of Turner's poetry was written, has been the subject of recent scholarship and its publication provides easily accessible transcripts of Turner's verse.[6]

Finally, although Turner's letters to some of his most intimate correspondents have been destroyed, a sufficient number survive to give some indication of his relations with friends and colleagues, his activities and his opinions.[7]

The following extracts are selected to provide examples of all five of these kinds of writing. Where appropriate, they are roughly grouped by theme, but the different contexts of all of these remarks should be constantly kept in mind. Some extracts, such as the notes on pictures and the marginalia, are professional memoranda for Turner's eyes only; others, such as the formal lectures and the often bantering letters, were intended for other listeners or readers, and range from the abstruse and complex to the relaxed and jocular.

Appreciations of other painters

Claude

'Pure as Italian air, calm, beautiful and serene springs forward the works and with them the name of Claude Lorrain. The golden orient or the amber-coloured ether, the midday ethereal vault and fleecy skies, resplendent valleys, campagnas rich with all the cheerful blush of fertilization, trees possessing every hue and tone of summer's evident heat, rich, harmonious, true and clear, replete with all the aerial qualities of distance, aerial lights, aerial colour, where through all these comprehensive qualities and powers can we find a clue towards his mode of practice? As beauty is not beauty until defin'd or science science until reveal'd, we must consider how he could have attained such powers but by continual study of parts of nature. Parts, for, had he not so studied, we should have found him sooner pleased with simple subjects of nature, and [would] not [have], as we now have, pictures made up of bits, but pictures of bits.'[8]

Rembrandt

'Rembrandt depended upon his chiaroscuro, his bursts of light and darkness to be *felt*. He threw a mysterious doubt over the meanest piece of Common; nay, more, his forms, if they can be called so, are the most objectionable that can be chosen, namely the Three Trees and the Mill, but over each he has thrown that veil of matchless colour, that lucid interval of Morning dawn and dewy light on which the Eye dwells so completely enthrall'd, and it seeks not for its liberty, but as it were, thinks it a sacrilege to pierce the mystic shell of colour in search of form.'[9]

Titian

'The Entombment may be ranked among the first of Titian's pictures as to colour and pathos of effect, for by casting a brilliant light on the Holy Mother and Martha and the figure of Joseph [Nicodemus], the Body has a sepulchral effect... Mary is in Blue which partakes of crimson tone, and by it unites with the Bluer sky. Martha is in striped yellow and some streakes of Red, which thus unites with the warm streak of light in the sky. Thus the Breadth is made by the 3 primitive colours breaking each other, and are connected by the figure in vermilion [Nicodemus] to the one in crimson'd striped drapery, which balances all the breadth of the left of the picture by its brilliancy... The drapery of the Body is the highest light, or more properly the first that strikes the eye. Of great use it is, gives colour to the dead Body and Breadth to the center ... the flesh is thinly painted, first by a cold color over a Brown ground, so that it is neither purple or green; some red is used in the extremities, and the lights are warm'[10]

Poussin

'[*The Gathering of Manna* is] the grandest system of light and shadow in the Collection.

Two figures of equall power occupy the sides and are color'd alike. They carry severally their satellites of color into the very centre of the picture, where Moses unites them by being in Blue and Red. This strikes me to be the soul of the subject, as it creates a harmonious confusion – a confusion of parts so arranged as to fall into the sides and by strong colour meeting in a background to the side figures which are in Blue and Yellow, so artfully arranged that the art of causing this confusion without distraction is completely hid.

'The colour of this picture [*The Deluge*] impresses the subject more than the incidents, which are by no means fortunate either as to place, position or colour, as they are separate spots untoned by the under colour that pervades the whole. The lines are defective as to the conception of a swamp'd world and the fountains of the deep being broken up. The boat on the waterfall is ill-judged and misapplied, for the figures are placed at the wrong end to give the idea of falling. The other boat makes a parallel with the base of the picture, and the woman giving the child is unworthy the mind of Poussin, she is as unconcerned as the man floating with a small piece of board. No current or ebullition (in the water), although a waterfall is introduced to fill up the interstices of the earth – artificially, not tearing and desolating, but falling placidly in another pool. Whatever may have been said of the picture by Rousseau never can efface its absurdity as to forms and the introduction of the figures. But the colour is sublime. It is natural, is what a creative mind must be imprest with by sympathy and horror.'[11]

Rubens

'Rubens, master of every power of handicraft and mechanical excellence ... threw around his tints like a bunch of flowers. Such is the impression excited by his 'Fête' in the Louvre, wholly without shadow ... obtaining everything by primitive colour, form and execution; and so abundantly supply'd by the versatility of his genius with forms and lines, could not be happy with the bare simplicity of Pastoral scenery or the immutable laws of nature's light and shade; feeling no compunction in making the sun and full moon, as in the celebrated picture of "Landscape with the Waggon", or introducing the luminary in the 'Tournament' while all the figures in the foreground are lighted in different directions. These trifles about light are so perhaps in Historical compositions, but in Landscape they are inadmissible and become absurdities, destroying the simplicity, the truth, the beauty of pastoral nature'[12]

David

'A good draftsman is a great artist but if he makes color and particularly chiaroscuro give way to shew the skill of his drawing, he recedes from the acme of a good painter which is a just proportion of each department and quit[s] nature, that is alone the test of our perceptions of art... Good drawing must necessarily be the first principles of education, but if all the powers are to tend to that alone, the student must distrust the opinions of his preceptors when he views the works of David and the French school, where drawing stands first second and third.'[13]

Tradition[14]

'We may suffer ourselves to be too much led away by great names and to be too much subdued by their overbearing authority; that their brilliances may prevent our enquiries may appear grounded on narrow principles both of art and of man. But in the study of our art, as in all arts, something is the result of our observation on nature as well as on those who have studied the same nature before us.'[15]

Painting and poetry

'Painting and Poetry flowing from the same source ... reflect and heighten each others beauties like ... mirrors.'[16]

'Poetic description[s] most full most incidental and display[ing] the greatest richness of verse, are often the least pictorial and hence hasty practice to use no harsher term is lead astray.'[17]

'The Painter's beauties are definable while the Poet's are imaginary as they relate to his association only, that is attributable to his imagination only. He seeks for attributes or sentiments to illustrate what he has seen in nature... But the Painter must adhere to the truth of nature.'[18]

Artistic creativity

'He that has that ruling enthusiasm which accompanies abilities cannot look superficially. Every glance is a glance for study: contemplating and defining qualities and causes, effects and incidents, and develops by practice the possibility of attaining what appears mysterious upon principle. Every look at nature is a refinement upon art: each tree and blade of grass or flower is not to him the individual tree grass or flower, but what is in relation to the whole, its tone its contrast and its hue and how far practicable: admiring nature by the power and practicability of his Art, and judging of his Art by the perceptions drawn from Nature.'[19]

'it is necessary to mark the greater from the lesser truth; namely the larger and more liberal idea of nature from the more narrow and confined, namely that which is solely addressed to the Eye.'[20]

'[The] imagination of the artist dwells enthroned in his own recess [and] must be incomprehensible as from darkness; and even words fall short of illustration, or become illusory of pictorial appreciations.'[21]

Genius and artistic training[22]

'Mechanical rules assume completely the guidance of our path and it requires something to guide us on our way. For although Genius may be in each body corporate, yet we cannot look into the seeds of time to know which may blossom or which shall fade; so we must be content a while to be led by these Mechanical rules'[23]

'For it may be laid down as a maxim that he who begins by presuming on his own sense has ended his studies as soon as he has commenced them. As on the other hand every opinion that Rules are the fetters of

Genius should be equally resisted as calculated to mislead. Rules says Sir Joshua are fetters only to those of no Genius as that armour which upon the strong is an ornament and a Defence, upon the weak and misshapen becomes a load and cripples the body which it was meant to protect.'[24]

'As a public lecturer Reynolds was excusable in encouraging the students to individual practical study... It would be too depressing upon young and feeling minds to say that all precept, industry and assiduity avail but little without genius.'[25]

'Genius may be said to be the parent of taste as it gives that enthusiastic warmth to admire first nature in her Common Dress, is conscious of the cause and effect of incidents to investigate not with the eye of erudition but to form a language of its own.'[26]

Theory and practice

'[When] the appearance of nature and the rules of art do vary, it is here the true artist must poise all the mechanical excellence of rules and the contrarities which are to [be] found in nature, with them to balance well the line between deformity and truth'[27]

'[Thomas Malton] had the courage to declare ... he had not the prejudice for [perspective] rules so strong as to reject nature whenever she appeared in opposition to such rules.'[28]

'It may seem improbable that any perspective representation should have a disagreeable effect if the rules laid down be nicely observed: yet there are some cases perhaps in which the artist will think it better to be guided by his own judgement than to follow the strict rule.'[29]

'we may feel to want further assistance and the help of rules, but it is here where the mind must work for its own reward and where given rules beyond general theoretical inductions would be useless to prescribe methods to those who have no talents; and those who have talents will find methods for themselves, says Sir Joshua, dictated to them by their own particular attention and by their own ... particular opinions, derived from their observations and necessities.'[30]

'In these elevated branches of art Rules my young friends languish[.] All they can contribute here is propriety of judgement as to practicality or discriminating the most proper in choice of subjects, compatable [sic] and commensurate with the powers of art... Gradation of line, gradation of tone, gradation of color is all that aerial Perspective can theoretically ask, or practically produce. The higher qualities of sentiments or application of interlectual [sic] feeling, forming the Poetic, historic, or perceptions gained from nature and her works are far beyond dictation; here rules are conducive only to select compatibility ... to produce the feeling excited by Poetic numbers; or judicious selections of Historic incidents[.] [T]hus the active powers of the Mind may not lead the imitative power of the Hand into a labyrinth through false choice...'[31]

'These attempts to define the powers of light and shade upon such changing surfaces as transparent bodies is like picking grains of sand to measure time.'[32]

'it must be observed that no information takes so deep a root as that which we gain ourselves. Our exertion imperceptibly gathers force, ease and readiness of handicraft ... the mind becomes capable of judging and retaining all the constant converse with nature which is pleasing and the hand is ready and capable of following and expressing its practicability.'[33]

Observations on light, colour and form

'Among the mutable and infinite contrasts of light and shade, none is so difficult either to define or [to make] deductable [sic] to common vision as reflexes. They enter into every effect in nature, oppose even themselves in theory, and evade every attempt to reduce them to anything like rule or practicality. What seems one day to be equally governed by one cause is destroyed the next by a different atmosphere. In our variable climate, where [all] the seasons are recognizable in one day, where all the vapoury turbulance [sic] involves the face of things, where nature seems to sport in all her dignity ... how happily is the landscape painter situated, how roused by every change

of nature in every moment, that allows no languor even in her effects which she places before him, and demands most peremptorily every moment his admiration and investigation, to store his mind with every change of time and place.'[34]

'Reflections not only appear darker but longer than the object which occasions them, and if the ripple or the hollow of the wave is long enough to make an angle with the eye it is on these undulating lines that the object reflects, and transmits all perpendicular objects lower towards the spectator... If the undulating surface of liquids did not, by currents, air and motion, congregate [?complicate] forms, it would be no difficulty to simplify all rules or attempts at such into a small space, by considering it and treating reflections as reflections upon polished bodies –when frequently reflections appear so true, but [are] most fallacious to the great book of nature when painting art toils after truth in vain.'[35]

'Light is ... color, and shadow the privation of it by the removal of these rays of color, or subduction of power... White [is] the substitute of light, as it is the compound in aerial light; the very inverse of colourable materials mixed produces strength or weakness, lightness or, [when] equal to each, the destruction of colour. The science of art and her combinations [is] coloring, not color. And here we are left by theory, and where we ought to be left, for the working of genius or the exercise of talent.'[36]

'Water has hitherto been said to be the same as polished bodies. Generally it may be considered as such, but abstractly [it is] quite different: first, from colour; secondly, from motion; and thirdly, by its reflections; which admit of such endless variety, incomprehensible contrarities and phenomena, that it imperiously demands more attention than the dismissal it has generally received: "Water, like other transparent bodies may be treated the same, it being like a mirror." True, it is a mirror, but of nature's choicest work. Do we ever trace the double tones and prismatic reflected ray of the glass, or do we see the liquid melting reflection, or the gentle breeze that on the surface of the water sleeps?'[37]

'The eye must take in all objects upon a Parabolic curve. For in looking into space the eye cannot but receive only what is within its limit of extended sight, which must form a circle to the eye. Therefore, as it always must view only a part of that circle at a time, the objects must be thrown on a part of a circle instead of a square. And as every line is more or less elevated, so it must partake of a parabolic curve.'[38]

Untitled poetry by Turner

Verse to accompany *Caernarvon Castle, North Wales*, exhibited at the Royal Academy in 1800:
And now on Arvon's haughty tow'rs
The Bard the song of pity pours,
For oft on Mona's distant hills he sighs,
Where jealous of the minstrel band,
The tyrant drench'd with blood the land,
And charm'd with horror, triumph'd in their cries,
The swains of Arvon round him throng,
And join the sorrows of his song.

Verse to accompany *London*, exhibited in Turner's gallery in 1809:
Where burthen'd Thames, reflects the crowded sail,
Commercial care and busy toils prevail,
Whose murky veil aspiring to the skies;
Obscures thy beauty and thy form denies,
Save where thy spires pierce thro the doubtful air,
As gleams of hope amidst a world of care.

Lines to accompany *The Fall of an Avalanche in the Grisons*, exhibited in Turner's gallery in 1810:
The downward sun a parting sadness gleams,
Portentous lurid thro' the gathering storm;
Thick drifting snow on snow,
Till the vast weight bursts through the rocky barrier;
Down at once, its pine clad forests,
And towering glaciers fall, the work of ages
Crashing through all! Extinction follows,
And the toil, the hope of man – o'erwhelms.

From the 'Verse Book' *c.*1805–10:
Bind not the Poppy in thy golden Hair
Autumn kind giver of the full Ear'd sheaf

Those notes have often melted to thy care
Check not their sweetness with thy falling leaf.[39]

Selected correspondence[40]

To A.B. Johns;[41] ?October 1814[42]:
Dear Johns
After an almost fruitless search for Opie Lectures my finding them only added to my mortification and to you[r] disappointment for alas, being troubled with a fit of scribbling at the time I read them (and having no paper at hand the margin bears marks of gall in divers places[43] – you'll say – this is but a poor excuse for breaking my promise but it is the best I can offer you to my mind as it is the truth, however I trust that Sir Jos. Reynolds works which I now send you will be of more real [service: *deleted*] assistance … being a new Edition with his life by Malone and his Flemish Journey – account of Pictures &c induced me to send them to you, in part a rub-off and impartially thinking them of most service – and with them a number of the Examiner to shew how the High-mightiness of Art are treated in the hot bed of scurillity [sic] *London* – and to those un-acquainted with the regulations of the Academy it must have a tendency to think ill of all *artists* (as drones fattening in the Academic *hive*) this system of detraction by comparison and personality no one should countenance, those that do cannot value art or have any feeling or concern for the failings of nature or respect exertions in any department, that after a long life, 'not passed in inglorious sloth' that any man's reputation should be immolated to enhance the value of a penny sheet of paper to 8 pence ½ is no cheering prospect. [A]nd the public to relish it (even as a joke upon Joe) deplorable indeed[44] – another Editor. [T]he Champion[45] has broached a new doctrine 'that as Encouragement never made Genius – it is unnecessary … that to look at ancient art useless because Genius will always find its own path and that *poverty* is the best guardian
 As one in darkness long immured
 Peeps through a craggy hole and calls it day
 So R.A. may hail the new light to Genius

being amply possesst of the main stimulus: so like the Cornish curate and congregation we shall start (without encouragement) *fair*...

To W.F. Wells;[46] 13 November 1820[47]:
Dear Wells

Many thanks to you for your kind offer of refuge to the House-less, which in the present instance is humane as to cutting, you are the cutter. Alladins palace soon fell to pieces, and a lad like me can't get in again unsheltered and like a lamb.[48] I am turning up my eye to the sky through the chinks of the Old Room and mine; shall I keep you a bit of the old wood for your remembrance of the young twigs which in such twinging strains taught you the art of wiping your eye of a tear[49] purer far than the one which in revenge has just dropt from mine, for it rains and the Roof is not finish'd...

To George Jones;[50] 13 October 1828[51]:
Dear Jones

Two months nearly in getting to this Terra Pictura, *and at work*; but the length of time is my own fault. I must see the South of France, which almost knocked me up, the heat was so intense, particularly at Nismes [sic] and Avignon; and until I got a plunge into the sea at Marseilles, I felt so weak that nothing but the change of scene kept me onwards to my distant point.

Genoa, and all the sea-coast from Nice to Spezzia is remarkably rugged and fine; so is Massa. Tell that fat fellow Chantrey that I did think of him, *then* (but not the first or the last time) of the thousands he had made out of those marble craigs which only afforded me a sour bottle of wine and a sketch; but he deserves everything which is good, though he did give me a fit of the spleen at Carrara...[52]

To Sir Thomas Lawrence;[53] 15 December 1828[54]:
I have but little to tell you in the way of Art and that little but ill calculated to give you pleasure. The Sistine Chapel Sybils and Prophets of the ceiling are as grand magnificent and overwhelming to contemplating as ever, but the Last Judgement has suffer'd much by scraping and cleaning particularly the sky on the lowermost part of the subject so that the whole of the front figures are in consequence one shadde. And it will distress you to hear that a Canopy (for the Host, the Chapel being now fitted up for divine service) is fixed by 4 hoops in the Picture, and altho' nothing of the picture is obliterated by the points falling in the sky part, yet the key note of the whole – sentiment is lost, for Charon is behind the said canopy, and the rising from the dead and the Inferno are no longer divided by his iron mace driving out the trembling crew from his fragile bark...

To C.L. Eastlake;[55] 16 February 1829[56]:
Now for my journey *home*. Do not think any poor devil had such another, but quite satisfactory for one thing at least, viz. not to be so late in the season of winter again, for the snow began to fall at Foligno, tho' more of ice than snow, that the coach from its weight slide about in all directions, that walking was much preferable, but my innumerable tails would not do that service so I soon got wet through and through, till at Sarre-valli the diligence zizd into a ditch and required 6 oxen, sent three miles back for, to drag it out; this cost 4 Hours, that we were 10 Hours beyond our time at Macerata, consequently half starved and frozen wet got to Bologna, where I wrote to you. But there our troubles began instead of diminishing – the Milan diligence was unable to pass Placentia. We therefore hired a voitura, the horses were knocked up the first post, sigr turned us over to another lighter carriage which put my coat in full requisition night and day, for we never could keep warm or make our day's distance good, the places we put up at proved all bad till Firenzola being even the worst for the down diligence people had devoured everything eatable (Beds none) ... crossed Mount Cenis on a sledge – bivouaced in the snow with fires lighted for 3 Hours on Mont Tarate while the diligence was righted and dug out, for a Bank of Snow saved it from upsetting[57] – and in the same night we were again turned out to walk up to our knees in new fallen drift to get assistance to dig a channel thro' it for the coach, so that from Foligno to

within 20 miles of Paris I never saw the road but snow!

To George Jones; 22 February 1830[58]:

Dear Jones

I delayed answering yours until the chance of this finding you in Rome, to give you some account of the dismal prospect of Academic affairs, and of the last sad ceremonies paid yesterday to departed talent gone to that bourne from whence no traveller returns.[59] Alas! Only two short months Sir Thomas followed the coffin of Dawe to the same place.[60] We then were his pall-bearers. Who will do the like for me, or when, God only knows how soon. My poor father's death proved a heavy blow upon me, and has been followed by others of the same dark kind.[61] However, it is something to feel that gifted talent can be acknowledged by the many who yesterday waded up to their knees in snow and muck to see the funeral pomp swelled up by carriages of the great, without the persons themselves...[62]

To John Hammersley;[63] 4 December 1838[64]:

Dear Sir

I have truly I must say written three times and now hesitate, for did I know your son's works or as you say his *gifted merit*, yet even then I would rather advise you to think well and not be carried away by the admiration which any friendly hopes (which ardent friends to early talent) may assume. They know not the difficulties or the necessities of the *Fine Arts* generally speaking: in regard to yourself it is you alone can judge how far you are inclined to support him during perhaps a long period of expense, and particularly if you look towards tuition the more so – for it cannot ensure success, (however it may facilitate the practice) and therefore it behoves you to weigh well the means in your power before you embark him in a profession which requires more care, assiduity and perseverance than any person can guarantee.

To Francis Hawkesworth Fawkes;[65] 28 December 1844[66]:

Now for myself, the rigours of winter begin to tell upon me, rough and cold and more acted upon by changes of weather than when we used to trot about at Farnley, but it must be borne with all the thanks due for such a lengthened period.

I went however to Lucerne and Switzerland, little thinking or supposing such a cauldron of squabbling, political or religious, as I was walking over. The rains came on early so I could not cross the Alps, twice I tried, was set back with a wet jacket and worn-out boots and after getting them heel-tapped I marched up some of the small valleys of the Rhine and found them more interesting than I expected...

To Francis Hawkesworth Fawkes; 27 December 1850[67]:

Old Time has made sad work with me since I saw you in Town.

I always dreaded it with horror now I feel it acutely now whatever – Gout or nervousness – it having fallen into my Pedestals – and bid adieu to the Marrow bone stage...

Criticism and Commentary on Turner's Art, 1797–1966[1]

1797

'We have no knowledge of Mr Turner, but through the medium of his works, which assuredly reflect great credit upon his endeavours; the present Picture is an undeniable proof of the possession of genius and judgement, and what is uncommon, in this age, is that it partakes but very little of the manner of any other master: he seems to view nature and her operations with a peculiar vision, and that singularity of perception is so adroit, that it enables him to give a transparency and modulation to the sea, more perfect than is usually seen on canvas.'[2]

1799

'Turner's views are not mere ordinary transcripts of nature: he always throws some peculiar and striking character into the scene he represents.'[3]

1801

'Nothing little appears from his hand, and his mind seems to take a comprehensive view of Nature. It must be confessed, however, that his desire of giving a free touch to the objects he represents betrays him into carelessness and obscurity so that we hardly ever see a firm determined outline in anything he does'[4]

1805

'Turner is indebted principally to his own exertions for the abilities which he possesses as a painter, and … he may be considered as a striking instance of how much may be gained by industry, if accompanied with temperance, even without the assistance of a master. The way he acquired his professional powers was by borrowing, where he could, a drawing or a picture to copy from; or by making a sketch of any one in the Exhibition early in the morning, and finishing it at home. By such practices, and by a patient perseverance, he has overcome all the difficulties of the art; so that the fine taste and colour which his drawings possess are scarcely to be found in any other.'[5]

1809

'the views of Sir John Leicester's seat, which in any other hands would be mere topography, touched by his magic pencil have assumed a highly poetical character. It is on occasions like this that the superiority of this man's mind displays itself; and in comparison with the

production of his hands, not only all the painters of the present-day but all the boasted names to which collectors bow sink into nothing.'[6]

1816

'We here allude particularly to Turner, the ablest landscape-painter now living, whose pictures are however too much abstractions of aerial perspective, and representations not properly of the objects of nature as of the medium through which they were seen... They are pictures of the elements of air, earth, and water. The artist delights to go back to the first chaos of the world, or to that state of things when the waters were separated from the dry land, and light from darkness, but as yet no living thing nor tree bearing fruit was seen upon the face of the earth. All is without form and void. Some one said of his landscapes that they were pictures of nothing, and very like.'[7]

1820

'Turner is the excuse for every caprice and every impertinence, for every unintelligible scrawl, for every indolent splash, to be considered as the effusions of "genius" of an inspired being, too much elevated above mortality to condescend to be intelligible.'[8]

1829

'the perfection of unnatural tawdriness. In fact, it may be taken as a specimen of colouring run mad – positive vermilion – positive indigo, and all the most glaring tints of green, yellow, and purple contend for mastery of the canvas, with all the vehement contrasts of a kaleidoscope or Persian carpet ... truth, nature, and feeling are sacrificed to melodramatic effect.'[9]

1829

'Of all living artists, Mr. Turner is, perhaps, the most profoundly versed in pictorial effect, using this term as combining the arrangement of colours and the distribution of light and shade... Turner does not, however, invent new series of colours. His sunshine is never cold; his morning mists are not orange; nor does the influence of his sunsets produce hard or discordant blues. Never does he lay on his tints in affected, incongruous, or inconsequential spots or masses. Those who do so, travestie

nature. Turner sublimes her. We look at his work, and it seems the creation of impulse, but it is, in fact, an elaborate structure, full of principle, and deep consideration, harmonious and elevated throughout'[10]

1833

'Instead of censuring, [Turner's critics] ought to rejoice in having the opportunity for observing, in his various experiments, the progress and process by which he attempts to embody the most beautiful and difficult effects of nature. Even when he is apparently most outrageous in his oppositions of colour... the perfect unity of part with part, and the breadth of effect of the whole, forms a powerful contrast to the stiffness, crudeness, and scattered appearance of inferior works. We look at Turner's as a condensation of nature within a limited scale. To look at Turner's is to look on nature herself.'[11]

1835

'This very agreeable state of affairs is, however, glaringly invaded by some flaming canvasses of Mr. J.M.W. Turner R.A. We seriously think the Academy ought, now and then, at least, to throw a wet blanket or some such damper over either this Fire king or his works; perhaps a better mode would be to exclude the latter altogether, when they are carried to the absurd pitch which they have now arrived at'[12]

1836

'A strange jumble – "confusion worse confounded". It is neither sunlight, moonlight, nor starlight, nor firelight... Amidst so many absurdities, we scarcely stop to ask why Juliet and her nurse should be at Venice. For the scene is a composition as from models of different parts of Venice, thrown higgledy-piggledy together, streaked blue and pink and thrown into a flour tub. Poor Juliet has been steeped in treacle to make her look sweet, and we feel apprehensive lest the mealy architecture should stick to her petticoat, and flour it.'[13]

1838

'Mr. Turner is in all his force this year, as usual – showering upon his canvas splendid masses of architecture, far distant backgrounds; and figures whereby the commandment is assuredly not broken – and presenting all these objects

through such a medium of yellow, and scarlet, and orange, and azure-blue, as only lives in his own fancy and the toleration of his admirers, who have followed his genius till they have passed, unknowingly, the bounds between magnificence and tawdriness... It is grievous to us to think of talent, so mighty and so poetical, running riot into such frenzies; the more grievous, as we fear, it is now past recall.'[14]

1841

'Here is a picture that represents nothing in nature beyond eggs and spinach. The lake is a composition in which salad abounds, and the art of cookery is more predominant than the art of painting.'[15]

1843

'There is no test of our acquaintance with nature so absolute and unfailing, as the degree of admiration we feel for Turner's painting. Precisely as we are shallow in our knowledge, vulgar in our feeling, and contracted in our views of principles, will the works of this artist be stumbling-blocks or foolishness to us: precisely in the degree in which we are familiar with nature, constant in our observation of her, and enlarged in our understanding of her, will they expand before our eyes into glory and beauty.'[16]

1851

'This year ... he has no picture on the walls of the Academy; and the Times of May 3rd says, "We miss those works of INSPIRATION!" We miss! Who misses? The populace of England rolls by to weary itself in the great bazaar of Kensington, little thinking that a day will come when those veiled vestals and prancing amazons, and goodly merchandize of precious stones and gold, will all be forgotten as though they had not been, but that the light which has faded from the walls of the Academy is one which a million of Koh-I-Noors could not rekindle, and that the year 1851 will, in the far future, be remembered less for what it has displayed than for what it has withdrawn.'[17]

1888

'For many a year we have heard nothing with respect to the works of Turner but accusations of their want of *truth*. To every observation on their power, sublimity, or beauty, there has been but one reply: They are not like nature. I therefore took my opponents on their own ground and demonstrated by thorough investigation of actual facts, that Turner *is* like nature, and paints more of nature than any man who ever lived.'[18]

1899

'Turner's career not only exhibits the instability of an individual artist, it exhibits the root of instability in modern art... As far back as Rembrandt we find the client's, the public claim losing hold on the painter, and his private interest gaining. In Turner the tendency proclaims itself more extravagantly. What was with Vandevelde the commissioned portrait of a warship passes over into a free picture of the sea, the topographer's portrait of a place into free landscape. Portrait goes out and Effect comes in. The successors of Turner have carried further this pursuit of an individual interest, and through the absence of a patron, a subject commanded, a public to be convinced, and its own shifty holiday nature their art lives a moody and uncertain life.'[19]

1902

'The more intimately we look into the texture and constitution of his pictures the less significant, the less stimulating in themselves, do they grow, and the more imperative does the necessity become to look through them to something beyond and comparatively external. Turner, in short, does not create, he adumbrates; he does not present original and concrete ideas of his own, he reproduces and illustrates existing things, playing with them, indeed, and enhancing them, so far as imitation can enhance the thing imitated, arranging them anew, for the most part with extraordinary sympathy and vigour, but seldom depending on the power innate in the language he is using to carry his own emotions into the souls of his fellow creatures.'[20]

1905

'His genius was so personal, so entirely the outgrowth of inspiration, that he stands alone, a Titan, impossible to imitate and difficult to follow... Turner formed no school of landscape art, and his painting belongs to the world rather than to any country.'[21]

1908

'The worship of originality characteristic of our age, which delights in novelty, acclaims the most extravagant orgies here... The less legible art becomes to the eye of the layman, the more easily does the burlesque succeed... Turner's burlesque had this peculiarity, that the parody was written before the original.'[22]

1910

'incidents of rural industry in Turner's pictures ... may at times help to lessen Turner's reputation as an artist, in the most narrow acceptation of the word; but they are of the essence of his outlook upon life, and of the thoughts and feelings under the impulse of which he painted his pictures ... take all of these things out of Turner's pictures, and – well – he would be another and a less humanly interesting Turner.'[23]

1926

'Now pure colour had become an instinctive part of his perception and the essential means of his expression. His use of it was no longer partly intellectual, as it had previously been in the stage when he was trying, consciously or unconsciously, to get pure colour into his pictures ... convincing truth is obtained by colour alone ... form has almost completely disappeared. It is a dream of colour, and yet it is significant. Turner ... forestalled the devices of the French Impressionists.'[24]

1928

'Turner was a man of glittering genius, but with an imagination that could not express itself within the limits of the painter's medium... Turner did create a new vision; he explored hitherto unrecorded aspects of nature, he noted passing effects that had eluded less alert observers, but his observation and his power of recording what he saw were at the bidding of a non-pictorial imagination. It was not, strictly speaking, a painter's sensibility that prompted him. It was the love of whatever was scenically impressive or dramatically striking that fired his imagination. He used all his resources and all his stored-up images of things seen to heighten effects that are not primarily concerned with the visual aspects of things. In short, Turner was primarily a sublime illustrator; he created almost a new conception, that of dramatic illustration by means of landscape.'[25]

1934

'It is no doubt very sketchy and unfinished, and people are apt to call anything sketchy Impressionist. But there is no necessary connection between the two... The Petworth contains no suggestion of the Impressionist principle of a consistent observation of the influence of different lights and of atmosphere on local colour. On the contrary, it is little else but local colour put on in vague splashes and dabs but not bound together by any such consistent idea... Turner does not observe, as the Impressionists did, any consistent naturalistic principle in the relation of his vivid colours – such relations as there are being, as it were, self-determined without much reference to optical laws.'[26]

1963

'[Turner] was rehearsing the chief relationship of the psyche to its objects... In the late or extreme "all-over" oil paintings, liquid and light-toned, we sense more easily what might be called a breathing or palpitation of the sky, water and land.'[27]

1966

'Up until the last three or four years of Turner's life, the high-keyed, diaphanous, contour-obliterating pictures of his last phase come off with great consistency. But he buys this consistency by lowering the terms of his success... Though ... they seldom fail, by the same token they tend to be too pat, too accessible as wholes... Visual sensibility gets its satisfaction too easily, without being challenged or expanded.'[28]

1966

'Transcending the concepts of romantic art, [Turner] reached out into the borderland between representation and the abstract... Presumably none of the present-day abstract painters whose principal means of expression is light and colour had Turner and his life-work in mind; but looking back upon their revolution, more than a hundred years later than his, we see a kinship.'[29]

Chronology

Turner's travelling
watercolour case

DATE	TURNER'S LIFE	CULTURAL EVENTS	POLITICAL EVENTS
1775	Joseph Mallord William Turner born at 21 Maiden Lane, Covent Garden, London, to William Turner, barber and wig maker, and his wife, Mary Marshall. In later life claims his birthday to be 23 April, St George's Day.	Thomas Girtin born. Self-Portrait *c.*1799 Oil on canvas 74.3 × 58.4 cm Tate. Bequeathed by the artist 1856	War of American Independence begins (ends 1783).
1776		John Constable born.	4 July, American Declaration of Independence.
1777		James Barry's cycle of paintings 'The Progress of Human Culture' begun (completed 1783).	
1778	Turner's sister Mary Ann born (dies in 1783, just before her fifth birthday).		
1779		Augustus Callcott born.	
1780			Gordon riots in London.
1781		Francis Chantrey and Walter Scott born.	
1782		Richard Wilson dies.	
1783		William Gilpin's first 'Picturesque Tour' published.	William Pitt the Younger becomes Prime Minister.
1785	Stays in Brentford, Middlesex, with maternal uncle.	David Wilkie born.	
1786	Stays in Margate, where he makes his first known drawings.	Somerset House, London, completed (henceforth home of Royal Academy).	
1787	Produces first signed and dated drawing.		

1788		Lord Byron born. Thomas Gainsborough dies. First working steam boat built.	George III's first attack of illness publicly announced.
1789	Stays with an uncle at Sunningwell, near Oxford. Works in drawing office of architect Thomas Hardwick as draughtsman; by end of year is working in same capacity for architectural draughtsman Thomas Malton. Admitted as student of Royal Academy Schools after one term's probation.	William Blake's *Songs of Innocence* published.	French Revolution begins. George Washington elected first President of America.
1790	Turner family moves across Maiden Lane to 26 Hand Court.	Edmund Burke's *Reflections on the Revolution in France* published.	
1791	Exhibits two watercolours at the Royal Academy; stays with Narraway family, friends of father, at Bristol, and from there visits Malmesbury and Bath.		
1792	Admitted to Life Class at Royal Academy. Meets W. F. Wells and John Soane. In summer stays with Narraways and tours South Wales.	Mary Wollstonecraft's *Vindication of the Rights of Women* and Thomas Paine's *The Rights of Man* published. Sir Joshua Reynolds dies. Percy Bysshe Shelley born.	French monarchy abolished.
1793	Awarded Great Silver Pallet by Society of Arts for a landscape drawing. Summer tour to Hereford and Tintern. In autumn visits Kent and Sussex. First contact with Dr Thomas Monro.	Louvre becomes national art gallery.	Louis XVI executed. War breaks out between Britain and France.

Portrait of Dr. Monro *c.*1795 (Monro Family collection; repr. in A. Wilton, Turner in his Time, 1987)

1794	Favourable reviews of his watercolours at Royal Academy exhibition. Tours Midlands and North Wales. Begins to take pupils as drawing master. Regular attendance at Monro's 'Academy', copying drawings by J. R. Cozens and others and working alongside Girtin.		
1795	Tours South Wales in early summer and then Isle of Wight.	John Keats born.	
1796	Exhibits his first oil painting at the Royal Academy, *Fishermen at Sea.*		
1797	His first extensive tour of north of England and Lake District. Stays at Harewood House, Yorkshire, to execute commissions for Edward Lascelles.		Naval mutinies at Spithead and the Norc.
1798	Tours Kent and Wales. Although under-age, applies (unsuccessfully) to become Associate of Royal Academy.	Samuel Taylor Coleridge and William Wordsworth publish *Lyrical Ballads.* Eugène Delacroix born. First year poetry allowed to accompany titles of pictures at Royal Academy exhibitions.	Nelson destroys French fleet at Battle of Nile.
1799	Approached to become Lord Elgin's draughtsman in Greece, but Turner's terms too demanding. Sees 'Altieri' Claudes in William Beckford's London home, then works for him at Fonthill, Wiltshire. Elected Associate of Royal Academy, aged twenty-four. Moves to 64 Harley Street. Takes Sarah Danby as mistress.	Rosetta Stone discovered in Egypt.	Napoleon appointed First Consul in France.
1800	Mother committed to Bethlehem Hospital for the insane.	Alessandro Volta develops electric battery.	

1801	Tours Scotland, returning via Chester and Lake District. Probable date of birth of Evelina, his elder daughter (with Sarah Danby).		Act of Union passed between Britain and Ireland.
1802	Elected full member of Royal Academy. First continental tour, of France and Switzerland, July–October; spends three weeks in Paris and studies paintings in Louvre.	Richard Parkes Bonington born. Thomas Girtin dies.	Peace of Amiens between Britain and France.
1803	Serves on Academy Council and Hanging Committee for first time. Sir George Beaumont begins to criticise his lack of finish.		Renewal of war between Britain and France.
1804	Mother dies. Opens gallery on corner of Harley Street and Queen Anne Street to display his work.	Society of Painters in Water-Colours established.	Spain declares war on Britain. Napoleon proclaimed Emperor of France.
1805	Stays at Sion Ferry House, Isleworth, where he keeps boat and sketches Thames. Sketches *Victory* on her return from Trafalgar.		Nelson defeats French and allied fleets at Battle of Trafalgar.
1806	Exhibits two oils at first exhibition of British Institution. Stays with W. F. Wells at Knockholt, Kent, and begins plans for *Liber Studiorum*. Takes house at 6 West End, Hammersmith (until 1811).	Parthenon ('Elgin') Marbles arrive in London. James Barry dies.	**Frontispiece to the 'Liber Studiorum'** *c.* 1810-11 Etching and watercolour on paper 29.9 × 38.4 cm Tate. Bequeathed by Henry Vaughan 1900
1807	First number of *Liber Studiorum* published. Elected Professor of Perspective at the Royal Academy.		Slave trade abolished in Britain.
1808	Stays with Sir John Leicester at Tabley House, Cheshire, then visits Wales. Stays for first time at Farnley Hall, Yorkshire, home of Walter Fawkes, his most important patron.		Peninsular War begins in Spain.

1809	Visits Lord Egremont at Petworth House, Sussex. Sketching tour of north of England.	Alfred Tennyson and Charles Darwin born.	

1810	Changes London address to 47 Queen Anne Street West. Visits Sussex and Farnley.		

Photograph of 47 Queen Anne Street West

1811	Delivers first series of six lectures as Professor of Perspective at Royal Academy. Spends summer in West Country, on commission for *Picturesque Views on the Southern Coast of England*. In autumn visits Farnley, where he will be a regular visitor until 1824. Probable year of birth of Georgiana, his younger daughter (with Sarah Danby).	Jane Austen's *Sense and Sensibility* published.	Owing to illness of George III, his eldest son, George, Prince of Wales, becomes Prince Regent. Luddite riots destroy industrial machinery.

Notes and Diagrams for 5th Perspective Lecture Pen and ink and wash on paper
Tate. Lent from a private collection 1994

1812	Begins building home, Sandycombe Lodge, at Twickenham, to own design.	Charles Dickens born. John Nash's architectural scheme for central London begins. Byron's *Childe Harold's Pilgrimage* (Cantos I and II) published.	Napoleon invades Russia.

1813	Summer visit to Plymouth and environs.	Robert Owen's *A New View of Society* published.	

1814	Summer visit to Devon.	George Stephenson builds world's first steam locomotive.	Allied armies defeat French and enter Paris; Napoleon exiled to Elba.

1815	Canova visits Turner's gallery.		Napoleon returns to France ('100 days') but is defeated at Waterloo and banished to St Helena. Corn Laws passed.
1816	Becomes Chairman of Directors and Treasurer of Artists' General Benevolent Fund. Summer tour of Yorkshire for Whitaker's *History of Richmondshire*.	British Museum buys Elgin Marbles. Samuel Taylor Coleridge's *Kubla Khan* published.	
1817	Visits Belgium, Netherlands and Rhineland, including tour of battlefield at Waterloo. On return visits Raby Castle and Farnley.	Jane Austen dies. Waterloo Bridge opened.	Potato famine in Ireland.
1818	Makes drawings for Hakewill's *Picturesque Tour of Italy*. Visits Scotland to discuss illustrations for Scott's *Provincial Antiquities of Scotland*.	Mary Wollstonecraft Shelley's *Frankenstein* published.	**Frontispiece for Volume One of 'The Provincial Antiquities of Scotland': Edinburgh Castle 1822-5 Watercolour and pencil on paper 24.1 × 17.8 cm Tate. Bequeathed by the artist 1856**
1819	Last *Liber Studiorum* plates published. Eight oils shown at Sir John Leicester's London gallery; sixty watercolours shown at Walter Fawkes's London home. First visit to Italy, lasting six months.	John Ruskin born. **John Varley Portrait of Walter Fawkes c.1811 Pencil on paper 28.3 x 21.6 cm Victoria and Albert Museum**	Peterloo Massacre in Manchester; local militia disrupts meeting demanding parliamentary reform; eleven protesters are killed.

1820	Returns from Italy by end of January. Enlarges Queen Anne Street residence, including building new picture gallery. Inherits property in Wapping, East London, and converts it into Ship and Bladebone pub.	Discovery of Venus de Milo. Benjamin West, President of Royal Academy, dies.	Revolution in Spain. George III dies and Prince Regent becomes George IV.
1821	Travels to Paris, Rouen and Dieppe to gather material for engravings of River Seine.	Champollion deciphers Egyptian hieroglyphics with aid of Rosetta Stone. Constable exhibits *The Haywain*. John Keats and Joseph Farington die.	Napoleon dies. Greek War of Independence against Turkish rule begins.
1822	Turner's new gallery opens in Queen Anne Street West. Travels to Scotland to record George IV's state visit to Edinburgh. Commissioned by George IV to paint large picture of Battle of Trafalgar.	Shelley drowns in Bay of Spezzia, Italy.	
1823	First *Rivers of England* engravings published.	Construction begins on Robert Smirke's redesigned British Museum. Electric telegraph invented.	
1824	Tours East Anglia, then Belgium, Luxembourg, Germany and northern France. Last visit to Farnley.	National Gallery established in London. Byron dies.	
1825	Begins work on commission for 120 watercolours to be engraved as *Picturesque Views in England and Wales*. Tours Netherlands. Walter Fawkes dies.	Henry Fuseli, Professor of Painting at Royal Academy, dies. World's first passenger railway opens between Stockton and Darlington, north-east England.	
1826	Commissioned by Samuel Rogers to illustrate his poem *Italy*. Sells Sandycombe Lodge. First *Ports of England* engravings published. Visits Normandy, Brittany and Loire.		

| 1827 | Stays with John Nash at East Cowes Castle, Isle of Wight. Visits Lord Egremont at Petworth, Sussex. | Ludwig van Beethoven and William Blake die. | Battle of Navarino destroys Turkish fleet. Treaty of London. |

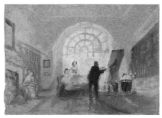

The Artist and his Admirers 1827
Watercolour and bodycolour on paper
13.8 × 19 cm Tate. Bequeathed by the
artist 1856

| 1828 | Gives last series of Perspective lectures. Visits Petworth to paint pictures for dining room. Second visit to Italy; shares house with Charles Eastlake in Rome. | Richard Parkes Bonington dies. | Duke of Wellington becomes Prime Minister. |

| 1829 | Returns from Italy early February. Visits Paris, Brittany, and Normandy to gather material for illustrations of Seine. Father dies. Draws up first will. | First horse-drawn buses appear in London. Catholic Emancipation Act. | |

Portrait Study of J.M.W. Turner's
Father, with a Sketch of Turner's
Eyes, Made during a Lecture 1812
Pencil on paper 18.7 × 22.5 cm Tate.
Purchased 1980

| 1830 | Publication of Rogers's *Italy*. Tours Midlands. Resigns from Artists' General Benevolent Institution because of financial disagreements. | Sir Thomas Lawrence, President of Royal Academy, dies. | George IV dies and William IV ascends throne. Revolution in Paris; abdication of Charles X and accession of Louis-Philippe, Turner's former neighbour in Twickenham. |

1831	Signs second will. Travels to Scotland to stay with Walter Scott and gather material for illustrated edition of Scott's *Poems*. Commissioned to illustrate Rogers's *Poems*. Spends Christmas at Petworth.		Declaration of Greek independence.
1832	Travels to France to gather material for *Rivers of France* and Scott's *Life of Napoleon*. Probably meets Delacroix in Paris. Spends winter at Petworth and East Cowes Castle. Has begun staying with Sophia Caroline Booth at Margate.	Cholera reaches London.	First Reform Act expands Britain's electorate.
1833	Extended tour through Berlin, Dresden, Prague and Vienna to Venice. Mrs Booth's husband dies. *Turner's Annual Tour: Wanderings by the Seine* published.	William Wilberforce dies. First steamship crosses Atlantic.	Abolition of slavery in British Empire.
1834	Records burning of Houses of Parliament. First instalments of William Finden's *Landscape Illustrations of the Bible* issued. Illustrations to Byron's *Works* exhibited.	Coleridge dies.	Tolpuddle Martyrs transported to Australia. Poor Law Act creates workhouses for poor.
1835	Extended tour of Denmark, Germany and Bohemia to gather material for Thomas Campbell's *Poetical Works*.		
1836	Revd John Eagles's violent criticism of *Juliet and her Nurse*, exhibited at Royal Academy, provokes Ruskin to write in Turner's defence, but Turner advises against publication. Tours France, Switzerland and Val d'Aosta.		

1837	Turner resigns his post as Professor of Perspective. Travels to Paris and Versailles. Spends October at Petworth. Lord Egremont dies. Illustrated edition of Thomas Campbell's *Poems* published.	Constable and Sir John Soane die. Royal Academy relocated to National Gallery, Trafalgar Square.	William IV dies and Queen Victoria ascends throne.
1838	Last plates published for *Picturesque Views in England and Wales*.	Opening of National Gallery, London. First electric telegraph.	Anti-Corn Law League established. People's Charter published.
1839	Travels to Belgium, Luxembourg and Germany.	Rebuilding of Houses of Parliament begins.	First Chartist riots in support of universal suffrage.
1840	Meets Ruskin for first time. Visits Venice via Rotterdam and Rhine, and Munich and Coburg on return leg.	Penny postage system established in Britain.	Queen Victoria marries Prince Albert of Saxe-Coburg-Gotha.

Charles Fairfax Murray
Portrait of John Ruskin, Head and Shoulders, Full Face 1875 Watercolour and gouache on paper 47.6 × 31.1 cm Tate. Purchased as part of the Oppé Collection with assistance from the National Lottery through the Heritage Lottery Fund 1996

1841	Tours Switzerland.	Sir David Wilkie and Sir Francis Chantrey die.	Robert Peel becomes Prime Minister.
1842	Paints ten watercolours as sample studies for his agent, Thomas Griffith, to offer to potential patrons. Tours Switzerland.		Chartist riots.

1843	Paints second series of sample studies.	First volume of Ruskin's *Modern Painters* published.	
1844	Last tour of Switzerland.	Sir Augustus Callcott and William Beckford die.	
1845	Becomes Acting President of Royal Academy during illness of Sir Martin Archer Shee. Last trip to continent: Dieppe and Picardy.		Potato famine in Ireland.
1846	Begins to live with Mrs Booth at 6 Davis Place, Cremorne New Road, Chelsea, under assumed name Admiral Booth.		Repeal of Corn Laws.
1847	Makes frequent visits to photographic studio of J.J.E. Mayall in London.	Charlotte Brontë's *Jane Eyre* and Emily Brontë's *Wuthering Heights* published. Thackeray completes *Vanity Fair.*	
1848	Hires Francis Sherrell as studio assistant.	Pre-Raphaelite Brotherhood founded. Karl Marx and Friedrich Engels's *The Communist Manifesto* published.	Revolutionary uprisings across Europe. Louis-Philippe abdicates and Louis Napoleon elected as President. Cholera epidemic in England. Chartist movement ends.
1850	Exhibits last four pictures at Royal Academy.	Sir Martin Archer Shee and William Wordsworth die.	
1851	Dies on 19 December at 10 am at home in Chelsea. Buried in crypt of St Paul's Cathedral on 30 December.	Great Exhibition held at Crystal Palace, London.	Louis Napoleon's coup d'état.

George Jones
Turner's Body Lying in State
29 December 1851 c.1852
Oil on board 14 x 23 cm
Ashmolean Museum, Oxford

Works in Public Collections

England

Bedford

CECIL HIGGINS ART GALLERY
Nine watercolours, including: *Norham Castle: Sunrise* (*c*.1798); *The Great Fall of the Reichenbach, in the Vallery of Hasle, Switzerland* (exh. 1804; Wilton 367); *Rokeby* (1822; Wilton 1053), acquired in 1997.

Birmingham

BIRMINGHAM MUSEUM & ART GALLERY
Twelve works, including: one oil painting, eight watercolours and three pencil sketches: *The Pass of St Gothard* (*c*.1803-4; Butlin & Joll 146); *Lancaster Sands* (*c*.1818; Wilton 581); *Hereford Cathedral* (1792).

Birmingham

BARBER INSTITUTE OF FINE ARTS
Two works including one oil painting and one watercolour: *The Sun Rising Through Vapour* (exh. 1809; Butlin & Joll 95); *Ludlow Castle* (1800; Wilton 265).

Blackburn

BLACKBURN ART GALLERY
Seven watercolours, including: *Cascade at Terni* (*c*.1817; Wilton 701); *View Near Jubberah* (*c*.1835; Wilton 1294).

Burnley

TOWNELEY HALL ART GALLERY
Five watercolours, including: *Towneley Hall* (1799; Wilton 292); *Temple of Minerva, Cape Colonna* (1830; Wilton 1213).

Bury

BURY ART GALLERY & MUSEUM
Five watercolours, including: *Malmesbury Abbey* (*c*.1891-2; Wilton 26); *Ehrenbreitstein* (*c*.1832; Wilton 1051).

Cambridge

FITZWILLIAM MUSEUM
Fifty-nine works, including four oil paintings and fifty-five watercolours: *Mountain Landscape with a Lake* (*c*.1799-1800; Butlin & Joll 38); *Studies of Seals from Whalley Abbey* (*c*.1799-1800; Wilton 285); *Hardraw Fall* (*c*.1816-1818; Wilton 574). Four

watercolours were undertaken following Turner's tour of France, Switzerland and the Val d'Aosta with his patron H. A. J. Munro of Novar in 1836.

Leeds
LEEDS CITY ART GALLERY

One oil painting, including: *A Valley in Devonshire* (1813; Butlin & Joll 225), and three pencil sketches undertaken in 1801 during Turner's first tour of Scotland, returning via the Lake District and Chester. Over thirty watercolours, including a series of twenty studies of birds (*c.*1815-20); two landscapes after John Robert Cozens, including, *The Lake of Klontal*.

Liverpool
WALKER ART GALLERY (NATIONAL MUSEUMS OF LIVERPOOL)

Five oil paintings and eight watercolours, including: *Linlithgow Palace, Scotland* (exh.1810; Butlin & Joll 104); *Schloss Rosenau, Seat of HRH Prince Albert of Coburg, near Coburg, Germany* (exh.1841; Butlin & Joll 392); *Falmouth Harbour* (*c.*1812-14; Wilton 455); *Richmond Terrace, Surrey* (*c.*1836; Wilton 879).

Liverpool: Port Sunlight
LADY LEVER ART GALLERY (NATIONAL MUSEUMS OF LIVERPOOL)

One oil painting and seventeen watercolours, including: *Fall of the Clyde* (*c.*1845; Butlin & Joll 510), *Haford* (*c.*1798; Wilton 331); *Minehead, Somersetshire* (*c.*1820; Wilton 469)

Liverpool
UNIVERSITY OF LIVERPOOL

One oil painting and five watercolours, including: *The Eruption of the Souffrier Mountains, in the Island of St Vincent, at Midnight, on the 30th of April, 1812, from a Sketch Taken at the Time by Hugh P. Keane, Esqre* (exh. 1815; Butlin & Joll 132); *Ambleside Mill, Westmoreland* (exh. 1798; Wilton 237); *Bolton Abbey, Yorkshire* (*c.*1809; Wilton 531).

London
BRITISH MUSEUM, DEPARTMENT OF PRINTS AND DRAWINGS

One hundred watercolours and seventeen sketches, including: *Tintern Abbey: The Transept* (*c.*1794; Wilton 59); a series of three works after John Robert Cozens, produced in the studio of Dr Monro in 1794; *A Storm (Shipwreck)* (1823; Wilton 508). Sketches include those from the *Smaller Fonthill Sketchbook* of 1801, and some undertaken during Turner's 1793 tour of Hereford and Tintern.

London
COURTAULD GALLERIES, SOMERSET HOUSE

Twenty watercolours and four sketches, including: *The Upper Fall of the Reichenbach* (1802; Wilton 362); *Tewkesbury Abbey*.

London
NATIONAL GALLERY

Nine works, including: two oil paintings bequeathed by Turner to the National Gallery: *Sun Rising Through Vapour: Fishermen Cleaning and Selling Fish* (exh.1807; Butlin & Joll 69); *Dido Building Carthage: The Rise of the Carthaginian Empire* (exh. 1815; Butlin & Joll 131); and seven oil paintings from the Turner Bequest, including *Ulysses Deriding Polyphemus: Homer's Odyssey* (exh. 1829; Butlin & Joll 339); *Rain, Steam and Speed: The Great Western Railway* (1844; Butlin & Joll 409).

London
SIR JOHN SOANE'S MUSEUM

Three oil paintings, including: *Refectory of Kirkstall Abbey, Yorkshire* (exh.1798; Wilton 234).

London
TATE BRITAIN

All oil paintings, watercolours and drawings from the Turner Bequest, with the exception of seven oil paintings, held at the National Gallery, London.

London
VICTORIA AND ALBERT MUSEUM

Five oil paintings and nearly forty watercolours, including: *St Michael's Mount, Cornwall* (exh.1834; Butlin & Joll 358); *Life-Boat and Manby Apparatus Going Off to a Stranded Vessel Making Signal (Blue Lights) of Distress* (exh. 1831; Butlin & Joll 336); *Inside of Tintern Abbey, Monmouthshire* (exh.1794;

Wilton 57); *Holy Island, Northumberland* (*c*.1829; Wilton 819); and a small quantity of Swiss landscape studies completed following his 1841-2 tour.

London
WALLACE COLLECTION
Four watercolours, including: *Scarborough Castle: Boys Crab Fishing* (1809; Wilton 527); *Hackfall, near Ripon* (*c*.1816; Wilton 536).

Manchester
MANCHESTER CITY ART GALLERY
Two oil paintings and nearly forty watercolours, including: *Thomson's Aeolian Harp* (exh.1809; Butlin & Joll 88); *Now for the Painter', (Rope.) Passengers Going on Board, 'Pas de Calais'* (exh. 1827; Butlin & Joll 236); *Rochester* (1795; Wilton 129); *Powis Castle, Montgomery* (*c*.1834; Wilton 861); *Heidelberg: Sunset* (*c*.1840; Wilton 1376).

Manchester
WHITWORTH ART GALLERY
Over sixty watercolours, many of which are from the collection of J. E. Taylor and were undertaken following Turner's tour of the Midlands and North Wales in 1794, including: *Warwick Castle and Bridge* (1794; Wilton 79). The collection also comprises a quantity of late Swiss landscapes, including, *Storm in a Swiss Pass, 'First Bridge above Altdorf'* (1845; Wilton 1546).

Oxford
ASHMOLEAN MUSEUM
Over eighty watercolours and drawings, over sixty of which were presented by John Ruskin, including a series of late Venetian scenes. The collection also comprises: *Transept of Tintern Abbey, Monmouthshire* (exh.1795; Wilton 58); and ten scenes of Oxford University's colleges, dated 1798-9, 1801 and 1803-4 respectively, and including a later watercolour of *Christ Church College* (*c*.1832; Wilton 853).

Petworth, West Sussex
PETWORTH HOUSE
Three works, including: one oil painting on long-term loan from Tate, *Petworth, Sussex, the Seat of the Earl of Egremont: Dewy Morning* (exh.

1810); and two watercolours: *Spilt Milk* (1827; Wilton 906); *Landscape Near Petworth* (1827; Wilton 907).

Sheffield
SHEFFIELD GALLERIES AND MUSEUMS TRUST, INCORPORATING WESTON PARK MUSEUM, GRAVES ART GALLERY AND RUSKIN GALLERY (MILLENNIUM GALLERIES)
One oil painting and eight watercolours, including: *The Festival upon the Opening of the Vintage at Macon* (exh.1803; Butlin & Joll 47); *Man-of-War, Making a Signal for a Pilot off the Tagus* (*c*.1819; Wilton 501).

Southampton
SOUTHAMPTON CITY ART GALLERY
One oil painting, *Fishermen upon a Lee-Shore, in Squally Weather* (exh.1802; Butlin & Joll 16).

Scotland
Edinburgh
NATIONAL GALLERY OF SCOTLAND
One oil painting and over sixty watercolours, thirty-one of which were bequeathed by Henry Vaughan in 1900. A number of watercolours were undertaken circa 1794-7, following tours of England and Wales (including the Midlands, South Wales, the Lake District, and the South coast). Notable works include: *Somer-hill, near Tunbridge, the Seat of W. F. Woodgate, Esq.* (exh.1811; Butlin & Joll 116); *Heriot's Hospital, Edinburgh* (*c*.1819; Wilton 1064); and twenty vignette illustrations for *Campbell's Poetical Works*.

Wales
Aberystwyth
NATIONAL LIBRARY OF WALES
One oil painting and one watercolour: *Dolbadarn Castle - Study for Diploma Picture* (?1800-2); *Aberdulais Mill, Glamorganshire* (1796 or 1797; Wilton 169b).)

Cardiff
NATIONAL MUSEUMS AND GALLERIES OF WALES
Five oil paintings and eighteen watercolours, including: *Morning after the Wreck* (*c*.1835-45; Butlin & Joll 478); *The Storm* (*c*.1840-5; Butlin & Joll 480); *The Day after the*

Storm (*c*.1840-5; Butlin & Joll 481); and some late Swiss scenes.

Australia
Sydney
ART GALLERY OF NEW SOUTH WALES
One watercolour: *High Force, or Fall of the Tees* (1816-18; Wilton 564).

Melbourne
NATIONAL GALLERY OF VICTORIA
Three oil paintings and three watercolours, including: *Falls of Schaffhausen ('The Val d'Aosta')* (*c*. 1845; Butlin & Joll 520); *Linlithgow Palace* (*c*.1801; Wilton 321); *The Red Rigi* (1842; Wilton 1525).

Canada
Ottawa
NATIONAL GALLERY OF CANADA
Two oil paintings and three watercolours, including: *Shoeburyness Fisherman Hailing a Whitstable Hoy ('The Pilot Boat'; 'The Red Cap')* (exh. 1809; Butlin & Joll 85); *Mercury and Argus* (exh.1836; Butlin & Joll 367); *Forum Romanum* (1818; Wilton 705).

Québec
MUSÉE DU QUÉBEC
One oil painting: *Scene in Derbyshire [formerly 'Near Northcourt in the Isle of Wight']* (*c*.1827; Butlin & Joll 240/269).

Germany
Munich
NEUE PIANKOTHEK (BAYERISCHE STAATSGEMALDESAMMLUNGEN)
One oil painting, *Ostend* (exh. 1844; Butlin & Joll 407).

Japan
Hachioji City, Tokyo
TOKYO FUJI ART MUSEUM
Two oil paintings, *Seascape with a Squall Coming Up* (*c*.1803-4; Butlin & Joll 143); *Helvoetsluys; - the City of Utrecht, 64, Going to Sea* (exh. 1832; Butlin & Joll 345).

Portugal
Lisbon
MUSEU CALOUSTE GULBENKIAN
Two oil paintings and two watercolours:

Wreck of a Transport Ship (*c*. 1810; Butlin & Joll 210); *Mouth of the Seine, Quille-Boeuf* (exh. 1833; Butlin & Joll 353); *Ruins of West Front, Tintern Abbey* (*c*.1794-5; Wilton 61); *Plymouth with a Rainbow* (*c*.1825; Wilton 760).

United States
California: Los Angeles
J. PAUL GETTY MUSEUM
One oil painting and two watercolours: *Van Tromp, Going About to Please his Masters, Ships a Sea, Getting a Good Wetting* (exh. 1844; Butlin & Joll 410); *Conway Castle* (*c*.1800; Wilton 270); *Longships Lighthouse, Land's End* (*c*.1835; Wilton 864).

California: San Marino
HUNTINGTON LIBRARY, ART COLLECTIONS AND BOTANICAL GARDENS
Two oil paintings and ten watercolours, including: *The Grand Canal ('Scene - a Street in Venice')* (exh.1837; Butlin & Joll 368); *Neapolitan Fisher Girls Surprised Bathing by Moonlight* (exh.1840; Butlin & Joll 388); *St Goarhausen* (1817; Wilton 676); *Beaumaris, Isle of Anglesey* (*c*.1835; Wilton 865).

Connecticut: Hartford
WADSWORTH ATHENAEUM
One oil painting: *Van Tromp's Shallop at the Entrance of the Scheldt* (exh.1832; Butlin & Joll 344).

Connecticut: New Haven
YALE CENTER FOR BRITISH ART
A large collection comprising fifteen paintings and over 250 watercolours and drawings. It also boasts the largest number of Turner prints in America. Notable works include: *Harlech Castle, from Twgwyn Ferry, Summer's Evening Twilight* (exh.1799; Butlin & Joll 9); *Dort, or Dordrecht, the Dort Packet-Boat from Rotterdam Becalmed* (exh.1818; Butlin & Joll 137); *Staffa, Fingal's Cave* (exh. 1832; Butlin & Joll 347); three 1795 watercolours after John Robert Cozens, including, *From the Isola Borromena - Lago Maggiore* (*c*.1795); three early Alpine watercolours, undertaken following Turner's first visit to Switzerland in 1802, including, *Glacier and Source of the Arveron, Going Up to the Mer de Glace* (exh. 1803; Wilton

365); and three watercolours from the 1817 tour of Belgium, Holland and the Rhineland, including, *Rheinfels Looking to Katz and Goarhausen* (1817; Wilton 650).

Illinois: Chicago
ART INSTITUTE OF CHICAGO
Two oil paintings and three watercolours, including: *Snow-storm, Avalanche and Inundation - a Scene in the Upper Part of Val d'Aouste, Piedmont* (exh.1837; Butlin & Joll 371); *Fishing Boats with Hucksters Bargaining for Fish ('Dutch Fishing Boats')* (exh. 1838; Butlin & Joll 371). Of the three watercolours, two are late Swiss scenes, *Val d'Aosta* (1836; Wilton 1436); *Lucerne [?Rapperswil]* (c.1842; Wilton 1471).

Indiana: Indianapolis
INDIANAPOLIS MUSEUM OF ART
Four oil paintings, over forty watercolours and drawings, and 3000 engravings (many of which are for *Liber Studiorum*). Notable works include: *Self-Portrait at the Age of Sixteen* (1791-2; Butlin & Joll 20); *The Fifth Plague of Egypt* (exh.1800; Butlin & Joll 13); *A View of Archbishop's Palace, Lambeth* (exh. 1790; Wilton 10); *Llanthony Abbey, Monmouthshire* [verso: *Colour Beginning for the Same Subject*] (1834; Wilton 863); and two late Swiss landscapes.

New York State: New York
FRICK COLLECTION
Five oil paintings, including: *Fishing Boats Entering Calais Harbour* (c.1803; Butlin & Joll 142); *Harbour of Dieppe (Changement de Domicile)* (exh.1825; Butlin & Joll 231).

New York State: New York
METROPOLITAN MUSEUM OF ART
Three oil paintings and four watercolours: *Saltash with the Water Ferry* (exh.1812; Butlin & Joll 121); *Venice, from the Porch of Madonna della Salute* (exh.1835; Butlin & Joll 362); *Whalers ('The Whale Ship')* (exh.1845; Butlin & Joll 415). *Lake of Zug, Early Morning* (1843; Wilton 1535).

Massachusetts: Boston
MUSEUM OF FINE ARTS
Three oil paintings and fifteen watercolours, and a quantity of outstanding Turner prints (many of which are for *Liber Studiorum*) from the Francis Bullard bequest. Notable works

include: *Fall of the Rhine at Schaffhausen* (exh.1806; Butlin & Joll 61); *View from the Terrace of a Villa at Niton, Isle of Wight, from Sketch by a Lady* (exh.1826; Butlin & Joll 234); *Slavers Throwing overboard the Dead and Dying - Typhon Coming On ('The Slave Ship')* (exh.1840; Butlin & Joll 385); and two studies for the *Little Liber* of c.1825-1830: *Catania, Sicily, in a Storm* (c.1824; Wilton 774); *Ship and Cutter* (c.1824; Wilton 777).

Massachusetts: Cambridge
FOGG ART MUSEUM, HARVARD UNIVERSITY
Two oil paintings and fifty watercolours, a number of which were executed in 1801, following Turner's tour of Scotland, the Lake District and Chester. Notable works include: *A Beech Wood* (c.1799-1801; Butlin & Joll 35c); *Rembrandt's Daughter* (exh.1827; Butlin & Joll 238); *Simplon Pass* (c.1848; Wilton 1566).

Ohio: Cincinnati
TAFT MUSEUM OF ART
Two oil paintings and ten watercolours, including three vignettes, two of which illustrate the works of Scott and Milton. Notable works include: *The Trout Stream ('Trout Fishing in the Dee, Corwen Bridge and Cottage')* (exh.1809; Butlin & Joll 92); *Europa and the Bull* (c.1845; Butlin & Joll 514); and the late Swiss watercolour, *Lake of Thun* (c.1848; Wilton 1567).

Ohio: Oberlin
PETER ALLEN MEMORIAL ART MUSEUM, OBERLIN COLLEGE
One oil painting: *Ducal Palace, Dogano* (exh. 1841; Butlin & Joll 390).

Ohio: Toledo
TOLEDO MUSEUM OF ART
One oil painting and one watercolour: *Campo Santo, Venice* (exh.1842; Butlin & Joll 397); *Schaffhausen: The Town and Castle* (1845; Wilton 1540).

Philadelphia: Pennsylvania
PHILADELPHIA MUSEUM OF ART
Two oil paintings and two watercolours, including: *The Burning of the House of Lords and Commons, 16th October 1834* (exh.1835; Butlin & Joll 359); *The Falls at Tivoli ?* (1803).

Providence: Rhode Island

RHODE ISLAND SCHOOL OF DESIGN

Fourteen watercolours and drawings, including: *Wharfedale, from the Chevin* (*c.*1816; Wilton 615); *The Lake, Petworth Park* (*c.*1827; Wilton 911).

Washington DC

NATIONAL GALLERY OF ART

Nine oil paintings and two watercolours, including: *Pluto Carrying off Proserpine* (exh.1839; Butlin & Joll 380); and three scenes of Venice, (1833, 1843 and 1844; Butlin & Joll 356, 403 and 412); *A Yorkshire River* (*c.*1827; Wilton 891); *A Packet Boat off Dover*.

Notes

Introduction

Note: References prefixed 'Add. MS...' indicate that the source is the British Library.

1 The inheritors of the estates of three key witnesses, Lord Egremont, Walter Fawkes and the Revd Henry Trimmer, destroyed large quantities of their personal papers. Moreover, very few records or manuscripts were found in Turner's studio after his death, which suggests that his executors may have disposed of them.

1. Turner's Inheritance: The British Art World and the Landscape Tradition

1 Add. MS 46151 C, p.3.
2 Turner's earliest signed and dated watercolour drawing is from 1787, but this was before he achieved exhibiting success at the Royal Academy. It may have been displayed in the window of his father's shop.
3 Strictly speaking, 'genre painting' was not widely used as a term until the 1840s. See Harry Mount, '"The Pan-and-Spoon Style" – The role of the accessories in David Wilkie's Academy pictures 1806–9', *British Art Journal*, vol.iv, no.3, 2003, pp.17–26, note 6 on p.25.
4 Farington *Diary*, 8 May 1799, vol.iv, p.1219.
5 He seems to have stopped offering tuition on a regular basis in 1797, not requiring that form of income once commissions began to take up his time.
6 Colt Hoare commissioned ten small watercolours of Salisbury and its environs and ten large watercolours of Salisbury Cathedral, as well as other watercolours of architectural subjects. These were executed *c.*1796–1805.
7 A codicil to his will, dated 20 August 1832, requests the Royal Academy, as a condition of its receiving the financial bequest outlined in the will, to hold a dinner 'every year on the 23rd of April (my birthday)'.
8 A plan of the property *c.*1809 shows an outbuilding smaller than this (37 ft x 16 ft), but Farington records the larger dimensions: *Diary*, 19 April 1804, vol.vi, p.2302.
9 Turner had moved round the corner to 44 Queen Anne Street West in 1809, subletting his original house but keeping control of the gallery. The new entrance meant that access to the gallery was no longer through his previous home. By 1822 he was the leaseholder of three adjacent houses in Harley Street, all of which, together with his house and studio, have subsequently been demolished.
10 Cited in Gage 1969, p.162.
11 Recalled in W.P. Frith, *My Autobiography and Reminiscences*, London 1888, pp.98–9.
12 Throughout his career Turner was fiercely loyal to the Royal Academy and served as one of its officers in a number of different capacities between 1803 and 1846. In addition to his teaching duties, between 1803 and 1845 Turner served as a member of the Academy's Council on ten occasions and on the Hanging Committee five times, and was acting President in 1845 and 1846 during the illness of Sir Martin Archer Shee. He audited the financial accounts every year from 1824 to 1839 and from 1841 to 1846. He was also Inspector of the Library and of the Cast Collection on several occasions.
13 The collection was passed on, following his death in 1833, to his son, Lord Francis Leveson-Gower, Earl of Ellesmere.
14 In 1795 Turner was commissioned by the then Viscount Malden (who became Earl of Essex in 1799) to make five watercolour views of Hampton Court, Herefordshire, one of his estates. He also made two groups of drawings of Cassiobury Park, Watford, Essex's main residence, the first in the 1790s and the second in 1807. Essex bought three oil paintings from Turner in the 1800s: *Walton Bridges* (1807), *Purfleet and the Essex Shore as Seen from Long Reach* (1808) and *Trout Fishing in the Dee, Corwen Bridge* (1809).
15 *Bacchus and Ariadne* (1840), Turner Bequest, Tate Britain. As well as *Dido Building Carthage* (1815), he also bequeathed *Sun Rising through Vapour* (1807) to hang alongside paintings by Claude.
16 Wark (ed.), Discourse XII (1784), p.217.
17 Wark (ed.) Discourse VI (1774), p.113.
18 TB LXXII, 'Studies in the Louvre' sketchbook, 1802, pp.41a–42.
19 Burke's treatise was first published in 1757 and had been through seventeen editions by the end of the century.
20 Fawkes himself had already visited Switzerland and was a competent amateur artist. He ordered thirty Swiss watercolours from Turner. Although he was not an aristocrat, it is just conceivable that Fawkes was one of the two 'noblemen' who joined with Lord Yarborough to fund Turner's 1802 trip to France and Switzerland.
21 In a bid to offset dwindling receipts, in 1812 the New Society of Painters in Miniature and Water-Colours admitted oil paintings to its exhibitions, but the experiment failed and its assets were seized. The Society of Painters in Water-Colours was also dissolved in 1812, re-establishing itself the following year as the Society of Painters in Oil and Water-Colours, before reverting to watercolours only in 1821. In 1832 another rival group appeared, the New Society of Painters in Water-Colours.
22 1821 Exhibition Catalogue for the New Society of Painters in Water-Colours.
23 Gill Hedley, *The Picturesque Tour in Northumberland and Durham, c.1720–1830*, Newcastle upon Tyne 1982, p.20.
24 Henry Fuseli, 'Lecture IV – on Invention, Part ii', in John Knowles (ed.), *The Life and Writings of Henry Fuseli,*

Esq., M.A., R.A., London 1831, vol.ii, p.217. The lecture was written in 1804.
25 Turner wrote to John Britton à propos his *Fine Arts of the English School* (1812), in which Britton had hoped to counterattack Fuseli: 'I rather lament that the remark which you read to me when I called in Tavistock Place is suppressed for it espoused the part of Elevated Landscape against the aspersions of Map making criticism, but no doubt you are better acquainted with the nature of publication, and mine is a mistaken zeal.' Letter dated November 1811, in Gage 1980, p.50.
26 *Scene in the Welsh Mountains with an Army on the March* (1799), TB LXX Q. A sketch of the Bard and his companions (TB LXX-h) suggests that Turner would have added these figures to this composition had he worked it up as an exhibition picture.
27 See Sam Smiles, *The Image of Antiquity: Ancient Britain and the Romantic Imagination*, New Haven and London 1994, pp.46–74.
28 Originally there were to be 120 watercolours for a history of Yorkshire, but only *Richmondshire* was published, for which Turner was commissioned to produce twenty drawings. In the event *Lancaster Sands* was not engraved.
29 These include *Picturesque Views on the Southern Coast of England* (issued from 1814), *Rivers of England* (from 1823), *Picturesque Views in England and Wales* (from 1825) and *Ports of England* (from 1826).
30 In a watercolour of *c.*1822, made for Walter Fawkes, Turner used Norham Castle to illustrate Walter Scott's poem *Marmion*, which relates the events of September 1513, when James IV of Scotland invaded England, burning Norham Castle, but was killed and his army slaughtered at the battle of Flodden Field.
31 Other versions of the castle were engraved for *The Rivers of England* series in 1824 and *The Provincial Antiquities of Scotland* in 1834.
32 Thornbury 1877, p.139.
33 A colour beginning for Norham Castle (TB CCLXIII-72; ?*c*.1835) also exists, which may conceivably have prompted the unfinished oil *Norham Castle, Sunrise*.

2. Making a Reputation: Patronage, the Art Market and the Independent Artist

1 In the late 1780s John Boydell (1719–1804), the engraver and publisher, had commissioned 162 paintings of Shakespearian scenes by the most respected artists of the day, for sale to subscribers as engravings. He believed this plan would stimulate British history painting and exhibited the paintings in his gallery in Pall Mall. The French wars ruined the export trade in prints and the scheme foundered, the collection being sold by lottery in 1804.
2 Marginal note written in Turner's copy of Martin Archer Shee's *Elements of Art*, facing p.25, cited in Barry Venning, 'Turner's Annotated Books: Opie's "Lectures on Painting" and Shee's "Elements of Art" (II)', *Turner Studies*, vol.2, no.2, Winter 1982, p.43.
3 Farington *Diary*, 17 July 1804, vol.vi, p.2380.
4 *Repository of Arts*, 1809, i, p.490.
5 For example, *Schloss Rosenau, Seat of H.R.H. Prince Albert of Coburg, near Coburg, Germany* (1841) and *The Opening of the Walhalla* (1842).
6 Over his whole career some eighty engravers were involved in transposing Turner's landscapes into a purely tonal medium.
7 TB CII, f4v, published in Wilton and Turner 1990, p.135. The final version of these lines, as offered to the public in 1809, is reprinted in the 'Turner's Writings' section of the present book.
8 Cited in Allan Cunningham, *The Lives of the Most Eminent British Painters, Sculptors and Architects*, London 1829, p.283.
9 James Northcote, *The Life of Titian, with anecdotes of the distinguished persons of his time*, London 1830, p.372.
10 Ibid., p.374.
11 Cunningham was secretary to Turner's friend the sculptor Sir Francis Chantrey.
12 Allan Cunningham, *The Cabinet Gallery of Pictures, selected from the splendid collections of art, public and private, which adorn Great Britain, with biographical and critical descriptions*, 2 vols., London 1833–4, vol.II, pp.11–12.
13 West's collection comprised his own work; Lawrence's was an enormous collection of old master drawings.
14 See Jeannie Chapel, 'The Turner Collector: Joseph Gillott, 1799–1872', *Turner Studies*, vol.6, no.2, Winter 1986, pp.43–50.
15 That said, he was quite prepared to adapt prevailing fashions when it suited him, as for example his experiments in 'Keepsake' subjects in the 1820s and 1930s. See Andrew Wilton, 'The "Keepsake" Convention: *Jessica* and Some Related Pictures', *Turner Studies*, vol.9, no.2, Winter 1989, pp.14–33.
16 *Literary Chronicle*, 22 June 1818.
17 Robert Hunt, *Examiner*, 3 February 1822. The exhibition had been assembled by the engraver and publisher W.B. Cooke at his London premises, 9 Soho Square.
18 Cited in Butlin and Joll 1984, p.204.
19 *Literary Gazette*, 31 May 1834. The critic was referring especially to two paintings exhibited at the Royal Academy in that year: *The Golden Bough* and *The Fountain of Indolence*.
20 See *Morning Chronicle*, 6 June 1833, and *Arnold's Magazine*, iii, November 1833–April 1834, pp.408–9.
21 Thornbury 1877, pp.228–9.
22 Charles Robert Leslie, *Autobiographical Recollections*, 1860, vol.I, p.202.
23 *Star*, 8 May 1806.
24 TB CXI, p.65a

3. The Intransigent Artist

1 Farington *Diary*, 15 May 1803, vol.vi, p.2031.
2 Farington *Diary*, 24 December 1803, vol.vi, p.2202.
3 Farington *Diary*, 11 May 1804, vol.vi, pp.2319–20.
4 *True Briton*, 4 May 1799, reviewing *Harlech Castle, from Twgwyn Ferry, Summer's Evening Twilight*.
5 *Porcupine*, 7 May 1801.
6 *Sun*, 10 May 1804.
7 See, for example, the critical disquiet occasioned by Turner's *Fall of the Rhine at Schaffhausen* (1806), now in the Museum of Fine Arts, Boston, cited in Butlin and Joll 1984, pp.48–9.
8 *Sun*, 10 May 1804.
9 See David Solkin, *Art on the Line: The Royal Academy Exhibitions at Somerset House, 1780–1836*, London 2001.
10 Farington *Diary*, 10 and 11 April 1812, vol.xi, pp.4107–8. As recorded by Farington, the picture had first been positioned over a door in the Great Room. When moved to its new position it gained an advantage at the expense of its surrounding pictures ('a scene of confusion and injuring the effect of the whole of that part of the arrangement') so that the Hanging Committee had to replace it in its original position. Turner threatened its removal until a compromise was reached by displaying it in an adjoining room.
11 Anthony Pasquin, *Morning Herald*, 1 May 1810, referring to Turner's *Lowther Castle, Westmorland, the Seat of the Earl of Lonsdale: North-West View from Ullswater Lane: Evening*.
12 *Athenaeum*, 11 May 1833.
13 *The Keepsake*, a Christmas annual, was published from 1827 to 1856. *Rembrandt's Daughter* (1827) (Fogg Art Museum, Harvard University) represents another approach by Turner to genre painting in this period, attempting to capture the Dutch master's treatment of interior scenes. See also Andrew Wilton, 'The "Keepsake" Convention: *Jessica* and Some Related Pictures', *Turner Studies*, vol.9, no.2, Winter 1989, pp.14–33.
14 Charles Robert Leslie, *Autobiographical Recollections*, 1860, vol.I, p.130. Leslie records Turner as saying Stothard was the 'Giotto of England', but he must surely have misheard him.
15 As recorded by William Kingsley and repeated by John Ruskin. See Cook and Wedderburn 1903–12, vol.35, p.601. See also Selby Whittingham, 'What you Will; or some notes regarding the influence of Watteau on Turner and other British Artists', *Turner Studies*, vol.5, no.1, Summer 1985, pp.2–24, and vol.5, no.2, 1985, pp.28–48.
16 Add. MS. 46151–P, pp.7 and 7v. This lecture, the only one of Turner's Perspective lectures to be substantially reprinted, can be found in Jerrold Ziff, '"Backgrounds, Introduction of Architecture and Landscape": A Lecture by J.M.W. Turner', *Journal of the*

Warburg and Courtauld Institutes, vol.26, 1963, pp.124–47.

17 Add. MS. 46151 – P, p.17.

18 An earlier version of this subject (c.1843) (National Gallery of Art, Washington DC), shows the ark more clearly and is generally less oppressive in its range of dark colours. It also includes what seems to be a crocodile-like creature in the right foreground, perhaps to stand for those creatures whose fossil remains had proved so contentious for believers in the biblical account of the earth's history.

19 See John 3:14–15. Theologically, this was understood to prefigure the crucifixion. Turner's normal use of the snake to symbolise evil must, however, complicate this interpretation.

20 Letter to Sir Thomas Lawrence, 15 December 1828, in Gage 1980, no.144, pp.122–3. The resurrection of the dead is described in Revelation, which Turner would use for *The Angel Standing in the Sun* (1846), and the passage referring to the sea giving up their dead (20:13) may have influenced him here.

21 *Second Report of the Commissioners of the Fine Arts*, London 1843, pp.63–4.

22 *Report of the Commissioners of the Fine Arts*, London 1842, p.13.

23 *Report from the Select Committee of the House of Lords appointed to consider … the will of the late Mr. Turner, R.A.*, London 1861, Parliamentary Papers, vol.v, p.8.

24 *Spectator*, 11 February 1837.

25 *Athenaeum*, 7 May 1842.

26 Fourteen parts, comprising seventy-one plates, were eventually published. A further twenty plates were engraved but not published.

27 Add. MS 46151 – P, p.16.

28 Farington *Diary*, 5 June 1815, vol.xiii, p.4638.

4. History – Ancient and Modern

1 Letter to the painter James Holworthy, 21 November 1817, in Gage 1980, no.70, p.71.

2 See William L. Pressly, *James Barry: The Artist as Hero*, London 1983. For Blake's opinions, see his annotations to Reynolds's *Discourses on Art* (ed. Wark), pp.284–5.

3 See W.B. Pope (ed.), *The Diary of Benjamin Robert Haydon*, 5 vols., Cambridge, Mass. 1960–3, and David Blayney Brown, Robert Woolf and Stephen Hebron, *Benjamin Robert Haydon*, Grasmere 1996.

4 Delivered 1788, in Reynolds's *Discourses on Art* (ed. Wark, 1975), p.255.

5 Add. MS 46151 – P, p.19v.

6 Letter dated 28 June 1822; no.97 in Gage 1980, pp.86–8. J.O. Robinson (*fl.* 1818–25) was a print seller and partner, with Hurst, in the publishers Longman & Co. By 1822 they may already have purchased Turner's *Temple of Jupiter Panellenius* (1816), engraved for them by John Pye in 1824. In 1825 they tried unsuccessfully to buy *Dido Building Carthage* (1815). Robinson and Hurst were declared bankrupt in 1826.

7 Turner suggested that John Pye undertake the engraving and that either *Hannibal* (1812) or *Dido and Aeneas Leaving Carthage on the Morning of the Chase* (1814) be selected as the first plate.

8 The first Punic War lasted from 264 to 241 BC, ending with the defeat of Carthage under Hamilcar Barca; in the second Punic War, 218–201 BC, Hannibal invaded Italy and won a string of victories before being defeated by Scipio Africanus at the battle of Zama, in north Africa; the third Punic War, 149–146 BC, ended in the obliteration of Carthage.

9 Farington *Diary*, 5 June 1815, vol.xiii, pp.4637–8.

10 The poses used in these reliefs allude to two of the most famous classical sculpted representations of violent death: the Uffizi's *Niobe* group, representing Niobe's children shot down by Diana and Apollo and the Vatican's *Laocoön* group, showing Laocoön and his sons being devoured by serpents.

11 Thornbury 1877, p.128.

12 Turner intended in his first will (1829) that *Dido Building Carthage* and *The Decline of the Carthaginian Empire* be bequeathed to the National Gallery. In his second will (1831) he changed his mind and bequeathed *Dido Building Carthage* and the *Sun Rising through Vapour* (1807).

13 Thornbury 1877, p.434.

14 TB CXL, 'Hastings to Margate' sketchbook, 1815–16, p.4. See also p.8.

15 The temple portico on the left includes the letters 'AMILCAR B', alluding to Hamilcar Barca, the first great Carthaginian general who had won victories in Sicily in the first Punic War, strengthened the army and extended control of Spain; on the triumphal monument to the right the letters 'HANN' appear at the top, alluding either to Hannibal or to Hanno, one of his generals in the second Punic War; below them can be seen 'AL', referring to Hannibal or Hasdrubal, his brother and second in command, followed by 'CANNAE', the battle in 216 BC in which Hannibal crushed the Romans. The lush ornamentation of sculptural details at Palmyra was widely known thanks to the engravings in James Wood's *Ruins of Palmyra* (1753).

16 The Bassae Frieze was excavated by C.R. Cockerell from 1811 and bought by the British government in 1814. The Elgin Marbles, taken from the Parthenon in Athens, were exhibited in Park Lane from 1807, in Burlington House from 1811 and in the British Museum from 1816. Lord Elgin had asked Turner to accompany his 1799 expedition as its official draughtsman but they had failed to agree terms. Their relations must have remained good, however, for Turner was allowed privileged access to the marbles in 1806, before they were open to limited public exhibition.

17 Oliver Goldsmith, *The Roman History*, London 1786, vol.I, p.309.

18 The whereabouts of Regulus in this picture has long been disputed, but the question appears to have been resolved with the publication of extracts from its engraver Daniel Wilson's 'Journal', in which the figure on the steps is identified as Regulus. See Finley 1999, p.213.

19 L. Cust, 'The portraits of J.M.W. Turner', *Magazine of Art*, 1895, pp.248–9.

20 The titles of the four paintings adumbrate the essentials of the story: *Aeneas Relating his Story to Dido*, *The Visit to the Tomb*, *Mercury Sent to Admonish Aeneas* and *The Departure of the Fleet*.

21 See *Forum Romanum, for Mr Soane's Museum* (1826) and the related watercolour design engraved for Samuel Rogers's poem *Italy* (1830).

22 In 1830 Turner had exhibited *Calais Sands, Low Water, Poissards Collecting Bait*, the purpose of which has also been interpreted as a tribute to Bonington's abilities as a landscape painter in its Bonington-like depiction of a large expanse of empty shore whose reflections mirror the light in the sky.

23 For the social and political meanings within Turner's topography see Shanes, *Turner's England*, 1990.

24 E.V. Rippingille, *Art Journal*, 1860, p.100, cited in Finberg 1961, pp.351–2.

25 Turner's religious subjects were painted in three periods: seven oils between 1800 and 1805, three oils and thirty-three watercolours between 1832 and 1835, and four oils between 1841 and 1846.

26 The figure of the chained serpent is also found in Revelation 22:1–2.

27 It has also been suggested that Turner included an autobiographical reference here. Ruskin had referred to him as 'the great Angel of the Apocalypse' in the first edition of *Modern Painters* (1843), Cook and Wedderburn 1903–12, vol.3, p.254.

28 Gage 1969, p.129.

29 Cited ibid., pp.130–1.

30 *Notes on the Turner Gallery at Marlborough House*, 1856–7, no.508, in Cook and Wedderburn 1903–12, vol.3, pp.136–7.

5. Witnessing the Age

1 Constable to Maria Bicknell, 30 June 1813, in R.B. Beckett (ed.), *John Constable's Correspondence*, Ipswich 1964, vol.2, p.110.

2 Quoted in Finberg 1961, p.434.

3 See Barry Venning, 'A macabre connoisseurship: Turner, Byron and the apprehension of shipwreck subjects in early nineteenth-century England', *Art History*, vol.8, no.3, September 1985, pp.303–19.

4 See Cecilia Powell, 'Turner's Women: The Painted Veil', *Turner Society News* 63, March 1993, p.15.

5 He had quoted from him as early as 1798, adding lines from *The Seasons* to

the Royal Academy catalogue for two of his pictures: *Dunstanborough Castle, N.E. Coast of Northumberland. Sun-Rise after a Squally Night* and *Buttermere Lake, with Part of Cromackwater, Cumberland, a Shower.*

6 Lines 1013–25. Of course, Turner's version has the ship afloat and only the slaves drowning.

7 See John McCoubrey, 'Turner's Slave Ship: Abolition, Ruskin, and Reception', *Word and Image*, vol.4, no.4, Oct–Dec 1998, pp.319–53.

8 John Ruskin, *Modern Painters* (1843), vol.1, no.3.572, in Cook and Wedderburn, 1903–12, vol.3, pp.571–3. Ruskin did not venture any discussion of the issue of slavery in his account. Modern commentators have speculated that his father's economic ties to the slave trade may have inhibited his response.

9 Turner had visited Newcastle and Shields in the 1820s and had produced a watercolour of Shields for the engraved series *Picturesque Views in England and Wales.*

10 Letter from John Hoppner, British Consul at Venice, 15 November 1816, quoted in David Laven, 'Venice under the Austrians', in Ian Warrell, *Turner and Venice*, exh. cat., Tate Gallery 2003, p.35.

11 See the watercolours *The Acropolis, Athens* (1822), *The Acropolis of Athens* (c.1823–4), *Hastings: Fish-market on the Sands* (1824), *Scio* (c.1832) and *The School of Homer, Scio* (c.1832).

12 Gage 1987, pp.209–11.

13 Whately's intention was to challenge the authority of philosophical scepticism by reducing it to an absurdity.

14 The most explicit example of this is the letterpress supplied to accompany the 1823 proof engraving of his watercolour *Wycliffe, near Rokeby* (c.1820) for Whitaker's *History of Richmondshire*, comparing Wycliffe's persecution to attacks on the freedom of expression in the 1820s. The text was not printed when the engraving was published.

15 Letter dated 24 October 1832, no.175 in Gage 1980, pp.148–9.

16 TB CLX, 'Waterloo and Rhine' sketchbook, 1817, especially pp.21a–26.

17 For Turner's tribute to Wilkie see Thornbury 1877, pp.323–4.

18 Holland House was the residence of Henry Fox, 3rd Baron Holland, and his wife. A centre of political influence and liberal thought, its guests included reformers, scientists and writers such as Jeremy Bentham, Samuel Romilly, Henry Brougham, Michael Faraday, Humphry Davy, Thomas Moore, George Byron and Sir Walter Scott.

19 Turner rented Sion Ferry House, Isleworth, on the banks of the Thames near Twickenham, from 1805 to 1806, before moving to 6 West End, Hammersmith, that autumn.

20 The commission was awarded through the good office of his friend, Sir Thomas Lawrence, Principal Painter in Ordinary to the King.

21 Letter dated 3 December 1823 in Gage 1980, p.90.

22 Egerton 1995, p.77.

23 For Turner's interest in science see Hamilton 1998.

24 *Art Union*, 15 February 1841. This was a review of the picture's exhibition at the British Institution, four years after its first appearance at the Royal Academy.

25 Turner seems to have acquired his interest in geology in the 1810s, knowing members of the Geological Society and owning two volumes of its *Transactions*. He knew Granville Penn from at least 1813, which may have disposed him to read his book *A Comparative Estimate of the Mineral and Mosaical Geologies* (London 1822) and to have taken an interest in the criticisms mounted at it, which required Penn to defend himself in a revised edition three years later. Lyell's *Principles* developed ideas already formulated by James Hutton in his *Theory of the Earth* (1788). When Lyell's *Principles* first appeared the term 'uniformitarianism' was coined to distinguish the idea of 'equable and steady' operations over very long time periods from the so-called 'catastrophism' of those who believed in a sequence of catastrophes, the last of which was that recorded in Genesis. For Turner's interest in geology see Gage 1987, pp.218–22.

6. Turner's Place in Art History

1 Knighthoods were awarded to many of Turner's contemporaries, including Lawrence, Chantrey, Soane, Shee, Wilkie, Callcott and Eastlake. Turner seems to have made an attempt to attract royal patronage from George IV, painting *England: Richmond Hill on the Prince Regent's Birthday* (1819), and, following George's accession to the throne in 1820, making a sketching trip to Edinburgh in 1822 to record the state visit. His only success in receiving royal patronage was *The Battle of Trafalgar* (fig.82), but this was due to Lawrence's influence at court.

2 He exhibited *Schloss Rosenau, Seat of H.R.H. Prince Albert of Coburg, near Coburg, Germany* in 1841 and *The Opening of the Walhalla* in 1842 and may conceivably have expected royal interest in his *Slave Ship* (fig.68) because Albert was patron of the Anti-Slavery League.

3 In a deliberate homage, Steer chose places depicted by Turner in the *Liber Studiorum* for some of his locales.

4 In addition to the artists mentioned below, the following landscape painters could also be included as responding to Turner's example: James Hamilton (1819–78), William Trost Richards (1833–1905) and Sanford Gifford (1823–80).

5 J.F. Cropsey, *Journals*, 20 March 1858, MS, Newington-Cropsey Foundation, Hastings-on-Hudson, New York State, cited in Andrew Wilton, 'The Sublime in the Old World and the New', in *American Sublime: Landscape Painting in the United States 1820–1880*, exh. cat., Tate Gallery 2002, p.24.

6 *Art Journal*, September 1859, p.297, cited in Andrew Wilton ibid., p.30.

7 See Richard P. Townsend, '"A Lasting Impression": Thomas Moran's Artistic Dialogue with J.M.W. Turner', in *J.M.W. Turner, 'The Greatest of Landscape Painters'*, exh. cat., Philbrook Museum of Art (Tulsa) 1998, pp.15–36.

8 McCubbin to his wife, Annie, 19 July 1907. La Trobe Library MS 8525 987/1. Cited in Ann Galbally, *Frederick McCubbin*, Richmond (Melbourne) 1981, p.132.

9 J.C.L. Dubosc de Pesquidoux, *L'École anglaise 1672–1851*, Paris 1858, p.198; cited in Gage 1987, pp.8–9.

10 All of the oils are now in the National Museum of Wales, Cardiff, except one which was sold to the Nationalmuseum, Stockholm, in 1960. Five works on paper were also sold at this time. Two of the oil paintings in Cardiff are no longer considered to be authentic. For information on the Davies collection see Mark Evans 'The Davies sisters of Llandinam and Impressionism for Wales, 1908–1923', *Journal of the History of Collections*, vol.16, no.2, 2004, pp.219–53.

11 Ernest Chesneau, *The English School of Painting* (trans. Lucy N. Etherington), London 1884.

12 Ibid., p.115; E. and J. de Goncourt, *Journal*, 12 August 1891. Groult's collection included *Ancient Italy – Ovid Banished from Rome* (1838) (fig.59), *Val d'Aosta* (c.1845–50) and *Landscape with a River and a Bay in the Distance* (c.1845–50).

13 Letter dated 20 February 1883, in John Rewald (ed.), *Camille Pissarro: Letters to his Son Lucien*, London 1943, p.22.

14 See Rémi Labrusse and Jacqueline Munck, 'Derain in London: Letters and a Sketchbook', *Burlington Magazine*, cxlvi, April 2004, pp.243–60.

15 Robert de la Sizeranne, *La Peinture Anglaise Contemporaine*, Paris: Hachette & Cie, 1894 (2nd ed., 1899), pp.11, 258.

16 Ibid., p.7.

17 *The Artist*, 1 June 1892, vol.13, p.190.

18 Kenneth McKonkey, *Impressionism in Britain*, London 1995, pp.119–20.

19 Letter to Dewhurst, dated November 1902, in Wynford Dewhurst, *Impressionist Painting: Its Genesis and Development*, London 1904, p.31.

20 Letter dated 30 March 1903, in Rewald, op. cit., p.355.

21 Despite its scepticism about Dewhurst's enterprise, Pissarro's letter is included in this book. See Dewhurst, op. cit., p.61.

22 Conversation dated 28 November 1918, in René Gimpel (trans. John Rosenberg), *Diary of an Art Dealer*, London 1966, p.73.

23 Robert de la Sizeranne, 'The Oil-

Painting of Turner', in C. Holmes (ed.), *The Genius of J.M.W.Turner, R.A.*, London 1903, p.xvi.

24. Ibid. pp.xiv–xv.

25 C. Lewis Hind, *Turner's Golden Visions*, London 1910, pp.214, 279.

26 See Andrew Wilton, 'The "Keepsake" Convention: *Jessica* and Some Related Pictures', *Turner Studies*, vol.9, no 2, Winter 1989, pp.14–33.

27 Board of Trustees' Minutes, 28 September, 1928, Tate Gallery Archive, TG 1/3/1/1, vol.II, p.260.

28 See Michael Auping, 'Clyfford Still and New York: The Buffalo Project', in Thomas Kellein (ed.), *Clyfford Still 1904–1980*, Munich 1992, pp.40–1.

29 For information on Turner and the Abstract Expressionists, see Barry Venning, *Turner*, London and New York 2003, pp.311–21.

30 Quoted in Barry Venning, 'Turner and the Moderns', *Turner Society News*, no.89, December 2001, p.11.

31 See Charles Ninnis, 'The Mystery of the Ariel', *Turner Society News*, no.20, January 1981, pp.6, 8.

32 Cook and Wedderburn, vol.13, p.161. The source of this criticism has not been found, but an echo of it occurs in William Beckford's remark, published by Cyrus Redding in 1844: 'He paints now as if his brains and imagination were mixed upon his palette with soap suds and lather; one must be born again to understand his pictures.' *New Monthly Magazine*, iii, September 1844, 72, p.24, cited in J.R. Piggott, 'Turner and William Beckford', *Turner Society News*, no.91, August 2002, p.6.

33 Cook and Wedderburn, vol.13, pp.161–2.

34 The artist's grandson, Horace Vernet, exhibited *Joseph Vernet Attached to the Mast Painting a Storm* at the 1822 Paris Salon.

35 The remark was made in connection with Turner's *Wreckers – Coast of Northumberland, with a Steam-Boat Assisting a Ship off Shore* (1834); see *Arnold's Magazine* for May–June 1834, p.136. Turner may also have read the 1839 article on severe storms at sea, published in *Blackwood's Magazine*, by his acquaintance Sir David Brewster. See William Rodner, *J.M.W. Turner: Romantic Painter of the Industrial Revolution*, 1997, pp.78–9.

36 In a conversation with Jane Fawkes, Turner said, 'the only secret I have got is damned hard work'. See W.L. Leitch, 'The Early History of Turner's Yorkshire Drawings', *Athenaeum*, 1894, p.327.

37 Letter dated 11 February 1830, in Gage 1980, p.136.

38 *Art Union*, June 1843.

39 These lines are partially adapted from Thomas Gray's poem *The Bard* and also seem to show some influence from Shelley's *Lines Written among the Euganean Hills*.

40 Perspective lecture draft, British Library, Add MS 46151 - H.

41 John Ruskin, *Modern Painters* (1843), vol.1, in Cook and Wedderburn, vol.3, p.254. This passage was omitted in all subsequent editions of *Modern Painters*.

Turner's Technique

1 Only a very few sketches were not part of the settlement, having left Turner's studio before his death. The Turner Bequest is now housed in the Clore Gallery at Tate Britain, where it can be consulted by appointment. The Tate website (http//:www.tate.org.uk/) offers an online facility, Turner Online, which allows users to examine this entire stock of material and to search it by category, using the reference of A.J. Finberg's *A Complete Inventory of the Drawings of the Turner Bequest*, 2 vols., London 1909.

2 Thornbury 1877, pp.143–9.

3 Farington *Diary*, 24 October 1798, vol.iii, p.1075.

4 Colour sketching in the open air is recorded from the tours to Wales in the 1790s, to Scotland and the north of England in 1801, to Switzerland in 1802, on the Thames *c*.1805, studying cloud formations ('Skies' sketchbook) *c*.1818, in Italy 1819–20, the Val d'Aosta in 1836, in Venice in 1840 and in northern France in 1845.

5 Letter from John Soane junior to his father, John Soane, 15 November 1819. Cited in Finberg 1961, p.262.

6 Two further groups of sketches formerly attributed to open-air work in Italy in 1828 are now presumed to represent studio work produced in England. The first group of sixteen (BJ 302–17) includes several scenes closely related to pencil sketches made in France in 1821; the second group of ten, smaller sketches (BJ 318–27) may conceivably derive from his first Italian tour of 1819, but may also be studio work produced in England in the early 1820s.

7 'M.L.' [Mary Lloyd], 'A Memoir of J.M.W. Turner, R.A.', *Sunny Memories*, 2 vols., 1879 and 1880, p.38; reprinted in *Turner Studies*, vol.4, no.1, Summer 1984, pp.22–3.

8 Farington *Diary*, 16 [17] November 1799, 1978–98, vol.iv, p.1303.

9 Farington *Diary*, 28 March 1804, vol.vi, p.2281.

10 B. Weber, *James Orrock R.I.*, 1903, I, pp.60–1.

11 Charles Holmes (ed.), *The Genius of J.M.W. Turner*, 1903 pp.vii–viii.

12 W.L. Leitch, 'The Early History of Turner's Yorkshire Drawings', *Athenaeum*, 1894, p.327.

13 TB CXXVII, 'Sandycombe and Yorkshire' sketchbook, 1812, p.31: 'Salvator Rosa painted a picture for the Constable of France in a day, and carried it home which rapidity so captivated the Constable that he ordered another large one which he likewise began finished and sent home. that (?) well paid for by purses of gold and as Constable commented which would be first weary, but upon the production of the 5th the employer sent 2 purses and declined the rivalship with the artist's powers of rapidity.'

14 See Martin Butlin, *Turner: Watercolours*, London 1962, p.36. It is important to note that this is not necessarily a reliable account, having been written down some years after the event by Mrs Edith Mary Fawkes, the daughter-in-law of Hawkesworth Fawkes's brother, the Revd Ayscough Fawkes. The one fact that can be checked, Hawkesworth Fawkes's age at the time, is wrong: he is described as 'a boy of about 15'.

15 See Eric Shanes, 'Turner and the creation of his 'First-Rate' in a few hours; A kind of frenzy?' *Apollo*, vol.cliii, no.469, March 2001, pp.13–15.

16 This sketch is numbered TB CXCVI N and is a preparatory study for *Loss of an East Indiaman* (*c*.1818).

17 Sir George Beaumont recorded in Farington *Diary*, 21 October 1812, vol.xii, p.4224.

18 Townsend 1993, p.33.

19 See Gage 1989.

20 Townsend, op.cit., p.40

21 Ibid., pp.41–3

22 TB CXXXV. For a full discussion of this sketchbook see Gage 1969, p.19.

23 Townsend, op. cit., pp.49–52.

24 Ibid., p.66.

Turner's Writings

1 The Perspective lectures have not been published in full as the manuscripts are of a technical nature, heavily revised and often difficult to interpret. The most complete text of one of them is in Jerrold Ziff, '"Backgrounds: Introduction of Architecture and Landscape." A Lecture by J.M.W. Turner', *Journal of the Warburg and Courtauld Institutes*, vol.26, 1963, pp.124–47. Partial transcripts can also be found in Gage 1969, especially pp.196–213, and in Davies 1992 *passim*. Of the twenty-eight manuscripts in the British Library (Add. MSS 46151, A-Z, AA and BB), there is some dispute about Add. MS 46151, Q. This is neither in Turner's handwriting nor that of his copyist, William Rolls. Moreover, in terms of its use of English and rhetorical polish it is very unlike the other manuscripts. For this reason, extracts from Add. MS 46151 – Q have been provided, where appropriate, in the notes for each subheading but not in the main text.

2 In 1811, 1812, 1814, 1815, 1816, 1818, 1819, 1821, 1824, 1825, 1827 and 1828.

3 TB LXXII, 'Studies in the Louvre' sketchbook, 1802; see also sketchbooks TB CXCIII, '"Remarks" (Italy)', 1819, and TB CCLVIII, 'Dieppe, Rouen and Paris', 1830.

4 These emendations have been published by Barry Venning, 'Turner's Annotated Books: Opie's "Lectures on Painting" and Shee's "Elements of Art" (I)', *Turner Studies*, vol.2, no.1, Summer 1982, pp.36–42; 'Turner's Annotated Books: Opie's "Lectures on Painting" and Shee's "Elements of Art" (II)', *Turner Studies*, vol.2, no.2, Winter 1982, pp.40–9; 'Turner's Annotated Books:

Opie's "Lectures on Painting" and Shee's "Elements of Art" (III)', *Turner Studies*, vol.3, no.1, Summer 1983, pp.33–44; and by John Gage, 'Turner's Annotated Books: "Goethe's theory of Colours"', *Turner Studies*, vol.6 no.1, Summer 1986, pp.2–9.

5 Before 1812, when *Fallacies of Hope* made its first appearance, Turner used quotations from poets he admired and also some of his own poetry to accompany his exhibits in exhibition catalogues. Scholars now believe that *Fallacies of Hope* did not exist independently of its fragmentary appearance in the exhibition catalogues. The most recent publication of Turner's poetry is Wilton and Turner 1990.

6 See Wilton and Turner 1990.

7 See Gage 1980. A few minor letters have subsequently surfaced, most of which were published by John Gage as 'Further Correspondence of J.M.W. Turner', *Turner Studies*, vol.6, no.1, Summer 1986, pp.2–9.

8 Add. MS 46151, I, ff. 17r-v.

9 Add. MS 46151, I, ff. 18v-19r.

10 TB LXXII, 'Studies in the Louvre' sketchbook, 1802, pp.30, 30a, 31a.

11 Ibid., pp.26a, 41a, 42.

12 Add. MS 46151, I, f. 19v. Turner's opinion on Rubens does not seem to have altered. David Wilkie heard him holding forth at a dinner party in Rome in 1828: 'He broke out, to the annoyance of all, against the landscapes of Rubens. There was no arguing with him. His violence was just inverse to the weakness of his position, which, however, he seemed to take the keenest interest in defending. We impressed upon him our regret that such a man as he could not feel the beauties of such an observer as Rubens.' Letter to Andrew Geddes, quoted in Finberg 1961, p.314.

13 Emendation to John Opie's *Lectures on Painting* (p.23), cited in Barry Venning, 'Turner's Annotated Books: Opie's "Lectures on Painting" and Shee's "Elements of Art" (I)', *Turner Studies*, vol.2, no.1, Summer 1982, p.41.

14 'I mean not to depreciate the antients to whom we are very much indebted for the valuable remains that have come to our hands, but let us not stop in our pursuit after perfection & think there is no excellence in Nature left for us to glean; we ought to endeavour to excell.' Add. MS 46151, Q, ff. 3v-4r. For discussion of this manuscript see note 1.

15 Add. MS 46151, I, f. 1r-v. In this passage Turner has borrowed from Reynolds's *Discourses*, rearranging part of the introductory paragraph of Discourse XIV; see Wark (ed.), p.247.

16 Add. MS 46151, K, f. 22v.

17 Add. MS 46151, N, f. 8v.

18 TB CVIII, 'Perspective' sketchbook, c.1809, p.95.

19 Emendation to John Opie's *Lectures on Painting* (p.58), cited in Barry Venning, 'Turner's Annotated Books: Opie's "Lectures on Painting" and

Shee's "Elements of Art" (I)', *Turner Studies*, vol.2, no.1, Summer 1982, pp.38–9.

20 Add. MS 46151, AA, f.28v. In this passage Turner has borrowed from Reynolds's *Discourses*, quoting part of Discourse XV; see Wark (ed.), p.268.

21 Add. MS 46151, H, f. 41v.

22 'What we call genius is not alone sufficient. Great industry and application must be so join'd with it, without which it will be better for young men to apply in time to some other Profession.' 'I don't believe genius innate, yet I believe some are born with more mental strength, as some are with more bodily Strength than common.' Add. MS 46151, Q, ff. 3r and 4v. For discussion of this manuscript see note 1.

23 Add. MS 46151, K, ff. 4-4r.

24 Add. MS. 46151, AA, f. 26v. Turner refers here to Reynolds's Discourse I; see Wark (ed.), p.17.

25 Emendation to Martin Archer Shee, *Elements of Art* (facing p.11), cited in Barry Venning, 'Turner's Annotated Books: Opie's "Lectures on Painting" and Shee's "Elements of Art" (III)', *Turner Studies*, vol.3, no.1, Summer 1983, p.40.

26 Emendation to Martin Archer Shee, *Elements of Art* (facing p.6), cited in Barry Venning, 'Turner's Annotated Books: Opie's "Lectures on Painting" and Shee's "Elements of Art" (II)', *Turner Studies*, vol.2, no.2, Winter 1982, p.42.

27 Add. MS 46151 G f 95v.

28 Add. MS 46151, M, f. 29v.

29 Add. MS 46151, F, f. 19r.

30 Add. MS 46151, H, ff. 12r-12 v. Turner is probably referring to Reynolds's Discourses I, II and VIII; see Wark (ed.).

31 Add. MS 46151, N, f. 8r.

32 Add. MS 46151, H, ff. 12r-v.

33 Add. MS 46151, G, f.1v.

34 Add. MS 46151, BB f.27.

35 TB CV, 'Tabley' sketchbook no.3, 1808, inside of cover.

36 Add Ms 46151, H, f. 41v.

37 Add. MS 46151, H, ff. 7r-7v.

38 Add, MS 46151, D, ff. 8v-9r.

39 Quoted in Wilton and Turner 1990, p.21.

40 These extracts are all taken from Gage 1980.

41 Ambrose Bowden Johns (1776–1858) was a Plymouth landscape painter who probably first met Turner when Turner visited Devon in 1811. He was instrumental in providing the equipment that allowed Turner to make *plein air* oil sketches in the countryside around Plymouth in 1813. This letter was written after Turner's third and last visit to Devon in 1814.

42 No.52 in Gage 1980, pp.57–9.

43 Turner owned Opie's *Lectures on Painting* (1809). Some of the comments written by Turner in the margins of this book are reproduced above.

44 Gage suggests that Turner is referring to the *Examiner* of 2 October 1814 and 12 February 1814, the first making sarcastic remarks about the

financial self-interest of the Royal Academy and the second criticising Turner's 'degrading' of his position as Professor of Perspective at the Royal Academy by entering his picture *Apullia in Search of Appullus, Vide Ovid* for the British Institution's prize for up-and-coming artists. See Gage 1980, p.58, notes 2, 3.

45 Gage believes that Turner refers here to articles written by William Hazlitt and published in the *Champion* of 28 August and 11 September 1814. See Gage 1980, p.58, note 4.

46 William Frederick Wells (1762–1836) was a watercolour painter, etcher and drawing master who first met Turner c.1792. Turner was a frequent guest at his home in the 1790s and 1800s. In 1804 Wells was co-founder of the Society of Painters in Water-Colours. In 1806 he inspired Turner to undertake the *Liber Studiorum*.

47 No.89 in Gage 1980, pp.82–3.

48 Turner was rebuilding his house and gallery ('Alladins Palace') and the builders had disrupted his normal routines.

49 Wells had been at school on the site where Turner's new house was being built.

50 George Jones (1786–1869) was a painter of historical subjects, elected RA in 1824. He was a loyal friend to Turner and was made one of his executors in 1831.

51 No.141 in Gage 1980, pp.119–20. Written in Rome.

52 Turner's colleague the sculptor Sir Francis Chantrey (1781–1841) was made a member of the Royal Academy in 1818 and knighted in 1835. He was interested in landscape painting both as a collector and a practitioner. Turner nominated him as his executor in 1829, but not in later versions of his will.

53 Sir Thomas Lawrence (1769–1830) was probably the most celebrated portrait painter of the age and from 1820 President of the Royal Academy. From at least 1798 he had been an important supporter of Turner's abilities as the latter's career developed.

54 No.144 in Gage 1980, pp.122–3.

55 Sir Charles Lock Eastlake (1793–1865) was a painter of historical genre and later became a significant arts administrator. He first met Turner in the early 1810s. He lived in Rome from 1821 to 1830 and shared a house with Turner on his visit there in 1828. He was made President of the Royal Academy in 1850 and Director of the National Gallery in 1855.

56 No.147 in Gage 1980, pp.124–6.

57 Turner exhibited a watercolour of this incident at the Royal Academy in 1829: *Messieurs Les Voyageurs on their Return from Italy (Par la Diligence) in a Snow Drift upon Mount Tarrar, 22nd of January, 1829*.

58 No.161 in Gage 1980, pp.137–8.

59 Turner is referring to the funeral of Sir Thomas Lawrence at St Paul's Cathedral.

60 The artist George Dawe had died on

15 October 1829.

61 Turner's father died on 21 September 1829. Harriet Wells also died in 1829; she was the daughter of perhaps his dearest friend, the artist William Wells (see note 46), whose home and children provided Turner with a surrogate family.

62 Turner exhibited a watercolour of the funeral at the Royal Academy in 1830.

63 John Hammersley lived in Stoke-on-Trent and was the father of James Astbury Hammersley (1815–69), who studied with J.B. Pyne after Turner had decided not to train him. James Hammersley made his career as an art teacher and was Head of Manchester School of Design from 1849 to 1862.

64 No.219 in Gage 1980, p.170.

65 F.H. Fawkes (1797–1871) was the son of Turner's friend and patron Walter Fawkes of Farnley Hall, Yorkshire. As a young man he witnessed Turner's reaction to the storm that reappeared in *Hannibal* (1812) and the production of *A First-Rate taking in Stores* (1818). Before and after his father's death in 1825, he supported Turner through commissions, exhibitions and gifts.

66 No.275 in Gage 1980, pp.202–3.

67 No.318 in Gage 1980, pp.224–5.

Criticism and Commentary on Turner's Art, 1797–1966

1 Press criticisms of Turner's exhibited works 1797–1841 have been largely taken from the relevant entries in Butlin and Joll 1984.

The end date of 1966 for posthumous commentary is deliberate. The publication of John Gage's *Colour in Turner: Poetry and Truth* in 1969, followed by the bicentennial exhibitions in 1975, established a more scholarly tradition for Turner's appreciation, narrowing the space for a wide range of critical opinions. There is still debate about Turner's achievement, but differing critical estimations have to combat the mass of scholarship and the critical orthodoxy it represents. Opinion about the merits of Turner's art is now expressed much less vividly than previously.

2 John Williams (Anthony Pasquin), 'A Critical Guide to the Present Exhibition at the Royal Academy', *Morning Post*, 5 May 1797, on Turner's *Fishermen Coming Ashore at Sun Set, Previous to a Gale* (the *Mildmay Seapiece*).

3 Mr Thomas Green of Ipswich, *The Diary of A Lover of Literature*, Ipswich 1810: 3 June 1799.

4 *Porcupine*, 7 May 1801, on Turner's *Dutch Boats in a Gale: Fishermen Endeavouring to Put their Fish on Board* (the *Bridgewater Seapiece*).

5 Edward Dayes, *Works of the Late Edward Dayes*, 1805, p.305.

6 *Repository of Arts*, 1809, vol.l, p.490.

7 William Hazlitt, *Examiner*, 1816.

8 Benjamin Robert Haydon *Correspondence and Table Talk*, ed. F.W. Haydon, London 1876, vol.ii, p.431.

9 *Morning Herald*, 5 May 1829, on *Ulysses*.

10 Anonymous letter published in *Birmingham Journal*, 12 December 1829, on the occasion of an exhibition by Birmingham Society of Arts in which Turner's watercolours were first shown in the city; republished in Hamilton 2003, Appendix 1, p.196.

11 *Arnold's Magazine*, 1833.

12 *Morning Herald*, 2 May 1835, on Turner's *Burning of the Houses of Lords and Commons, October 16th, 1834*.

13 Revd John Eagles in *Blackwood's Magazine*, 1836 criticising *Juliet and her Nurse*. This was the criticism that promoted Ruskin's defence of Turner.

14 *Athenaeum*, 12 May 1838. The 'unbroken commandment' is the third, concerning graven images.

15 *The Times*, 4 May 1841, on *Schloss Rosenau, Seat of H.R.H. Prince Albert of Coburg, near Coburg, Germany*.

16 John Ruskin, *Modern Painters* (1843), vol.1, London 1888, pp.405–6.

17 John Ruskin, 'Postscript', dated June 1851, reprinted in *Modern Painters* (1843), vol.1, London 1888, pp.422–3.

18 John Ruskin, 'Preface to the second edition', *Modern Painters* (1843), London 1888, p.xliv.

19 D.S. MacColl, 'Genius Mislaid: Turner at the Guildhall: A Reverie' (1899), reprinted in D.S. MacColl, *What is Art? And Other Papers*, Harmondsworth 1940, pp.171–2.

20 Sir Walter Armstrong, *Turner*, London 1902, p.211.

21 G. Gasquoine Hartley, *Pictures in the Tate Gallery*, London 1905, p.32.

22 Julius Meier Graefe, *Modern Art, Being a Contribution to a New System of Aesthetics* (trans. Florence Simmonds and George W. Chrystal), London 1908, pp.97–8.

23 J.E. Phythian, *Turner*, London 1910, pp.89, 106, 181.

24 J.B. Manson, *Hours in the Tate Gallery*, London 1926, p.69.

25 Roger Fry, 'Introduction' in R.R. Tatlock (ed.), *English Painting of the XVIIIth-XXth Centuries … A Record of the Collection in the Lady Lever Art Gallery*, London 1928, pp.19–20.

26 Roger Fry, *Reflections on British Painting*, London 1934, pp.133–4.

27 Adrian Stokes, 'Painting and the Inner World – Part III: The Art of Turner 1775–1851', in *The Critical Writings of Adrian Stokes*, vol.iii, London 1978, p.251.

28 Clement Greenberg, 'The Smoothness of Turner' (book review of Jack Lindsay's *J.M.W. Turner: His Life and Work: A Critical Biography*, first published in *Washington Post Book Week*, 11 September 1966), in *The Collected Essays and Criticism*, ed. J. O'Brian, vol.4, *Modernism with a Vengeance, 1957–1969*, Chicago 1993, pp.231–2.

29 Monroe Wheeler, 'Foreword' to Gowing 1966, p.5.

Photographic Credits

Image © The Art Institute of Chicago / 82

Ashmolean Museum, Oxford / 7

© Copyright The Trustees of The British Museum / 5, 29

City Museums and Art Gallery, Birmingham / 18

Trustees, Cecil Higgins Art Gallery, Bedford, England / 13, 98

Corcoran Gallery of Art, Washington, D.C. / 38

© Fitzwilliam Museum, Cambridge / 77

Fuji Art Museum, Tokyo / 34

Glasgow Art Gallery and Museum / 56

Calouste Gulbenkian, Lisbon / 66

Indianapolis Museum of Art/ 1, 76

Paris, musee du Louvre © Photo RMN / 11

Lowell Libson Ltd. / 28

Museum of Fine Arts, Boston / 68

National Gallery, London / 50, 51, 64, 81, 88

Image © 2005 Board of Trustees, National Gallery of Art, Washington / 44, 69, 70

© National Maritime Museum, London / 80

National Museums Liverpool (Lady Lever Art Gallery)/ 32

National Museums and Galleries of Wales / 87

Collection of The New-York Historical Society / 84

North Carolina Museum of Art, Raleigh/ 85

Courtesy Nottingham City Museums and Galleries: Nottingham Castle / 61

Philadelphia Museum of Art / 62

© Royal Academy of Arts, London Photographer: Prudence Cuming Associates / 16

Salisbury and South Wiltshire Museum / 4

Seattle Art Museum, Gift of Mr. And Mrs. Louis Brechemin (photo credit Paul Macapia) / 27

Sheffield Galleries and Museums Trust, UK. Bridgeman Art Library / 3, 14

Tabley House Collection, University of Manchester, UK. The Bridgeman Art Library / 24

Tate Picture Library / 2, 6, 8-10, 12, 17, 19-21, 23, 25, 26, 30, 33, 35, 36, 39, 40, 42, 43, 45-48, 49, 52-55, 58,59, 63,65, 72, 75, 78, 79, 89-97, 99, 100

The Toledo Museum of Art / 22, 71

© Yale Center for British Art, Paul Mellon Collection. Bridgeman Art Library / 15, 41, 74, 83

Select Bibliography

Bibliographic information for articles and specialist literature referred to in the Notes appears there. This bibliography gives more general information.

Reference books

The *catalogue raisonné* for Turner's oil paintings is Butlin and Joll 1984, for his watercolours Wilton 1979 and for his engraved work Rawlinson 1908 and 1913.

Butlin, Martin and Joll, Evelyn *The Paintings of J.M.W.Turner*, 2 vols., New Haven and London, revised ed. 1984
Butlin, Martin, Joll, Evelyn and Herrmann, Luke (eds.) *The Oxford Companion to J.M.W. Turner*, Oxford and New York 2001
Finberg, A.J. *A Complete Inventory of the Drawings of the Turner Bequest*, 2 vols., London 1909
Gage, John (ed.) *Collected Correspondence of J.M.W.Turner*, Oxford 1980
Lindsay, Jack *The Sunset Ship – The Poems of J.M.W.Turner*, Lowestoft 1966
Rawlinson, W.G. *The Engraved Work of J.M.W.Turner, R.A.*, vol.1: *Line Engravings on Copper, 1794–1839*, London 1908
Rawlinson, W.G. *The Engraved Work of J.M.W.Turner, R.A.*, vol.2: *Line Engravings on Steel; Mezzotints; Aquatints, Plain and Coloured; Lithographs and Chromolithographs*, London 1913
Wilton, Andrew *The Life and Work of J.M.W.Turner*, London 1979
Wilton, Andrew and Turner, Rosalind Mallord *Painting and Poetry: Turner's Verse Book and his Work of 1804–1812*, London 1990

Specialist periodicals

Turner Society News 1975– (newsletter of the Turner Society; www.turnersociety.org.uk)
Turner Studies, 1981–91 (11 vols., with index, vol.11, no.2)

Modern editions of contemporary sources

Farington, Joseph *The Diary of Joseph Farington*, ed. Kenneth Garlick, Angus Macintyre and Kathryn Cave, 17 vols., New Haven and London 1978–98
Reynolds, Sir Joshua *Discourses on Art*, ed. Robert Wark, New Haven and London 1975
Ruskin, John *The Works of John Ruskin*, ed. E.T. Cook and Alexander Wedderburn, 39 vols., London 1903–12

Studies on eighteenth- and nineteenth-century art

Barrell, John *The Political Theory of Painting from Reynolds to Hazlitt*, Cambridge 1980
Brown, David Blayney *Romanticism*, London 2001
Clarke, Michael *The Tempting Prospect: A Social History of English Watercolours*, London 1981
Fyfe, Gordon *Art, Power and Modernity: English Art Institutions, 1750–1950*, London and New York 2000
Gage, John *George Field and his Circle: From Romanticism to the Pre Raphaelite Brotherhood*, Cambridge 1989
Hemingway, Andrew *Landscape Imagery and Urban Culture in Early Nineteenth-Century Britain*, Cambridge 1992
Hutchinson, Sidney C. *The History of the Royal Academy 1768–1968*, London 1968
Kriz, Kay Dian *The Idea of the English Landscape Painter: Genius as Alibi in the Early Nineteenth Century*, New Haven and London 1997
Owen, Felicity and Brown, David Blayney *Collector of Genius: A Life of Sir George Beaumont*, New Haven and London 1988
Parris, Leslie *Landscape in Britain c.1750–1850*, exh. cat., Tate Gallery 1973
Rosenthal, Michael *British Landscape Painting*, Oxford 1982
Solkin, David *Richard Wilson: The Landscape of Reaction*, London 1982
Vaughan, William *British Painting: The Golden Age from Hogarth to Turner*, London 1999
Whitley, W.T. *Art in England 1800–1820*, Cambridge 1928
Whitley, W.T. *Art in England 1821–1837*, Cambridge 1930
Wilton, Andrew and Lyles, Anne *The Great Age of British Watercolours, 1750–1880*, exh. cat., Royal Academy 1993

Biographies of Turner

Bailey, Anthony *Standing in the Sun: A Life of J.M.W.Turner*, London 1997
Finberg, A.J. *The Life of J.M.W.Turner, R.A.*, 2nd ed., Oxford 1961
Hamilton, James *Turner: A Life*, London 1997
Lindsay, Jack *J.M.W. Turner: His Life and Work: A Critical Biography*, London 1966
Thornbury, Walter *The Life of J.M.W. Turner*, 2nd ed., London 1877

Studies on Turner's art

Bachrach, A.G.H. *Turner's Holland*, exh. cat., Tate Gallery 1994
Bower, Peter *Turner's Papers: A Study in the Manufacture, Selection and Use of his Drawing Papers 1787–1820*, exh. cat., Tate Gallery 1990
Bower, Peter *Turner's Later Papers: A Study in the Manufacture, Selection, and Use of his Drawing Papers 1820–1851*, exh. cat., Tate Gallery 1999
Brown, David Blayney *From Turner's Studio: Paintings and Oil Sketches from the Turner Bequest*, exh. cat., Tate Gallery 1991
Brown, David Blayney *Oil Sketches from Nature: Turner and his

Contemporaries, exh. cat., Tate Gallery 1991

Brown, David Blayney *Turner and Byron*, exh. cat., Tate Gallery 1992

Brown, David Blayney *Turner in the Alps, 1802*, exh. cat., Tate Gallery and Fondation Pierre Gianadda, Martigny 1998

Brown, David Blayney *Turner in the Tate Collection*, London 2002

Chumbley, Ann and Warrell, Ian *Turner and the Human Figure: Studies of Contemporary Life*, exh. cat., Tate Gallery 1989

Davies, Maurice, *Turner as Professor: The Artist and Linear Perspective*, exh. cat., Tate Gallery 1992

Egerton, Judy *Making and Meaning: Turner, the Fighting Temeraire*, exh. cat., National Gallery 1995

Finley, Gerald *Landscapes of Memory: Turner as Illustrator to Scott*, London 1980

Finley, Gerald *Turner and George the Fourth at Edinburgh 1822*, exh. cat., Tate Gallery in association with Edinburgh University Press 1981

Finley, Gerald *Angel in the Sun: Turner's Vision of History*, Montreal, Kingston (London) and Ithaca (New York) 1999

Forrester, Gillian *Turner's 'Drawing Book': The Liber Studiorum*, exh. cat., Tate Gallery 1996

Gage, John *Colour in Turner: Poetry and Truth*, London 1969

Gage, John *Turner, 'Rain, Steam and Speed'*, London 1972

Gage, John *J.M.W. Turner – 'A Wonderful Range of Mind'*, New Haven and London 1987

Gowing, Lawrence *Turner: Imagination and Reality*, exh. cat., Museum of Modern Art, New York 1966

Guillaud, Maurice (ed.) *Turner en France*, exh. cat., Centre Culturel du Marais, Paris 1981

Hamilton, James *Turner and the Scientists*, exh. cat., Tate Gallery 1998

Hamilton, James *Turner: The Late Seascapes*, exh. cat., Sterling and Francine Clark Art Institute, Williamstown, Mass., and Yale University Press 2003

Hamilton, James *Turner's Britain*, exh. cat., London 2003

Harrison, Colin *Turner's Oxford*, exh. cat., Ashmolean Museum, Oxford 2000

Heffernan, James A.W. *The Re-creation of Landscape: A Study of Wordsworth, Coleridge, Constable, and Turner*, Hanover, NH, and London 1985

Herrmann, Luke *Ruskin and Turner: A Study of Ruskin as a Collector of Turner*, London 1968

Herrmann, Luke *Turner Prints: The Engraved Work of J.M.W. Turner*, London 1990

Hewison, Robert, Warrell, Ian and Wildman, Stephen, *Ruskin, Turner and the Pre-Raphaelites*, exh. cat., Tate Gallery 2000

Hill, David, Warburton, Stanley and Tussey, Mary *Turner in Yorkshire*, exh. cat., York City Art Gallery 1980

Hill, David *In Turner's Footsteps through the Hills and Dales of Northern England*, London 1984

Hill, David *Turner in the Alps: The Journey through France and Switzerland in 1802*, London 1992

Hill, David *Turner on the Thames: River Journeys in the Year 1805*, New Haven and London 1993

Hill, David *Turner in the North: A Tour through Derbyshire, Yorkshire, Durham, Northumberland, the Scottish Borders, the Lake District, Lancashire, and Lincolnshire in the Year 1797*, exh. cat., New Haven and London 1996

House, Emma, Rudd, Michael and Clark, Paul *Joseph Mallard William Turner: Tours of Durham and Richmondshire*, The Bowes Museum 2006

Krause, Martin F. *Turner in Indianapolis: the Pantzer Collection of Drawings and Watercolors by J.M.W. Turner and by his Contemporaries at the Indianapolis Museum of Art*, Indianapolis 1997

Lyles, Anne and Perkins, Diane *Colour into Line: Turner and the Art of Engraving*, exh. cat., Tate Gallery 1989

Lyles Anne *Young Turner: Early Work to 1800; Watercolours and Drawings from the Turner Bequest 1787–1800*, exh. cat., Tate Gallery 1989

Lyles, Anne *Turner and Natural History: The Farnley Project*, exh. cat., Tate Gallery 1988

Lyles, Anne *Turner: The Fifth Decade: Watercolours 1830–1840*, exh. cat., Tate Gallery 1992

Lloyd, Michael (ed.) *Turner*, exh. cat., Canberra 1996

Nicholson, Kathleen *Turner's Classical Landscapes: Myth and Meaning*, Princeton 1990

Omer, Mordechai *Turner and the Bible*, exh. cat., Jerusalem 1979 and Oxford 1981

Paris *J.M.W. Turner*, exh. cat., Grand Palais, Paris 1983

Paulson, Ronald *Literary Landscape: Turner and Constable*, New Haven and London 1982

Perkins, Diane *Turner – The Third Decade; Turner Watercolours, 1810–1820*, exh. cat., Tate Gallery 1990

Piggott, Jan *Turner's Vignettes*, exh. cat., Tate Gallery 1993

Powell, Cecilia *Turner in the South: Rome, Naples, Florence*, New Haven and London 1987

Powell, Cecilia *Turner's Rivers of Europe: The Rhine, Meuse and Mosel*, exh. cat., Tate Gallery 1991

Powell, Cecilia *Turner in Germany*, exh. cat., Tate Gallery 1995

Powell, Cecilia *Italy in the Age of Turner: The Garden of the World*, exh. cat., Dulwich Picture Gallery and Merrell Holberton 1998

Reynolds, Graham *Turner*, London 1969

Rodner, William S., *J.M.W. Turner: Romantic Painter of the Industrial Revolution*, Berkeley, Calif., 1997

Royal Academy *Turner, 1775–1851*, exh. cat., Royal Academy 1974

Shanes, Eric *Turner's Human Landscape*, London 1990

Shanes, Eric *Turner's England*, London 1990

Shanes, Eric *Turner's Watercolour Explorations, 1810–42*, exh. cat., Tate Gallery 1997

Shanes, Eric *Turner in 1066 Country*, exh. cat., Hastings Museum and Art Gallery 1998

Shanes, Eric et al. *Turner: The Great Watercolours*, exh. cat., Royal Academy 2000

Sloan, Kim. *J.M.W. Turner: Watercolours from the R.W. Lloyd Bequest to the British Museum*, exh. cat., British Museum 1998

Smiles, Sam. *J.M.W. Turner* London 2000

Smiles, Sam. *Light into Colour: Turner in the South West*, St.Ives 2006

Stainton, Lindsay *Turner's Venice*, London 1985

Townsend, Joyce *Turner's Painting Techniques*, exh. cat., Tate Gallery 1993

Upstone, Robert *Turner: The Second Decade: Watercolours and Drawings from the Turner Bequest, 1800–1810*, exh. cat., Tate Gallery 1989

Upstone, Robert *Turner: The Final Years*, exh. cat., Tate Gallery 1993

Venning, Barry *Turner*, New York and London 2003

Warrell, Ian and Perkins, Diane *Turner and Architecture*, exh. cat., Tate Gallery 1988

Warrell, Ian *Turner: The Fourth Decade: Watercolours 1820–1830*, exh. cat., Tate Gallery 1991

Warrell, Ian *Through Switzerland with Turner: Ruskin's First Selection from the Turner Bequest*, exh. cat., Tate Gallery 1995

Warrell, Ian *Turner on the Loire*, exh. cat., Tate Gallery 1997

Warrell, Ian *Turner on the Seine*, exh. cat., Tate Gallery 1999

Warrell, Ian, Rowell, Christopher and Brown, David Blayney *Turner at Petworth* exh. cat., Tate Gallery 2002

Warrell, Ian *Turner and Venice*, exh. cat., Tate Gallery 2003

Wilkinson, Gerald *Turner's Early Sketch Books, 1789–1802*, London 1972

Wilkinson, Gerald *The Sketches of Turner, R.A, 1802–20: Genius of the Romantic*, London 1974

Wilkinson, Gerald *Turner's Colour Sketches, 1820–34*, London 1975

Wilton, Andrew *Turner in Switzerland*, Dubendorf 1976

Wilton, Andrew *Turner and the Sublime*, exh. cat., British Museum 1980

Wilton, Andrew *Turner Abroad: France, Italy, Germany, Switzerland*, London 1982

Wilton, Andrew *Turner Watercolours in the Clore Gallery*, London 1987

Wilton, Andrew *Turner in Wales*, exh. cat., Mostyn Art Gallery, Llandudno 1984

Wilton, Andrew *Turner in his Time*, London 1989

Wilton, Andrew *Turner as Draughtsman*, Aldershot 2006

Index